LORENZO DE' MEDICI AT HOME

LORENZO DE' MEDICI
AT HOME

THE INVENTORY OF THE PALAZZO MEDICI IN 1492

EDITED AND TRANSLATED BY

RICHARD STAPLEFORD

THE PENNSYLVANIA STATE UNIVERSITY PRESS

UNIVERSITY PARK, PENNSYLVANIA

Library of Congress Cataloging-in-Publication Data

Libro d'inventario dei beni di Lorenzo il Magnifico. English
Lorenzo de' Medici at home : the inventory of the Palazzo Medici in 1492 / edited and translated
by Richard Stapleford.
p. cm
Summary: "An inventory of the private possessions of Lorenzo il Magnifico de' Medici,
head of the ruling Medici family during the apogee of the Florentine Renaissance"
—Provided by publisher.
Includes bibliographical references and index.
ISBN 978-0-271-05641-8 (cloth : alk. paper)
ISBN 978-0-271-05642-5 (pbk. : alk. paper)
1. Medici, Lorenzo de', 1449–1492—Estate—Catalogs.
2. Medici, Lorenzo de', 1449–1492—Homes and haunts—Italy—Florence.
3. Palazzo Medici Riccardi—Catalogs.
4. Medici, Lorenzo de', 1449–1492—Art collections—Catalogs.
5. House furnishings—Italy—Florence—Catalogs.
6. Material culture—Italy—Florence—Catalogs.
I. Stapleford, Richard, 1939- .
II. Title.

DG737.9.L5313 2013
945'.511—dc23
2012028875

CONTENTS

ILLUSTRATIONS

Illustrations follow page 38

PREFACE

Archives are like attics. We put things in them thinking we might have need of them later, and then we forget, and the years pass, until no one remembers and they undergo a kind of sea change, becoming somehow more than they were when they were new. What was mundane becomes extraordinary; what was prose becomes poetry.

Nothing could be more banal than a listing of material goods in the house of Lorenzo de' Medici in April 1492. On a shelf over a stair in the ground-floor storage rooms are four leather-covered flasks, two crystal wine coolers, a candleholder, a collection of gardening tools, and a place for three small casks "that Giovanni the cooper has at the moment." In an instant we recognize a long-ago moment: the gardening staff gathering their tools to prune and plant, the anticipation of a midmorning break as they fill their water flasks, a house servant descending the stair and lighting a candle to make his way with his pitcher to the wine barrels, the scribe intent on the commonplace detail as he records the temporary absence of the casks. The vanished moment is magically restored.

The inventory of the household goods belonging to Lorenzo il Magnifico promises to supplement the wealth of information we have amassed about this extraordinary man. It does not disappoint, confirming studies and adding facts about his collecting habits and intellectual interests. But in addition to providing information about his paintings, books, and ancient gems, the inventory allows us to look over the shoulder of the scribe as he opens a storage chest and unfolds gown after luxurious gown, thumbs through a box to count coral beads, brocade dog collars, and a miniature chess set, and lists the various kinds of pots and pans in the kitchen. The day-to-day life of the family is brought into sharp focus in these lists, and with that focus we see Lorenzo in a new light.

All scholars stand on the shoulders of their teachers and colleagues. Without the archival work of Marco Spallanzani and Giovanna Gaeta Bertelà, my translation of the inventory would not have been possible. I owe them a debt of gratitude. I remember with thanks some of the many from whom I have profited in my work on the Italian Renaissance: Creighton Gilbert, Erwin Panofsky, James Beck, Leo Steinberg—a list too short but particularly sincere. I offer this small work with the wish that it will instill in students the desire to ask more questions and see a little further.

A NOTE ON MEASUREMENTS

The clerk who took the inventory of the Medici palace measured length using the *braccia* (Italian for arm, abbreviated br. in the inventory), equal to twenty-three inches (.583 m). For measuring wine, the clerk used the *barile*, equal to 15.5 ounces or .46 liters; for measuring the volume of other liquids (e.g., oil, vinegar), he used a *barile* equal to 11.6 ounces or .33 liters. He measured weight using the *libbra* (lib.), equal to 339.54 grams and broken down into 12 ounces (*once*, 28.29 grams each); an *oncia* is broken down into 24 *denari*; when weighing gold and silver, one *denaro* is equal to 1.17 grains. He measured monetary value in florins; one florin (*fiorono*, abbreviated f.) is broken down into 20 *soldi*, and there are 12 *denari* in a *soldo*; thus f. 1.10 stands for 1 florin, 10 soldi. The translation preserves the clerk's use of a dash (—) to indicate that he is unsure of a weight or monetary value.

INTRODUCTION

Lorenzo il Magnifico de' Medici (fig. 1) was the head of the ruling political party in Florence from 1469 to 1492, a period that marks the apogee of the golden age of quattrocento Florence. Born in 1449, Lorenzo lived a life shaped by privilege and responsibility, and his deeds as a statesman were legendary even while he lived. During his last years he was plagued by gout, the disease that killed his father, and was incapacitated with intense pain and fever, unable to walk or even to ride his horse. In March 1492 he was carried by litter from his palace on the Via Larga to his villa at Careggi, where he died on April 8, at the age of forty-three. In spite of his long illness, Lorenzo's death was a shock to Florence. The contemporary diarist Luca Landucci, in lamenting the loss, wrote, "This man in the eyes of the world was the most illustrious, the richest, the most stately and the most renowned among men. Everyone declared that he ruled Italy; and in very truth he was possessed of great wisdom and all his undertakings prospered."[1]

In his private life, Lorenzo was master of the largest and most famous palace in Florence, a building crammed full of the household goods of four generations of Medici, as well as the most extraordinary collections of art, antiquities, books, jewelry, coins, cameos, and rare vases in private hands. After his death Lorenzo's heirs made an inventory of the estate, a common undertaking following the demise of an important head of family. An anonymous clerk, pen and ledger in hand, walked through the palace from room to room, measuring the furniture, opening cabinets and chests, unfolding and inspecting clothes and fabrics and tapestries, recording the condition of musical instruments, examining elaborate clocks, counting stacks of dishes and piles of swords and other weapons, documenting the paintings and reliefs he saw on the walls, describing cameos, counting coins and medals, and unlocking jewel boxes to weigh gems, brooches, and rings.

The original document he produced has been lost, but in December 1512, before it disappeared, Lorenzo di Piero de' Medici, the grandson of Lorenzo il Magnifico, commissioned a copy from the priest Simone di Stagio dalle Pozze. The reason for the copy is clear: the Medici family was returning officially to

Florence that year after living in exile since 1494.[2] Since the expulsion, the family's possessions had been dispersed: some were confiscated by the state, others looted by thieves or sequestered by friends, and the remainder sold at auction.[3] When the copy was ordered, the process of reclamation had already started, vigorously supported by the new pro-Medici government. In October 1512 Landucci reported that the government had issued a proclamation stating that "whoever had property of the house of Medici was to notify it, *on pain of the gallows; and many things were recovered*" (emphasis added).[4]

The heads of the family in 1512 were Lorenzo il Magnifico's two surviving sons, Giovanni and Giuliano, and their cousin Giulio, all of whom had grown up in the palace. Lorenzo di Piero was younger, having been born the year Lorenzo il Magnifico died, but as Lorenzo's grandson he was an important heir. Apparently, this copy of the 1492 inventory was made as part of an effort by Lorenzo to establish an inventory of objects owed to him and to his two uncles and cousin in their negotiations with the state over the restoration of the Medici property.[5]

The document, of which this is my translation, is in the Archivio di Stato in Florence.[6] It was transcribed by Marco Spallanzani and Giovanna Gaeta Bertelà in 1992 and published as the *Libro d'inventario dei beni di Lorenzo il Magnifico*. Previously, the document had been published only in parts, and though the inventory was often referred to in discussions of Renaissance art and material culture, its full extent and depth was known to only a handful of scholars.[7]

LORENZO IL MAGNIFICO

The historian Francesco Guicciardini wrote in 1510 that as Lorenzo lay dying, Florence was in a state of prosperity and peace, largely owing to his stewardship (see fig. 2 for a contemporary view of the city). "The city was in perfect peace. . . . The people were daily entertained with festivals, spectacles and novelties; the city abounded in everything; trades and businesses were at the height of prosperity. Men of talent found their proper place in the great liberality with which the arts and sciences were promoted and those who practiced them were honored. The city, quiet and peaceful at home, enjoyed high esteem and great consideration abroad, . . . [and] she in some measure kept Italy in equilibrium."[8]

Lorenzo's life coincided with a pivotal period and a pivotal place in the evolution of the modern world. During the quattrocento, secular learning rose to challenge theology on matters of history, philosophy, and even morals.

Florentine humanists developed methods for the analysis of art an(
ture, history, philosophy, literature, and language that were to unl(
crets of the vanished civilizations of the past. Florence played an
role in the development of the nation-states that became Europe. ꜰⅼ○ⱦⅇⅬⅬⅬⅬⅬ
merchants maintained commercial arteries throughout Europe, and Florentine
bankers provided the exchange structures essential to international trade.[9] Lo-
renzo was at the center of all of these developments. He was the head of the
influential Medici bank and a subtle political manipulator, both within Flor-
ence and internationally. He was also a significant poet, a gifted scholar, and the
patron of artists, architects, musicians, and philosophers. As such, he seems the
embodiment of the Renaissance man. A close reading of the historical record,
however, casts a shadow on this picture. Scholars have pointed out Lorenzo's
ethical lapses in monetary dealings, his ineffective oversight of the family bank,
his failure to grasp the negative impact of some of his political manipulations,
and his moral indiscretions.[10] Such observations only seem to stimulate our
interest in the man. Who was the true Lorenzo?

Lorenzo's entry into public life was premature, owing to the illness of his
father, Piero (figs. 3 and 12), who was all but incapacitated by pain and swelling
in his joints caused by gout. Indeed, he was so afflicted that even during his
lifetime he had acquired the sobriquet "Gouty" (*Piero il Gottoso*). By the time
Lorenzo was a young teen, his father was no longer able to ride a horse but had
to be carried in a litter or sedan chair, and then only on occasions when he
absolutely had to travel. One can imagine that the young man's experience of
his father's decline left him with a vivid sense of the brevity of life. In the mid-
1480s, when Lorenzo was in his thirties but already experiencing symptoms of
gout, his poetry took a distinct turn toward melancholy and religious piety.[11] As
it turned out, he was to die at forty-three, ten years younger than his father was
when he died.

He was groomed from youth to head the family (see figs. 11 and 12). His entry
onto the international stage began in 1465 when, at only sixteen years old, he was
sent to Milan to be the official Medici representative at the marriage of Ippolita
Sforza to Alfonso of Aragon, the son of the king of Naples. That Piero would
entrust him with such an important, high-profile mission speaks to his prepa-
ration and the skills he had already demonstrated in Florence. His presence in
Milan was laden with significance. In addition to serving as the official delegate
of his city, reaffirming the political alliance between Milan and Florence, Lo-
renzo also stood for the Medici family, the living embodiment of the family's
ambitions to elevate themselves from the merchant class to the nobility.[12]

Lorenzo’s journey to Milan was so successful that in 1466 Piero again sent him on a diplomatic mission, this time to Rome and Naples, where he acted as the ambassador of Florence before Pope Paul II and Ferdinand I, king of Naples.[13] At age seventeen Lorenzo was already comfortable in the complex and subtle world of court etiquette and intrigue. His diplomatic skills, honed at that early age, served him well as he guided the fortunes of Florence and of his family for the next twenty-five years. The stakes were high, as demonstrated by a plot in 1466 to ambush and kill Piero as he was returning to the city from his villa at Careggi. Lorenzo, who had preceded his father’s entourage, played a key role in foiling the plot by riding bravely into the ambush while sending a companion back to warn his father to take a different route into the city. Even as a young man he had an intuitive ability to charm and disarm opponents and to know the right moment to act in perilous situations.[14]

Politics in the quattrocento was a dangerous game. In 1478 a plot to assassinate Lorenzo and his brother Giuliano was fomented by the aristocratic Pazzi family, who had become their enemies, with the active collusion of Pope Sixtus IV and Federico da Montefeltro, Duke of Urbino.[15] On Easter Sunday assassins infiltrated the crowd of worshippers in the Duomo and, on a prearranged signal, attacked Lorenzo and Giuliano with swords and knives. Giuliano died of nineteen stab wounds, while Lorenzo was able to deflect the first blow with his cape and fight off the assassins. With the help of two companions, including his friend Angelo Poliziano, who used his body as a shield to protect Lorenzo, he fought his way to safety in the sacristy. There, bleeding from a slashing blow to his neck, he and his companions barricaded the door with furniture, daring to open it only much later, when his supporters outside assured the group that it was safe (see figs. 4, 5).[16]

Lorenzo’s escape meant that the plot had failed. After a botched attempt by the plotters to occupy the Palazzo della Signoria, the perpetrators were hunted down and summarily executed, often in the most humiliating fashion. Florence was gripped with bloodlust as old slights were remembered and violently avenged. No more than a handful of individuals could have been involved in the plot, but before the day was over as many as a hundred people had been hanged, burned, torn apart, or beheaded. In the following days many more were tracked down and executed. The pope, enraged that the archbishop of Pisa had been ignominiously hanged as a plotter (a charge of which he was guilty), declared war on Florence and persuaded the king of Naples to throw in his armies. The conflict went badly for Florence, and by the winter of 1480 enemy troops were camped only a short ride from the city walls, poised to take the city by force

in the spring. At this precarious moment Lorenzo chose to travel to Naples, placing himself in the hands of his enemy. Over the course of two months at the Naples court, his personal charm and political shrewdness resulted in the withdrawal of Naples from the papal alliance and the end of hostilities.

It might be said that Lorenzo calculated his options to serve his own interests, but if the enemy had taken the city, as seemed inevitable with the resumption of hostilities in the spring, not only would Lorenzo have been murdered on the spot but Florence would have lost her independence. By traveling to Naples he was able to influence King Ferrante and save his city, though at considerable risk to himself. "It was considered a marvel that he should have returned," Landucci wrote in March 1480, "as everyone had doubted that the king would allow him to resume his post. . . . The ratification of peace arrived in the night, about 7 [3:00 A.M.]. There were great rejoicings with bonfires and ringing of bells."[17] After this, whatever other charges they might bring against him, Lorenzo's enemies could never impugn his willingness to act selflessly for the good of the state. Following the war, he was able to demonstrate once again his diplomatic skill and cunning. Upon the signing of the peace treaty Lorenzo arranged to send three Florentine artists and their assistants to Rome to fresco the walls of the Sistine Chapel, ensuring that even in the heart of Sixtus's artistic legacy, his *Capella Maggiore,* Florence's cultural preeminence would prevail.[18]

Lorenzo's reputation for diplomatic skill was carefully nurtured, though not always deserved. In 1472 he led Florence into a bloody reprisal against the citizens of Volterra, who were seeking independence in order to control their own alum mines. Lorenzo hired mercenaries who indiscriminately slaughtered the inhabitants. Though he was not directly responsible for the bloodshed, the stain of the Volterra massacre stayed with him and generated distrust even among his supporters. Nevertheless, he assumed the status of mediator and power broker in the intense political struggles within the Italian peninsula. In 1486 a number of wealthy barons in northern Italy declared war on one another and on the pope in the so-called Barons' War, but Lorenzo was able to broker a compromise between them and end the hostilities.[19]

During the course of Lorenzo's life, the Medici bank declined in importance. This was not entirely his fault, since the economic structure of Europe was shifting, reducing the influence of Florentine banks, but his stewardship of the family business certainly played a role. The Medici bank branches were located in Rome, Naples, Venice, Bruges, Lyon, Geneva, and London. Each was a separate enterprise overseen by the Florence bank, that is, by Lorenzo. Several of the branches were threatened with collapse through bad loans. If Lorenzo can

be faulted, it may be because he gave too much independence to the individual managers and was reluctant to fire them when their decisions imperiled the system.[20]

An illuminating part of Lorenzo's story is his relationship to his younger cousins, Lorenzo di Pierfrancesco (1463–1503) and Giovanni di Pierfrancesco (1467–1498), who were descended from Cosimo's brother, Lorenzo, whose son was Pierfrancesco.[21] That branch of the family lived next door to the Medici palace but was independent. The boys' mother, Laudomia Acciaioli, died in 1469, and Pierfrancesco followed in 1476, leaving his two sons orphans at the ages of thirteen and nine. Lorenzo assumed their guardianship, though he already had four young children of his own. He established a program of education for them, assigning tutors from his own network of scholars, poets, teachers, and philosophers.[22] This apparently generous act may not have been entirely selfless, as the boys were heirs to a large fortune. Immediately after he became their guardian in 1476, Lorenzo persuaded them to buy a villa at Castello, an acquisition more in line with Lorenzo's own interests. During the difficult years of war following the Pazzi conspiracy, Lorenzo dipped into the boys' inheritance to prop up the Medici bank's cash reserves. His action constituted embezzlement, and in 1485 he was forced by the courts to pay it back, partly in cash and partly in the transfer of ownership of his villa at Caffagiolo to the boys. Lorenzo's treatment of his wards seems mixed in equal parts of generosity and callous self-interest.[23]

Lorenzo's private life is well documented in stories, letters, and other records of his activities. From this patchwork emerges the image of a man with several abiding passions. He took full advantage of his station to avail himself of all the sensual pleasures Florence could offer. He wept upon hearing beautiful music, was known to keep mistresses, reveled in good food and clever company, and wrote bawdy lyrics for carnival songs. Most of all, he loved learning and antiquity, passions imbued in him from his earliest days as a pupil of several eminent scholars (fig. 6).[24] His tutors included Cristoforo Landino, a Latinist and Dante scholar who dedicated his energies to publishing the first edition in Florence of *The Divine Comedy* in the new medium of printing; Marsilio Ficino, a scholar of Greek and the foremost Neoplatonic philosopher of the Renaissance; and Gentile Becchi, the most eloquent Latinist in Italy. Another friend was Leon Battista Alberti, the famous architect and humanist.[25] As Lorenzo grew to manhood, this circle of intellectuals was enriched by the addition of younger poets and philosophers, including Angelo Poliziano, a scholar and the paramount poet of the quattrocento, who became his lifelong friend and the tutor to his children; Luigi Pulci, another poet, whose long poem *La giostra di Lorenzo de'*

Medici documented Lorenzo's joust of 1469; and Pico della Mirandola, the re-
markable scholar and philosopher who supplemented his knowledge of Greek
and Latin with Arabic and Hebrew as a means of unlocking the wisdom of the
past.[26] Lorenzo spent substantial personal sums and a great deal of effort to in-
vigorate the Studio, the university of Florence, and the university at Pisa. At the
Studio he created a chair for the study of Greek, the first in Italy, and spawned
the study of Greek throughout Europe.[27]

Lorenzo's poetry is well known and documents his love of the countryside.[28]
Indeed, as the English-speaking world was discovering Italian Renaissance po-
etry in the nineteenth century, John Addington Symonds called Lorenzo the
inventor of nature poetry. He saw nature as an antidote to the stress of urban
life, as in his sonnet "Let Search Who Will."

> Let search who will for pomp and honors high,
> The plazas, temples and the great buildings,
> The pleasures, the treasures, that accompany
> A thousand hard thoughts, a thousand pains.
> A green meadow filled with lovely flowers,
> A little brook that bathes the grass around,
> A little bird pining for his love,
> Better stills our ardor.[29]

His finest poetic work is his long poem *Ambra,* a series of forty-eight sonnets
that describe his pleasures in life at his villa at Poggio a Caiano. The poem
begins with a rich description of the sensual pleasures of the fall season as it
changes into winter, filled with memories of flowers and ripening apples, be-
fore moving on to a series of classical mythological references. In this poem are
concentrated two of the moving principles of his private life: love of nature and
love of antiquity.[30]

Lorenzo had an unquenchable thirst for the material remains of the an-
cient world. When he was sent to Milan in 1465 as the official representative of
Florence at the wedding of Ippolita Sforza and Alfonso of Aragon, he took the
opportunity to acquire a number of ancient objects.[31] In 1471, when he was dis-
patched to Rome as ambassador of Florence for the coronation of Pope Sixtus
IV, he wrote, "[I] carried away two ancient marble heads with the images of Au-
gustus and Agrippa, which the said Pope gave me; and in addition, I took away
our dish of carved chalcedony [the Tazza Farnese (fig. 16)] along with many
other cameos and coins."[32] For the rest of his life he combined diplomatic trips

with buying expeditions and maintained agents throughout Italy to spot new discoveries. His appetite for collecting was known even beyond Italy, as demonstrated by the gift of two large (Chinese) porcelain vases, "the likes of which no one had ever seen, nor any better made," from Sultan Qa'it-Baj of Cairo.[33]

Analysis of the collections in his palace shows that he spent little on contemporary art but acquired a vast number of coins, medals, antique cameos, ancient statues, and rare hardstone vases (figs. 16, 17, 18). The vases alone—many embellished with Lorenzo's initials and ornamented with gold and silver fittings—account for a full 27 percent of the total value of the inventory. But the most revealing aspect of the cameos, medals, and coins is not their monetary value but the way they reflect the interior life of their owner.[34] In this assemblage of small precious objects, evocative of other times and places and meant to be savored alone and up close, we see the mind of a private person of poetic meditative sensibilities.

Nevertheless, Lorenzo used the collection to impress visitors to Florence, designing his tours to appeal to the character of the guest. In 1480 Lorenzo escorted Giovanni of Aragon, son of the king of Naples, through the palace and showed him the collections in a cunningly orchestrated manner, as reported by the ambassador to Duke Ercole d'Este of Ferrara in a letter to the duke.

> Then he entered the studio and there he examined the said studio with copious quantities of books, all worthy, written with a pen—a stupendous thing. Then we returned to the little loggia opening off the camera. And there on the table he had brought his jewels [out of the studio] . . . vases, cups, hardstone coffers mounted with gold, of various stones, jasper and others. There was a crystal beaker mounted with a lid and a silver foot, which was studded with pearls, rubies, diamonds, and other stones [folio 17v]. [He also showed] a dish carved inside with diverse figures, which was a worthy thing, reputed to be worth 4000 ducats [the famous Tazza Farnese, folio 18r]. Then he brought out two large bowls full of ancient coins, one of gold coins and the other full of silver, then a little case with many jewels, rings and engraved stones.[35]

Lorenzo knew his audience. Giovanni was no scholar and cared nothing for the literary value of the books, just that they were "written with a pen." Aware of his limitations, Lorenzo did not showcase his antiquities or visit his library. Instead, he led Giovanni from cabinet to cabinet, unveiling his bright, shiny hardstone vases, his rings and jewels, finishing theatrically with two bowls full

of gold and silver coins and a case of jewels—a display calculated to impress the materialistic young man.

Lorenzo's intellectual life is demonstrated by his library, which included books collected by his grandfather and father and enhanced by his own purchases. He bought and commissioned books voraciously: it has been estimated that he expanded the manuscripts alone from the two hundred he inherited to one thousand at his death.[36] The library, however, is missing from the inventory, possibly because of construction work. We know that Lorenzo had been rebuilding the library from a number of references to marble he collected for the work. (After his death, even the Opera del Duomo confiscated marble from his palace for one of its altars.)[37] His death interrupted whatever work had been done, but the project was revived in 1524 when Pope Clement VII, Lorenzo's nephew, Giulio de' Medici, who had been raised in the palace, commissioned Michelangelo to construct a new housing for the books at San Lorenzo, a library that eventually became the Biblioteca Laurenziana.

Contemporary descriptions of Lorenzo often seem intended to create the fiction of an exemplary Renaissance humanist and Florentine hero. The Florentine government's official epitaph, written at the time of his death in 1492, is typical of the praise heaped on Lorenzo.

> Whereas the foremost man of all this city, the lately deceased Lorenzo de' Medici, did, during his whole life, neglect no opportunity of protecting, increasing, adorning and raising this city, but was always ready with counsel, authority, and painstaking in thought and deed; subordinated his personal interest to the advantage and benefit of the community; shrank from neither trouble nor danger for the good of the State and its freedom; and devoted to that object all his thoughts and powers, securing public order by excellent laws; by his presence brought a dangerous war to its end; regained the places lost in battle and took those belonging to the enemy; and whereas he furthermore, after the rare examples furnished by antiquity, for the safety of his fellow citizens and the freedom of his country gave himself up into his enemies' power and, filled with love for his house, averted the general danger by drawing it all on his own head; whereas, finally he omitted nothing that could tend to raise our reputation and enlarge our borders; it has seemed good to the Senate and to the people of Florence, on the motion of the chief magistrate, to establish a public testimonial of gratitude to the memory of such a man, in order that virtue might not be unhonored among the Florentines, and

that, in days to come, other citizens may be incited to serve the common-wealth with might and wisdom.[38]

Other contemporary sources underscore the complex and contradictory character of Lorenzo. Niccolò Machiavelli (1469–1527) knew Lorenzo well, and his judgment is informed by personal observation. In his *Florentine Histories* he does not shrink from identifying Lorenzo's weaknesses, but in the end he offers an admiring description of the whole man:

> His reputation grew every day because of his prudence; for he was elo-quent and sharp in discussing things, wise in resolving them, quick and spirited in executing them. Nor can the vices of his be adduced to stain his great virtues, even though he was marvelously involved in things of Venus and he delighted in facetious and pungent men and in childish games, more than would appear fitting in such a man. Many times he was seen among his sons and daughters, mixing in their amusements. Thus, considering both his voluptuous life and his grave life, one might see in him two different persons joined in an almost impossible conjunction.[39]

The picture of Lorenzo that emerges from these documents rests upon an ocean of legend and quotidian facts, some of which tarnish the man while oth-ers embellish his character. A more interesting Lorenzo peers from between the lines of letters about and from him, and from his poems about the villa life that he so loved.[40] Equally revealing, however, is the testimony of his possessions, packed away in *cassoni* and boxes, stacked in cupboards, and hanging on the walls of his private palace, all recorded in the inventory. It is not a document capable of resolving the contradictions in his life, but it has the unique virtue of presenting a true picture of one aspect of the man, unadulterated by legend or contrivance. This is the private world he lived in, constructed by himself and his family over his lifetime.

THE PALACE AND THE FAMILY

The Medici palace was an epoch-making building in the history of architecture, proclaiming by its large size and classical rhetoric the new self-confidence of its humanist builders (fig. 8). It established the model for urban palace archi-tecture for the next two centuries. The palace was commissioned by Cosimo de' Medici, probably in 1444, from Michelozzo di Bartolomeo (1396–1472), a

pupil and close collaborator of Donatello and Ghiberti. Michelozzo had already worked for Cosimo beginning in 1433, redesigning the Medici villa at Careggi and renovating and expanding the monastery of San Marco. The palace, begun in 1446 and occupied in about 1458–59, is Michelozzo's masterpiece, a seamless integration of the desires and political intentions of the patron expressed through the imagination of the artist.[41]

The palace was originally about 140 feet long on its main façade along the Via Larga, 140 feet deep, and 140 feet high through its cornice: a perfect cube (fig. 9). Its massive cornice imitates ancient Roman prototypes and expresses the geometric integrity of the design by being scaled to the whole building, not just the top floor. (The building was sold to the Riccardi family in 1659 and expanded along its main façade by about one-third, destroying the building's original proportions.) The building occupied the site of as many as twenty smaller townhouses that were razed to make way for the new palace. Its plan was square, with the rooms disposed in four stories around a large, open, arcaded courtyard (the top story is not articulated on the exterior façade). In addition to the four stories, the palace was equipped with a cellar and mezzanine levels. It also had a garden attached at the rear, an unusual amenity that Lorenzo used to display his collection of marble antiquities. The enormous size of the building was reflected in the scale of the rooms, a scale that required grander furniture, more wall coverings, and more art, all of which are documented in the 1492 inventory.[42]

The building was distinguished on the exterior by the masonry, which articulated each floor as a separate entity. The alignment of the windows united the floors, while the treatment of the stone differentiated them. Massive rusticated stones on the ground floor expressed the defensive strength appropriate to the street level. On the *piano nobile* (the second floor), ashlar masonry with crisply carved deep joints between the stones manifested the refined elegance of the public face of the family. On the third floor, the smooth ashlar masonry was more reticent, suitable for private family purposes. In this carefully graded hierarchy of masonry Michelozzo merged the vocabulary of architectural expression with the layered structure of Florentine family life.

The most striking feature of the palace was the courtyard (fig. 10). Previously, Florentine city palaces were likely to contain small interior open spaces, more like light wells than courtyards. The Medici palace courtyard, wide and bright and carefully finished with the finest carved detail, was ceremonial in function and symbolic in form. By copying exactly the colonnade of Brunelleschi's Ospedale degli Innocenti, Michelozzo evoked that building's sense of pure

mathematical proportions as well as its elegant classicizing vocabulary. Visitors to the palace were introduced to the humanist values of the family from the first moment they stepped into the courtyard, surrounded by the well-proportioned bays, graciously scaled columns, finely sculpted capitals, and finished wall surfaces. The experience was heightened by the display of ancient statuary in the surrounding ambulatory.[43] The importance of the collection of antiquities to the family's public image was underscored by the stucco medallions in the frieze of the courtyard entablature, reproductions of carved gems in the Medici collection. Standing on a high base in the center of the courtyard, Donatello's bronze *David* gave symbolic meaning to the space. In style it evoked the sculpture of antiquity and in its inscription proclaimed the republican values of the family: "The victor is whoever defends the fatherland. God crushes the wrath of an enormous foe. Behold! A boy overcame a great tyrant. Conquer, O citizens!"[44]

The palace had been commissioned by Cosimo di Giovanni de' Medici (1389–1464) for himself, his two sons, Piero (1416–1469) and Giovanni (1424–1463), and their families (figs. 11, 12). Lorenzo (1449–1492) was the first legitimate son of Piero and grandson of Cosimo. He became head of the family in 1469 upon the death of his father. As a boy, he watched the construction of the building and moved in when he was about ten years old. For all intents and purposes he grew up in the palace. In 1469 he married Clarice Orsini (1453–1488), a patrician from an important Roman family, and had ten children with her, six of whom survived into adulthood (Lorenzo's three sons are pictured in Ghirlandaio's painting of 1483–86 in Santa Trinitá, fig. 13). When Lorenzo died in 1492, his wife had been dead for four years, and four of their children were still living at home.[45] Piero, Lorenzo's first son and principal heir, was twenty-one and lived there with his wife, Alfonsina Orsini,[46] who was pregnant with their first child. (That child was Lorenzo di Piero de' Medici, who ordered this copy of the inventory in 1512.) Also living at home were Lorenzo's daughter Contessina, who was fourteen, his son Giuliano, thirteen, and his nephew Giulio (the future Pope Clement VII, the son of his murdered brother Giuliano), who was fourteen.

Living quarters for the principal male family members were arranged in suites of two to four rooms.[47] Two suites were designated as belonging to Lorenzo and one to his son, Piero, while young Giuliano had just taken over the quarters of his brother Giovanni (the future Pope Leo X), who had moved out. The other living areas are not specified as belonging to particular family members. Each suite consisted of a *camera,* which served as a living room as well as a bedchamber, an *antecamera,* a multipurpose auxiliary room, and another

room, such as a study, an armory, or a bath and/or toilet room. Marble busts placed over the doors identified the original occupants of these suites. In the living spaces on the *piano nobile,* a bust of Lorenzo's father, Piero (fig. 3), and a bust of his mother, Lucrezia Tornabuoni, were placed over the entrance to the *antecamera* and *camera* that then became Lorenzo's suite (folio 13v).[48] Cosimo's bust adorned the entrance to the *camera* of his suite on the same floor. In another suite a marble bust of Giovanni, Piero's brother and Lorenzo's uncle, marks the entrance. That room is identified in the inventory as "the chamber of Monsignore, where Giuliano lives" (folio 38v). The marble bust proves that it must have belonged to Giovanni first. Paintings in the room confirm that it then passed to Lorenzo himself before becoming the quarters of Lorenzo's second son, Giovanni (later Pope Leo X), who was Monsignore.[49] Giovanni lived there until he was officially consecrated a cardinal and moved out, in March 1492, and his brother Giuliano moved in. Piero, Lorenzo's first son, had a prime suite. It had its own terrace and consisted of a *camera, antecamera,* water closet, and armory. Lorenzo's younger brother, Giuliano, had lived there until he was murdered in the Pazzi conspiracy in 1478.[50] Lorenzo had two suites: a large reception hall called the Sala Grande on the ground floor and another on the *piano nobile,* each with an attached *camera* and *antecamera.* The famous study, which contained the most valuable treasures, was connected to the suite on the upper floor.

The palace also had a family chapel in a prominent position at the top of the main staircase on the *piano nobile* (fig. 14). The room on the *piano nobile* called the *saletta* was the family dining room (folio 38r). A suite of rooms on the third floor served for food preparation, including the kitchen proper, a pantry, a bread room, a fruit storeroom, and a vinegar room. An armory on the top floor was used to stockpile weapons, and a room there was set aside for a priest's quarters. The famous Medici collection of books, compiled over three generations by Cosimo, Piero, and Lorenzo, was kept in a library on the fourth floor, though it was not inventoried.[51]

APPORTIONMENT OF THE ASSETS

The furnishings and household goods with which Cosimo and his son Piero filled the rooms of the palace, and the valuables they amassed, were augmented by the addition of the valuables Lorenzo collected. Comparison of the present inventory with earlier inventories of the Medici and other wealthy Florentine families reveals a change in the percentage of the estate vested purely in

household goods. Previously, the inventoried estimate of a palace's value lay predominantly in the value of household goods like furnishings and clothes, but the value of Lorenzo's estate in his townhouse resided overwhelmingly in his collections.[52]

The total estimated value of the itemized goods in the inventory is 79,618 gold florins (fig. 15).[53] (The value of a florin should be understood in terms of its buying power. In 1480 one estimate of the cost of living stated that an annual income of seventy florins was sufficient to support a worker, his wife, and three or four children for one year.)[54] An accounting of the Medici holdings had been made upon the death of Lorenzo's father in 1469 that totaled, according to Lorenzo's own account book, 227,982 *scudi* (a *scudo* and a florin were comparable in value), but this included all the holdings in the *campagna* as well as the value of the real estate itself. The present inventory includes only the value of the goods within the city palace, not that of the palace itself. (When the palace alone was sold in 1659 to the Riccardi family, the purchase price was forty thousand *scudi*.) Of the estimated evaluation of the goods in the palace, approximately 20 percent is made up of what might be called household goods. Collectibles—that is, luxury items that are independent of the running of the household—make up the remaining 80 percent of the total.[55]

Household goods are defined as:

(1) Furniture, including benches, beds, chairs, and tables and the chests and caskets in which things were kept, altogether totaling only 1 percent of the value of the inventory.

(2) Clothes and dressmaking fabrics, about 5 percent of the total.

(3) Household linens, including sheets and bed covers, mattresses and pillows, bed-curtain sets, towels, table and bench covers, cushions, and table linens, altogether totaling about 7 percent of the total.

(4) Weapons and armor, including tournament and jousting gear, about 4 percent.

(5) Miscellaneous goods, including wine, kitchen equipment, dishes, and various pots, urns, basins, and jugs, about 3 percent.

Collectibles include:

(1) The paintings and sculpture, as well as small objets d'art, totaling about 5 percent of the total value of the inventory.

(2) Tapestries, about 1.5 percent.

(3) Hardstone vases, 27 percent of the entire value of the inventory.

(4) Cameos and incised stones, 19 percent.

(5) Gems and jewelry, 18 percent.

(6) A single "unicorn horn" estimated to be worth six thousand florins, or 8 percent of the inventory's value.

(7) Three distinct specialized collections: clocks (folio 24v), musical instruments (folio 10v), and Chinese porcelain (folio 7v), altogether totaling 964 florins, or slightly more than 1 percent of the total.

The palace had a renowned collection of books, the bulk of which, those kept in the family library on the fourth floor, were not itemized in the inventory. Any estimate of the value of the Medici property would consider the books among the most valuable items, so the total value of the estate should be adjusted accordingly. In 1465 Piero had his library inventoried and found that the estimated monetary value of his books came to 2,860 florins. That nucleus of Lorenzo's collection would have amounted to 3.5 percent of the amended total, but the substantial number of books and manuscripts that Lorenzo himself added later would have enhanced it.[56] The total value of the books, then, would have surpassed considerably the 5 percent valuation of the paintings and sculptures.

An important category of art objects that failed to find its way into the inventory is the collection of statuary, ancient and modern, placed in the courtyard and the rear garden. Among the modern works were Donatello's bronze *David,* which stood on a tall base in the courtyard, and the same artist's *Judith and Holofernes,* in the garden. After the expulsion of the Medici family in 1494, both were confiscated by the state as symbols of civic justice.[57] Lorenzo had an extensive collection of ancient statuary, about forty-three whole figures and fragments, most of them positioned around the garden of the palace and omitted in the inventory.[58] The clerk also failed to account for Lorenzo's large collection of ancient coins, most of them gold and silver. Angelo Poliziano, who catalogued them during Lorenzo's lifetime, found that they numbered no fewer than 4,678 pieces, though only 484 are mentioned in the inventory. The value of the coins would have been substantial, from a little less than one florin each for the silver coins to four florins for the gold, and would have inflated the overall value of the estate.[59]

The most highly valued item in the inventory was the Tazza Farnese (fig. 16), now in the Museo Archeologico Nazionale in Naples, described as "a bowl of sardonyx, chalcedony and agate, within which are several figures and on the

outside a head of Medusa," valued at 10,000 florins (folio 18r).[60] The other highly valued items include a jasper wine cooler (2,000 florins) (fig. 17), a sardonyx ewer (2,000 florins), a cameo with the scene of Noah's Ark (2,000 florins) (fig. 18), an incised chalcedony of a figure seated on an altar (1,500 florins), another cameo with a nude figure in front of a tree and other figures (1,000 florins), a carnelian depicting three figures (1,000 florins) (fig. 19),[61] and another carnelian with a chariot running over figures (1,000 florins). A reliquary known in earlier inventories as the "reliquary of the libretto" and in this inventory as "a golden reliquary in the form of a tabernacle" was estimated at 1,500 florins (folio 22v).[62] And, finally, the previously mentioned "unicorn horn" was evaluated at 6,000 florins. The estimate of these ten objects alone, at 28,000 florins, amounts to 35 percent of the total of the entire estate.

FURNITURE

Furniture was both moveable (e.g., chairs, tables, and benches) and built in (e.g., attached benches, credenzas, and cabinets that were part of the wooden paneling lining the walls). Most of the pieces would have been familiar to modern eyes: trestle tables, benches, credenzas, and cabinets, for example (see fig. 22). Beds were found in almost all the rooms. There were two types of beds: the *lettiera*, a large four-poster bedstead usually surrounded with a podium serving as both bench and storage chests, and the *lettuccio*, a smaller combination bench, daybed, and storage chest, often with a high back used as a clothes rack. A major decorative and utilitarian piece was the ubiquitous chest, a free-standing, coffinlike box called either a *cassone* or a *forziere*, used to store clothes, tapestries, table linens, and similar goods (fig. 20). These chests were often painted with scenes presenting moral lessons from mythology, ancient history, or the Bible.[63] A number of chairs are described as *alla cardinalesca* (cardinal's chair), the type of folding X-frame armchair commonly referred to today as a Savonarola chair (fig. 21). A special bench with a high back that could fold over to face either direction was placed in front of fireplaces. Most rooms were lined with walnut paneling up to shoulder height or above and sometimes incorporated built-in benches or credenzas or cabinets. Almost all the individual pieces were of walnut, either carved or inlaid with wood intarsia, including especially spindle wood, a light-colored dense-grained wood.[64]

An example of the disposition of furniture in a typical suite can be seen in the quarters occupied by Piero, Lorenzo's son and principal heir (folios 42r–48v). The suite had been designed for Giovanni di Cosimo, Piero di Cosimo's brother, and had passed to Giuliano, his nephew and Lorenzo's brother, then

in turn to Piero. The suite consisted of four rooms: a bedchamber (*camera*), antechamber (*antecamera*), bath, and armory. The bedchamber itself was furnished with a walnut bedstead (*lettiera*) 10.5 feet long, with a step-plinth all around decorated in intarsia and inlay, and a walnut bed-settle (*lettuccio*) with a built-in linen chest and clothes rack, decorated with images and two large gilt bronze balls. Also in the room were two leather armchairs (*alla cardinalesca*), a reversible bench in front of the fireplace, a walnut cabinet (*cassa*) with two doors, two oblong chests (*forzieri*) with gilt cornices and painted pictures, and a poplar-wood credenza (*armadio*) with beveled corners and walnut and spindle-wood inlay (fig. 22). Connected to this room was Piero's antechamber, another room equipped as a bedroom (folios 47v–48v). It was lined with pine wainscoting with walnut panels and a built-in cabinet (*casse*) with two doors. It had a bedstead (*lettiera*) 7.5 feet long, with an inlaid step-plinth around and a pine bed-settle (*lettuccio*) with a built-in chest, inlaid in walnut. The bedstead, a four-poster like most beds of the time, had a painted bed tester (canopy) above, depicting Fortune by Botticelli. A little bookcase, two coffer chests, a walnut armchair, and a cypress trestle table 7.5 feet long completed the furnishings. On the walls were two mirrors. A bathroom connected to the suite contained a cedar trestle table, a footed washtub, a barber's bowl, and a washbasin, all of brass, as well as other utensils. The last room, Piero's so-called armory, was full of weapons and armor stored in cabinets and chests (folios 45v–47v).

CLOTHING

The inventory is of great importance for documenting the quality and quantity of clothing that wealthy Florentine families possessed.[65] From paintings (e.g., figs. 23, 24, and 25) we can reconstruct the fashions of men and women of the period, but the clerk's detailed description of the fabrics, including the great variety of colors, textures, and linings, provides an even more vivid image of their appearance. The inventory uses terms for clothing that are not always clear to the modern reader. What, for example, was the difference between the *lucco,* the *robetta,* and the *turca,* three types of men's gowns? How should we understand the distinctions between a *bernia* and a *cioppa,* both women's overdresses? The English translation "gown or overdress" for these terms obscures the nuances of type, now lost, that the inventory clerk was recording.

Women of the patrician class generally wore three layers of garments (figs. 23, 24). Next to the skin was worn a light linen garment like a shirt or shift (*camicia* or *converciere*). These garments are always inventoried in groups, which suggests that they were generic in form rather than decorative. The next

layer was a long dress, from shoulder to floor, called a *cotta* or *gammurra*, tight around the bodice and flaring at the waist, with or without sleeves and either plain or elaborately decorated. For public display an overdress—a *bernia*, *cioppa*, *giornea*, or *roba*—completed the ensemble, often lined and of the most recherché fabric, also with or without sleeves and so tailored as to reveal artfully the underdress through slashed sleeves, side slits, or an open front. The descriptions of these garments conjure up images of women elegantly turned out in brightly colored textured fabrics, often brocade or watered to create variegated color effects, lined with fur or rare silk and with inset gores of complementary colors and fabrics.

Men also wore a light linen shift next to the skin to which they added colored hosiery, either a pair of tights or two individual stockings fastened at the waist with points (laces), sometimes with soles attached. The informal dress would then be completed by a doublet, a short, tight-fitting jacket that flared over the hips, called in the inventory a *farsetto* or *giornea* or, if equipped with a longer skirt, a *gonnellino*. In public or for formal occasions patricians generally wore a long, voluminous gown called a *lucco* or *robetta* (see figs. 3, 6, 7, 25). Other terms used by the clerk to describe a masculine overgown are *saio*, *vesta*, and, perhaps for its resemblance to Eastern dress, *turca*. These loose robes were simple in tailoring, extended from shoulder to floor, were either sleeveless or had wide, deep sleeves, and derived their beauty from their expensive, deep-colored fabrics, often brocade or velvet with contrasting linings of fur or silk. Lorenzo had a large collection of these elaborate one-of-a-kind gowns, suggesting that his public image depended in part upon the conspicuous display of his wealth and sartorial taste.

Outdoor garments included hats called *berrette* and a number of different kinds of overcoats, some with attached hoods or cowls. These are called *cappa* (a hooded cape), *mantello*, *catalano*, *gabbana*, and *gabbanella*. The inventory also lists separate cowls or hoods called *cappucci*. Men also wore a shorter wrap or shawl called a *mongile* or *pitoco*, often made of fine fabrics and sometimes lined. Strangely, only a single pair of shoes is mentioned in the inventory (folio 52r) but some tights are described as *con solate*, i.e., equipped with attached soles.

THE ARTWORKS

The clerk documented about 139 paintings and sculptures.[66] Of these, eighty-two are paintings on panel, twenty-one are paintings on canvas, one is Gozzoli's fresco, and thirty-five are sculptures in bronze, marble, or terracotta. Five

paintings are called Flemish, but the portrait of a "French woman" by Petrus Christus, a Flemish painter (folio 28r), indicates that the scribe was uninformed about northern painting, calling any northern work "French." The nine paintings described as "in the French style" must mean transalpine rather than French. Most of the artworks were bought by Cosimo and Piero, but in spite of the fact that the art was part of the one-time expenses intended to complete the rooms—interior decoration—the selection of works was in no way casual. They knew which artists they wanted to patronize.[67]

Though Cosimo was the head of the family, Piero played an increasingly important role in directing art purchases. By 1438 Piero had already assumed a position as art adviser to his father.[68] Piero's role became even more pronounced after 1455, as the palace began to be decorated. Correspondence between Piero and Benozzo Gozzoli confirms that he, rather than his father, was the authority of last resort in the final stages of the palace decoration. Gozzoli, who was given the plum commission of frescoing the chapel, practically grovels in a letter to Piero written in 1459 during the execution of those frescoes, offering to change a detail that he heard had displeased Piero.

> This morning I had a letter from your lordship through Roberto Martelli. And I learned that you thought the seraphs I had done were not suitable. I made one in a corner among some clouds, of which nothing is to be seen but some wing points, and it is so hidden, and the clouds cover it in such a way, that it doesn't create any bad effect, but rather adds beauty. I made one on the other side of the altar but also hidden in the same way. Roberto Martelli saw them and said it was nothing to make a fuss over. Nevertheless, I will do what you order; two clouds will wipe them out.[69]

Lorenzo, whom history considers the great aesthete and promoter of Florentine art, bought almost no artwork to decorate the walls of his own home.[70] When he became head of the family upon the death of his father in 1469, the palace had been lived in for a decade and was fully decorated. Its rooms were paneled and furnished, and the large expanses of wall were adorned with paintings, relief sculpture, and tapestries. Since it was not necessary for him to acquire more paintings to dress the walls, Lorenzo added only a few of the inventoried works. These few include the set of three *spalliera* paintings by Lo Scheggia (folio 39r), Piero del Pollaiuolo's *Portrait of Galeazzo Maria Sforza* (fig. 26) (folio 6r), a bronze relief of a battle scene by Bertoldo di Giovanni (fig. 27) (folio 38r), and two Botticelli paintings (folios 42v and 48r). Each of these additions was occasioned by special circumstances. The three *spalliera* paintings

by Lo Scheggia depicted Lorenzo's famous joust of 1469 and were probably commissioned on the occasion of the redecoration of the suite of rooms that Lorenzo and his new bride, Clarice Orsini, were moving into in 1469.[71] The *Portrait of Galeazzo Maria Sforza* was commissioned to commemorate the duke's visit to Florence in 1471.[72] The bronze battle scene relief by Bertoldo dates from ca. 1480 and must have been added to the decor of the family dining room by Lorenzo because of his close relationship to the artist. The Botticelli paintings, one of which was a parade banner made for Lorenzo's brother Giuliano for his joust in 1475, were certainly commissioned by Giuliano and date from 1475. This notably short list of additions confirms that Lorenzo bought a few works for specific reasons but felt no need to add to the paintings assembled by his father and grandfather.[73]

Many of the works must have been imported to the new palace from the old Medici houses (the *case vecchie*). The family moved into the new palace in about 1459, yet Fra Angelico, who died in 1455, is credited with six works, Pesellino (d. 1457) with four works, Masaccio (d. 1428) with three works, Giotto (d. 1337) with two works, and Andrea del Castagno (d. 1457) with one. These paintings probably hung in the family's old residences. Other works brought from the old residences include Jan van Eyck's *St. Jerome in His Study* (fig. 28), which Cosimo must have owned already in the 1440s since it belonged to Niccolò Cardinal Albergati, who died while traveling near Siena in 1443.[74] A tondo depicting the adoration of the magi, which the scribe mistakenly attributed to Pesellino, is believed to be the tondo in Berlin by Domenico Veneziano (fig. 29) that dates from about 1439–41, and therefore was part of the furnishings of the family's *case vecchie*.[75] Also predating the move into the new quarters was Lorenzo's birth salver with the *Triumph of Fame* (fig. 30), painted in 1449 (folio 14r).[76]

Some of the original works commissioned for the palace seem to have been conceived as a programmatic cycle. Apparently, the decoration of the Sala Grande on the ground floor (folio 6r) and that of the equivalent large room on the *piano nobile* (folio 13v) were designed as ensembles. In the ground-floor room, three of six large panels that lined the walls just below the vaulted ceiling were the scenes from Paolo Uccello's series *The Battle of San Romano* (1430s–1450s) (fig. 31), which celebrate the military prowess of Florence. In the great room on the *piano nobile* were three large canvases, each ten feet square, depicting the labors of Hercules (lost) by Antonio Pollaiuolo (ca. 1432–1498) commissioned for that room.[77] Completing the ensemble were a canvas depicting Saint John by Andrea del Castagno (1421–1457) and another titled *Lions in a Cage* by Pesellino (both now lost). Both Saint John and caged lions were

symbols of Florence, so the *Labors of Hercules* series may symbolize the Herculean efforts of the Medici family in its leadership of the Florentine state. The programmatic character of these decorations reflects the rooms' function as formal reception areas.

Cosimo's and Piero's selection of artists is interesting. The largest number of paintings by a single artist are by Fra Angelico, who is represented by six paintings, including *The Adoration of the Magi* (fig. 32) in Lorenzo's bedchamber, valued at one hundred florins, the highest valuation of a single painting in the entire inventory.[78] The most frequently represented sculptor is Donatello, with four relief works. Not counted in the inventory, but among the most impressive works of sculpture in the palace, were Donatello's two full-size freestanding bronze sculptures *David* and *Judith and Holofernes,* in the courtyard and garden of the ground floor.[79] Cosimo's intimate relationship with Donatello is well documented and accounts for the frequent appearance of his works. The only other sculptors to be identified by name are Desiderio da Settignano, with a relief of "a story about fauns" and a marble head, and Bertoldo di Giovanni, with a bronze centaur and his previously mentioned relief of a battle scene.[80] Two anonymous "glazed" reliefs of the Madonna and child were probably by Luca della Robbia.[81] A small bronze statuette titled *Hercules Crushing Antaeus,* in the room called "the chamber of Monsignore, where Giuliano lives," was almost certainly by Pollaiuolo (folio 38v).[82] The many anonymous carved images of the Madonna and various portrait sculptures mentioned in almost all of the rooms would probably have included works by other respected Florentine sculptors such as Mino da Fiesole, the Rossellino brothers, and Benedetto da Maiano, but their authorship eluded the inventory clerk.

Pesellino (ca. 1422–1457) is credited with four paintings plus a collaboration with Filippo Lippi, a panel showing Saint Jerome and Saint Francis.[83] In Giuliano's room was a Pesellino *Madonna and Child with Angels* in a tabernacle. The attribution of *The Adoration of the Magi* to Pesellino, however, is generally believed to be mistaken and is now thought to refer to the tondo by Domenico Veneziano in Berlin (fig. 29). But the two most prominent works by Pesellino were his *Hunt,* in the ground-floor Sala Grande, and his *Lions in a Cage,* in the Sala Grande on the *piano nobile.* Piero must have commissioned both as part of the decoration of the *case vecchie* and transferred them to the palace in 1459. Domenico Veneziano is credited in the inventory with a *Portrait of a Woman* in a tabernacle with shutters that hung in Giuliano's room and a "half-nude figure seated in a niche holding a skull," probably a Saint Jerome, as well as the previously mentioned tondo of the *Adoration.*[84]

Filippo Lippi, a favorite of Cosimo, is represented by four works: the collaboration with Pesellino mentioned above, a painting of a "nude figure asleep on a bench," the noted but uncredited chapel altarpiece *The Virgin Adoring the Child with St. Bernard* (fig. 33), now in Berlin, and a collaboration with Fra Angelico in his large tondo of *The Adoration of the Magi* (fig. 32) in the ground-floor bedchamber of Lorenzo (folio 6r).[85] Two more panels by him were in the Medici palace but are not mentioned in the inventory. They are *Seven Saints* (fig. 34) and an *Annunciation,* both now in the National Gallery in London. They were sold directly from the Medici-Riccardi palace in 1858 and are connected to the Medici family by the presence of Medici arms in the *Annunciation* and by the selection of the name saints of the senior members of the family in *Seven Saints.* Lunettes about five feet in width, they are of a shape and size that suggest that they were painted as overdoors and were the only artworks besides the Gozzoli chapel frescoes that were not removed and sold at auction in 1494. Apparently, then, they were installed in a fixed position in the palace, unable to be easily removed and carried off to auction. Since they were definitely in the palace, they must have been in a part that was not inventoried. The only room omitted from the inventory important enough to contain such impressive paintings was the family library. It appears under the heading "the room of the library on the same terrace" at the bottom of folio 61v but is followed by no entries, as if the scribe had been unable to enter the room. The London Filippo Lippi lunettes, therefore, may have been part of the built-in decor of the library.[86]

Botticelli (1444–1510), who was too young in 1455–60 to be among the original painters of the palace, nevertheless appears in the inventory with two works, as noted above: a painted bed canopy depicting Fortune (folio 48r) and a Pallas Athena with a shield on canvas (folio 42v), both in the suite belonging to Lorenzo's son Piero but occupied earlier by Lorenzo's brother, Giuliano. We know from Vasari in his life of Botticelli, written in the 1540s, that a life-size *Pallas Athena with a Shield* by Botticelli hung in the palace. This lost work was the parade banner that Giuliano used in his famous joust of 1475, chronicled by Poliziano in his long poem *Stanze per la giostra del Magnifico Giuliano.* He apparently had the banner mounted and hung along with the four prize jousting helmets and the horse and body armor from the Duke of Calabria that had been given to him on the occasion of his joust. Giuliano, with two works by Botticelli in his suite, must have had a particular predilection for the painter's work.[87]

Among the slew of anonymous paintings, several are intriguing. In the chamber of the wet nurses a large painting on canvas of the calumny of Apelles,

a subject based on Lucian's essay *On Slander*, may be misidentified (folio 56r). It is described as hanging in a group of four paintings, apparently a matched set with a composite valuation of four florins, all of which are on canvas "in the French [i.e., northern] style." This "calumny" is paired with a "story of Moses Crossing the Red Sea," both slightly larger than two *braccie* (about four feet) long. In the 1495 sale of the Medici belongings a certain Luigi della Stufa is recorded as purchasing a *Judgment of Solomon* for two florins, the only painting sold at the auction that was not mentioned in the 1492 inventory. Might the della Stufa purchase be the painting identified by the original clerk as the calumny? The judgment of Solomon is a subject better suited to the wet nurses' room than the calumny, and since both involve a crowd gathered around a king seated on a raised dais, the clerk could have confused the two subjects.[88]

Another work, the "panel painting depicting a perspective scene, that is, the palazzo de' Signori with the piazza and the loggia and the houses around looking the way they are" (folio 11r), might be the very painting by Brunelleschi described by his biographer Antonio Manetti as "a perspective of the piazza of the palazzo de' Signori." This epoch-making work was Brunelleschi's demonstration of the new science of linear perspective that was to capture the imagination of Florence's painters. Vasari, in his life of Brunelleschi, described this panel as "the palace, the piazza and the loggia of the signori, as well as the roof of the Pisani and all the surrounding buildings." This detailed description, which matches the inventory description perfectly, makes it clear that Vasari knew the work at first hand, and since he had access to the Medici collections, he may have seen it there.[89]

Several artists of Lorenzo's generation are conspicuous by their absence. No works by Verrocchio, Perugino, Ghirlandaio, Filippino Lippi, or Leonardo da Vinci are mentioned. All were working in Florence during Lorenzo's lifetime, and at one time or another he recommended all for government or private commissions. He even hired Verrocchio, Filippino Lippi, and Botticelli to work on projects in his own suburban villas at Careggi, Lo Spedaletto, and Poggio a Caiano, yet he did not buy works from them for his palace. Apparently, he felt that the interior decoration of his rooms was complete, except for the aforementioned few works. This fact speaks to the issue of Lorenzo as collector. He seems to have devoted his collecting energies to acquiring such objets d'art as gemstones and ancient vases and sculpture rather than contemporary art. He did not "collect" art by contemporary painters and sculptors, though he commissioned work from them for his architectural projects. On the other hand, starting in 1465, when he was only sixteen, he bought coins, cameos, antique

vases, and other collectibles, items that fill his study and account for more than 70 percent of the estimated value of the entire inventory.

THE INVENTORY PARAPHRASED

The clerk who made the original inventory was a professional who was able to identify and give a reasonable estimate of value to a wide variety of goods, from furniture, to art, to jewelry, to raw bolts of fabric.[90] When he measured length he used the *braccia* (Italian for arm, abbreviated br. in the inventory), equal to twenty-three inches (.583 m). For liquid measurements he used the *barile* (Italian for cask or barrel, plural *barili*), equal to .486 quarts (.46 liters). His estimates of monetary value were in Florentine florins (abbreviated f. in the inventory). A useful comparison, as noted above, is given by a source in 1480 who stated that seventy florins would be sufficient to support a family of husband and wife and three or four children, meaning that this amount would buy housing, clothing, and food for one year.[91]

The clerk occasionally allowed his personal tastes to make their way into his lists, using *bello* (beautiful or handsome) to describe finely executed embroidery, a decorated chest, a child's cradle, and even a well-made dough-mixing trough, but he was remarkably dispassionate, considering the impressive works he was describing. He seems to have had fairly specialized knowledge of all types of possessions, but he was not a connoisseur of art or books, among other things, and seemed to be most at home picking through luxury items such as fine fabrics and jewelry.

To organize his inventory, the clerk began on the ground floor and ascended upward through the floors to the attic and roof, entering each room and describing furniture, wall decorations, and cabinet contents.[92] He treated the storage rooms peremptorily. These vaulted areas were used for the storage of wood and wine. Originally, he tells us, one ground-floor area was used as a stable, but these rooms were reassigned to wine and tool storage. One small room contained only malmsey wine (a wine made from the malvasia grape), and another was called the "summer cave." The total wine storage amounted to about 635 liters, a relatively small figure for such a large extended family.

He then entered the ground-floor living areas, called the loggia, beginning in the great reception area, the Sala Grande, the largest of the suite of rooms (folio 3r). He measured the built-in benches and intarsia wall paneling lining the four walls at 153 feet. Before documenting the rest of the contents of the great room, he went into the attached bedchamber (folios 3r–5r). There, a large

inlaid wooden four-poster bed (*lettiera*) with parapet sides, seats all around, and a trundle bed beneath dominated the room. A settle (*lettuccio*) with a built-in storage chest stood nearby. On the wall were a marble relief of the Virgin and child with angels set in a carved and gilded wooden frame, a mirror, and paintings (views?) of Italy and Spain. Three storage chests four to four and a half feet long held an assortment of tapestries, many expensive, for covering benches, tables, and walls.

Next, he moved on to the little antechamber called the study, a room equipped with a daybed, a cupboard, a leather Savonarola chair, and storage boxes and trunks (folio 5r). These contained weapons and armor, including no fewer than twenty-five swords and daggers, as well as a gong and a brass horn. The weapons and alarms inside Lorenzo's private chambers reflect the dangers faced by political leaders at the time: more than once plotters had made attempts on his father's life, and the Pazzi conspiracy in 1478 cost his brother Giuliano his life and almost succeeded in assassinating him. Also in the room were items for personal use, including a case decorated in silver containing four razors and a silver mirror, and two little silver boxes in a bag to hold soap.

From there the clerk returned to the great room called the chamber of Lorenzo in the Sala Grande suite (folios 6r–8r).[93] This was the room with many of the best-known works of art in the Medici collection, beginning with the six large paintings surrounded with gilt frames, altogether eighty feet long by seven feet high, lining the upper walls: the three Uccello paintings of the battle of San Romano (fig. 31), Uccello's battle between dragons and lions, his story of Paris, and a hunt picture by Pesellino. Also in the room were Fra Angelico's *Adoration of the Magi* (fig. 32), a framed *St. Sebastian and Other Figures* by Squarcione, Piero del Pollaiuolo's *Portrait of Galeazzo Maria Sforza* (fig. 26),[94] and a portrait of the Duke of Urbino. Paneling and built-in furniture lined the walls. Paneling framed in walnut with intarsia and with a built-in cupboard covered forty-six feet of the wall, and a credenza with five doors covered twenty-nine feet. Seven brass candelabra stood around the room. The bedstead was decorated with walnut moldings and intarsia with a surrounding plinth, but a much more expensive bed-settle (forty-five florins versus the four-florin valuation of the larger bedstead) was decorated in walnut panels and intarsia, with cupboards at either end, altogether eighteen feet long, with four drawers underneath the cupboards. The larger bed had a bed-curtain set embroidered with herons and falcons valued highly at sixty florins. Other furniture included a cypress table with carved and inlaid trestle supports, a round table of *lignum vitae*, two leather armchairs, and another armchair with a moveable back. One

cupboard held various vases and jugs and miscellaneous items. The cupboard built into the wall paneling was filled with Chinese porcelain, one of Lorenzo's collecting interests.[95] Weapons stored in one of the bed cabinets recall the importance of vigilance and the perception of imminent danger: ten small swords of various types, four larger swords, six rapiers, four daggers, and an iron mace.

Attached to the Great Room was a bath and toilet with benches and odds and ends, including a brass foot-washing basin and a bed warmer (folio 8r). Above that room was a small mezzanine room with a makeshift bed composed of two chests with mattress and some simple furniture, perhaps a night attendant's room (folio 8v). Several servants' rooms followed: a grooms' (i.e., servants') room, the so-called clerk's bedroom, and an antechamber. All of these rooms were equipped with beds and storage cupboards and chests, apparently suitable for servants' use but unremarkable.

Next came a large room, the "chamber of the two beds," so named because its most prominent features were two large four-poster beds (folios 9r–11r). It may have been the bedroom of Piero, Lorenzo's father, judging by the presence of a tapestry bed-curtain set called "the bed curtains of Piero," described in detail and valued highly at one hundred florins. The room also had a bed-settle (*lettuccio*) painted to imitate intarsia. This was an important room that contained such luxury items as paintings, chess sets, and an exceptional collection of musical instruments. That collection, enough to equip a small orchestra, included five organs, five harpsichords, three bass drones, four violas, a harp, two lutes, three sets of flageolets, and three pipes. On the wall were a number of paintings, notably the aforementioned perspective scene of "the palazzo de' Signori with the piazza and the loggia and the houses around looking the way they are" (folio 11r).

There followed the doorkeeper's chamber, a very simple room (folio 11v). It would have been next to the main entrance, suggesting that at this point the clerk had inventoried all of the ground-floor rooms in order around the courtyard and was ready to continue up to the *piano nobile*. Stairs led to a mezzanine area above the ground-floor loggia that housed a series of servants' quarters (folio 11v): first, Bertoldo's room, followed by a grooms' bedroom and the housekeeper's room.[96] All were supplied with minimal furniture. Finally, on the mezzanine level was a small study fitted out for keeping records and furnished with a writing desk and a wooden bench, a portable writing stand, a plank shelf for documents and books, and a small walnut table with a paper spike.

At the top of the stairs a corridor ran to the palace chapel, a suite of rooms consisting of a vestibule, chapel, and sacristy (folios 12r–13v). The chapel today

is dominated by Gozzoli's fresco *The Procession of the Magi* (figs. 12, 14, and 35).[97] The clerk placed the fresco in the passageway before the entrance to the chapel proper, whereas the painting actually covers the interior walls of the chapel. He described the painting as 13.5 feet high by 9.5 feet wide. The word he used for the support was *panno*, meaning "paneling," but he intended that to include fresco. The inventory of the chapel proper included the appropriate altar cloths, towels, and liturgical accoutrements, all counted and described by the clerk, as well as wall paneling with sixteen built-in choir stalls and a carved wooden railing totaling 30.5 feet. Above the altar, in an elaborate frame with columns, was the altarpiece by Filippo Lippi (though the clerk mentions no artist), *The Virgin Adoring the Child with St. Bernard* (fig. 33).[98] One item in the sacristy is of particular interest. Just before exiting the room the clerk mentioned a "box in which is a sacred stone," probably the Byzantine portable altar called the Sacred Stone, known to be in the Medici collection from earlier inventories, valued highly in 1465 at one hundred florins but given no estimate in this inventory.[99]

The clerk next entered the suite of rooms connected to the Sala Grande, the major apartment on the *piano nobile* (folio 13v). Adorning the walls were the three huge Pollaiuolo paintings of the labors of Hercules, each 11.5 feet square, Pesellino's *Lions in a Cage*, and Andrea del Castagno's *St. John*, discussed above. Seven shields with the arms of the Medici and the arms of guilds also decorated the walls. Around the room were built-in inlaid wooden benches and paneling 153 feet in length. Twelve freestanding iron candelabra were arranged throughout.

The next room in the suite was the bedchamber of Lorenzo (folios 13v–16r). A marble bust of Piero di Cosimo de' Medici (fig. 3) stood in a niche over the entrance door and another of Lucrezia Tornabuoni over the door into the anteroom, indicating that these rooms were the suite of Lorenzo's father and mother. By the time the clerk made his inventory in 1492, the room had come to be called Lorenzo's room. Decorating the chamber were a number of paintings and sculptures: a freestanding marble nude Hercules,[100] a marble relief of the ascension by Donatello,[101] a Flemish painting on canvas 10.5 by 7.5 feet, four panels in mosaic, and Lorenzo's own birth salver *The Triumph of Fame* (fig. 30).[102] A few curiosities suggest Lorenzo's personal taste and attest to the private character of the room: an ostrich egg, a mirrored glass sphere suspended by a silken cord, and an expensive wall clock.[103] An inlaid wooden bedstead 10.5 feet square with a surrounding plinth and a matching inlaid wood bed-settle stood in the room. Both were decorated with gilt carved figures and heads. Three chests, a *cassone* and two matching *forzieri*, held clothes. The two *forzieri*

were painted with scenes of Petrarch's triumphs. The first contained nineteen men's gowns and the second, forty-five various gowns. The *cassone* held mostly overcoats, hoods, hose, and doublets. They were in a great variety of fabrics, colors, and linings: purple wool lined in beige leather, purple and crimson satin lined in white leather, black damask lined in ermine.[104] An unusual item was the damask fabric doublet lined in chain mail, for use in times of danger. And true to what seemed to be an interest of Lorenzo (see below), on the wall was a gilt copper clock two feet high, valued at twenty-five florins (folio 14v).

Continuing into the antechamber (folio 16v), the clerk identified more works decorating the walls. Curiously, he named the artists of eight works in a row, including three Donatello reliefs, two paintings by Fra Angelico, a Giotto *Crucifixion,* and two works by Pesellino, including one painted with Filippo Lippi. This is the only place in the inventory with such a meticulous listing of artists' names, a notable fact because it suggests that tags on the frames may have identified these works, unlike the majority of the other artworks in the inventory.[105] He also listed a lunette 4.5 feet wide with a double portrait of Francesco Sforza and Gattamelata, a painting titled *The Universe* (Last Judgment), valued highly at fifty florins, a lunette of Rome, one of Italy, and two reliefs with antique figures. For furniture the room had a plain full-size bed and a pine bench locker nineteen feet long, with wainscoting of inlaid walnut panels.

The next room was the famous study, a treasure room for the Medici collections of vases, cameos, rings, small paintings, clocks, and other valuables (folios 17–31).[106] It had been Piero's study but had become Lorenzo's on the death of his father. Its contents were the most valuable in the whole palace, the twenty-seven vases and cups alone estimated at 17,850 florins. There were seventy-five cameos and other carved stones, each carefully described, though not always identified as to subject: for example, "a large carnelian with three figures . . . one partially clothed and standing with a lyre in his hand, with a nude figure kneeling at his feet, the other with the head of an old man, seated with his hands behind him tied to a tree," actually depicts Apollo, Marsyas, and Olympus (fig. 19). The most highly valued cameo depicted Noah's Ark (fig. 18), now preserved in the British Museum. At two thousand florins it was twenty times more valuable than the most expensive painting, Fra Angelico's *Adoration* tondo. Though probably regarded as ancient, the Noah's Ark cameo was in fact produced in the workshop of Frederick II in about 1250.[107] A large number of rings, gems, and jewelry[108] were counted and itemized (folio 21r), and a gold reliary, called the "reliquary of the libretto" in earlier inventories, with shutters, chains, locks, and keys, was valued at fifteen hundred florins.[109] Lorenzo kept a collection of five

different clocks in the study, four more than necessary to tell the time. He seems to have been interested in clock mechanics.[110] A bronze statuette, about eighteen inches high, was called *The Nude of Fear*. It was sold at auction in 1495, and the nickname appears in later documents to refer to a bronze Marsyas owned by Jacopo de' Nerli.[111] The study also had eighteen small paintings and mosaics described as of "Greek workmanship," meaning that they were Byzantine in origin. The clerk recorded a collection of fifteen maps as well as nineteen books ranging from religious texts to Dante and Petrarch, many luxuriously bound. Among the books was a manuscript of "Petrarch's work, first the Triumphs, illustrated and illuminated, written in pen on pages of handmade paper, and the Songs, Sonnets, and the Vita of Dante, covered in crimson satin, with many insets" (folio 27r). That manuscript is now preserved in the Bibliothèque nationale in Paris.[112] Another manuscript, "a little book of the Offices of the Madonna, with silver boards," can be identified as the Holkham Book of Hours in the collection of the Earl of Leicester.[113]

The paintings included *St. Jerome in His Study* (fig. 28) by Jan van Eyck (probably actually workshop or Petrus Christus),[114] *Portrait of a French Lady* by Petrus Christus, and *Judith with the Head of Holofernes* by Squarcione.[115] Three caches of coins were recorded as follows: 284 antique silver coins, 200 various coins, and 1,844 bronze coins. (Missing from the inventory is Lorenzo's collection of gold coins, which we know from other documents was highly valued.) Among the curiosities were a "unicorn horn" about 6.5 feet long, valued at six thousand florins, and an elephant tooth.

Following what must have been several long and tedious days counting cameos, gems, jewelry, and coins in the study, the clerk moved into the mezzanine room above the antechamber of the room "called the large bedchamber of Lorenzo" (folios 31v–38r). This room held a collection of material appropriate to the running of the household and an extensive collection of coral as well as other odds and ends. Household items included decorative cushions, sets of towels, sheet sets, handkerchief sets, chemises, tablecloths, runners and napkins, bedspreads, canopy bed curtains, wall tapestries stored in cabinets, and bolts of cloth. A walnut writing desk held a collection of seventeen unidentified books. A great many personal items for women were stored here, including handkerchiefs, head scarves, a "little woman's book," linen undergarments (*convercieri*), and a roll of "woven cotton cloth for bandages [*bende*]," 115 feet long, and twenty-four individual long bandages for women (*benducci da donne*), apparently for menstrual periods. The list suggests that this was the domain of the women of the house.

The clerk then proceeded into the *saletta* opposite the Sala Grande (folio 38r). This seems to have been the family's dining room. At the door was placed a windbreak/cupboard eight feet wide and four feet deep. The room was furnished with inlaid paneling all around, framed in walnut, and had two very large tables on trestles, seventeen and twenty-one feet, respectively, with matching benches. A high-backed bench with arms stood in front of the fireplace. On the wall hung paintings by Filippo Lippi, Domenico Veneziano, and a Flemish painting with "many Bacchanalian figures at carnival time," as well as a bronze relief above the fireplace of men and horses in battle by Bertoldo (fig. 27). In the middle of the room was a large brass floor candelabrum with places for twelve candles. A cupboard housed a brass basin and ewer with the arms of the Medici and the Tornabuoni (Lorenzo's father and mother, respectively), six saltcellars, an enameled spice box, and cutlery, including ivory-handled knives and silver spoons and forks.

The next room, the "chamber of Monsignore, where Giuliano lives," overlooked the street (folios 38v–41r). As noted above, Monsignore was Lorenzo's second son, Giovanni, who had moved out of the palazzo when he was consecrated a cardinal only one month before Lorenzo died. His younger brother, Giuliano, thirteen years old at the time, was quick to move into the vacated bedchamber. A marble bust of Giovanni di Cosimo de' Medici, Piero di Cosimo's brother and Lorenzo's uncle, stood in a niche above one of the doors, indicating that the room had originally belonged to the elder Giovanni, who died in 1463. Lorenzo himself seems to have lived in this room when he came of age, as already noted. It was decorated with *spalliera* paintings 25 feet long by 2.5 feet high, divided into three parts by gilt frames and colonnettes, depicting the joust of Lorenzo. The joust, which took place in February 1469, was a famous event in Lorenzo's life, chronicled in elaborate detail by Luigi Pulci in his long poem *La giostra di Lorenzo de' Medici*. The paintings would have been added to the wall paneling in 1469, probably on the occasion of redecorating the apartments for Lorenzo and his new bride, Clarice Orsini. Also displayed on the walls were the prize helmet from the joust, distinguished by an elaborate crest of a woman in gold with a gown embroidered in pearls, and a gilt jousting lance. Other artwork in the room included a Madonna and child by Pesellino, the *Portrait of a Woman* by Domenico Veneziano, a glazed terra-cotta Madonna and child (probably by Luca della Robbia), a *poesia* (mythological scene) of two figures in a landscape, a small bronze nude holding a golden ball, and an even smaller statuette of Hercules crushing Antaeus, most probably by Pollaiuolo, as noted above.

Furniture in this room was dominated by the usual two beds: a richly decorated and inlaid wooden four-poster bed 10.5 feet long with a surrounding stepplinth, and a bed-settle, also richly decorated with intarsia, with two attached storage cupboards. Also in the room were a high-backed bench in front of the fireplace decorated in intarsia with the Medici arms, two sumptuously decorated storage chests with paintings of the story of Marcus Marcellus of Sicily, and an inlaid pine and walnut *cassone* linen chest 7.5 feet long, all three chests sitting on an inlaid wooden plinth. The *spalliera* paintings of Lorenzo's joust were set into the paneling above this set of three chests. The first storage chest held unfinished fabric and remnants as well as twelve overcoats. The second held mostly women's and girls' dresses of various colors and fabrics, including *cotte, gabbanelle, gammurre, cioppe, robe,* and *bernie.* The *cassone* contained a few garments and various household items, including cushions, sheet sets, and towels.

Next to this room was an antechamber (folio 41r), a small space decorated with thirty-eight feet of inlaid walnut paneling; into the wainscoting was built a bed-settle, a cabinet with two doors, and the side and foot of a full-size bed. Judging by the absence of wall decorations, this seems to have served as an attendant's quarters attached to the bedchamber described above.

A staircase continued up to the mezzanine level. Part of the way up, apparently on a landing, was a shrine with an altar and the gilt-framed *Adoration of the Magi* by Fra Angelico (folio 41v). A mezzanine room followed. It was equipped with a plain bed, a table, and two cupboards containing an assortment of goods, notably a number of expensive damascened metal basins, a horse-trapping set, and many weapons. The only paintings mentioned are a birth salver depicting a battle scene by Masaccio and a portrait of Madonna Bianca, Lorenzo's older sister. Two bronze statuettes of nudes, one holding a fish and a snake, stood in the room. In a cabinet were four small bronze (?) nudes and two bronze reliefs of cherubs, along with a carved marble head by Desiderio da Settignano.

The chamber of Piero followed (folios 42v–45v). In the corridor leading to the chamber hung a Fra Angelico panel of saints' stories, 7.5 feet long, and a relief sculpture of "fauns and other figures" by Desiderio da Settignano. As mentioned above, the chamber of Piero belonged to Lorenzo's eldest son and heir and opened onto its own terrace. On the walls hung a gilt carved wooden tabernacle of the Madonna and child, 3.75 feet high,[116] two Byzantine Greek panels, and a gold-framed painting on canvas of Pallas Athena by Botticelli.[117] Also on display were four prize helmets from jousts, as well as two bronze statues

of a mounted rider and a centaur. The room held a large walnut bedstead 10.5 feet long with a step-plinth, all inlaid with light-colored wood. It also had a bed-settle combined with a clothes rack and a storage cupboard inlaid with perspective designs and decorated with two large gilt bronze balls. Two gilt storage chests decorated with paintings, an inlaid wooden credenza like a *cassone,* and a walnut cabinet with two doors provided more storage. Finally, there were two cardinal-style (Savonarola) leather chairs and a folding-back bench with walnut moldings and intarsia in front of the fireplace. The first of the two gilt storage chests contained eight pairs of cushions, richly decorated and described by the clerk. The second held sets of sheets, towels, and a number of canopy bed sets, the most interesting of which was a linen and taffeta canopy curtain set with a dome of white taffeta, all decorated with fine gold thread and enamel and valued at one hundred florins. The credenza contained twenty-four men's gowns called *turche* or *lucchi* and nineteen gowns, called *veste, robette,* or *saie,* of luxurious fabrics in rich colors, many lined with fur. It also held an assortment of wraps, cloaks, tunics, and doublets, equally rich in color and fabric.

Attached to the room was a small water closet equipped with a cedar table, washtub, barber's bowl, basin, and jug (folio 45v). This small room was followed by a large armory containing sets of armor, both full and partial, as well as a large collection of weapons (folios 45v–47v).[118] Some of these were intended for jousts but others for military use: decorative and armored horse trappings, processional banners, sets of crossbows, crossbow winches and boxes of crossbow bolts, swinging maces, sixteen Turkish bows, eleven two-handed swords, five rapiers, and thirteen gilt and plain swords, to name only a few.

The adjacent *antecamera* of Piero was lined with inlaid walnut paneling with a cornice above for books and cupboards below with inlaid wooden doors (folios 47v–48v). It had a little walnut bookcase with a drawer and a writing stand, and a long trestle table with a tapestry table cover. On the cornice above the writing stand were three cocoanuts. On the walls were a round mirror with an ivory frame decorated with the seven virtues, a small *Crucifixion* by Fra Angelico, a portrait of Alfonsina Orsini, Piero's wife, a bronze relief of the triumph of Bacchus with twenty-one figures, and two pale silk-fringed banners, among other works. The furniture consisted of a plain four-poster bed with a surrounding step-plinth and a pine bed-settle with a built-in chest and balustrade back. Above the bed hung the canopy with Botticelli's painting of Fortune. Also in the bedchamber, presumably in the chest of the bed-settle, were sixteen beautiful women's shifts of French linen and sixteen aprons, also of linen.

The clerk proceeded to the mezzanine room of the antechamber of the *tascha* (bank holdings) (folio 48v). It was furnished with a large bedstead surrounded with bench lockers and a poplar-wood bed-settle with a clothes rack and a built-in *cassone* with two lids. Also in the room was a wooden cupboard with eight doors, veneered in walnut, 9.5 feet long by 7.5 feet high. The cupboards apparently were almost bare, as the clerk recorded only a few pieces of clothing and some bolts of cloth. The room above the antechamber of Piero (folio 49r) was used to store linens, towels, some clothes, and various fabrics, all in a large cedar chest, nine gilt boxes, and three smaller caskets. No other furniture was in the room. Among the notable items were a dog's bed of green taffeta, an elaborate canopy bed-curtain set, five bolts of Egyptian linen from Cairo, twenty-four used men's and women's chemises, forty-five half-length linen chemises, nine dresses belonging to Clarice, Lorenzo's wife, who had died in 1488, a short green linen cape decorated along its borders with gold interlace studded with enamels, and two brass spittoons.

The chamber of the *tascha* (bank assets) came next (folios 50r–51r). It contained an antique walnut chest "in which are kept the assets of the bank," but it was equipped as a bedroom as well. The room had the expected inlaid wood four-poster bedstead, 10.5 feet on a side, with a step-plinth all around and a matching inlaid wooden bed-settle 7.5 feet long. Also in the room was a small wooden cabinet in which were stored pharmaceutical herbs. In the chest built into the box-settle were women's clothes: twenty-five garments of varied materials and colors, including *cioppe, robette,* and *cotte.* Under the heading "clothes of Giuliano" were six capes and overcoats.

The intriguing antechamber to the chamber of the wet nurses marks the point at which the clerk ascended to the third floor, where the utilitarian functions of the palace were housed (folios 51r–52r). This antechamber, like all the sleeping rooms, was equipped with a large four-poster bedstead and a bed-settle. The large bed had surrounding benches and the bed-settle a canopy and inlaid wooden garlands. Two exceptionally large *cassoni,* altogether 14.5 feet long, inlaid and with matching back boards, contained a large wardrobe of clothes. Three smaller chests, three upholstered "women's chairs," and a small cabinet in the closet latrine completed the furniture. Among the clothes, all women's, were six overdresses (*giachette*), nine dresses (*cotte*), and four bodices for nursing women. All of these garments were made of luxurious fabrics, though many were designated as stained or faded, suggesting that they may have been handed down or stored here. Two gowns were even designated as belonging to

Madonna Clarice, Lorenzo's deceased wife. Among other interesting objects were a hat press, seven bath shifts, "both torn and intact," a little basket with three pairs of beautiful scissors decorated in gold, three sacks of cloth scraps, and many pounds of thick and thin white and black thread. This was obviously one of the sewing rooms.

The corridor leading from the chamber of the *tascha* to the chapel was outfitted with furniture indicating that it was a kind of vestibule as well as a passageway (folio 52r). It contained five benches of various kinds totaling fifty-seven feet in length, a trestle table twenty-three feet long, a small cabinet, and four upholstered "women's chairs." On the wall were a birth salver and a painting on canvas of "a dinner table with many figures, a fountain, and other things, French [i.e., northern]," about eleven feet long. Since it was followed by the servants' dining room, it may have been the waiting room before meals or, judging by the long table, an auxiliary dining area.

A suite of rooms dedicated to the culinary needs of the house followed (folios 52v–55v), beginning with the "dining room where the servants eat," outfitted with a table twenty-three feet long, two long benches, two cabinets, and a side table. The room had its own well, with buckets, chain, and pulley. The main room in this suite, and the largest, was the kitchen, used for food preparation and cooking. Though the inventory makes no specific mention of it, the kitchen would have centered on a large walk-in kitchen fireplace. Furnishings included a trestle table 9.5 feet long, another table six feet long, and a third, 13.5 feet long, described as a "table cabinet" with three doors and two shelves. For seating, the room had two benches in total twenty-three feet long, ten stools, and a chair. Sets of dishes were stored here, some designated as belonging to the masters, other, simpler ones for the staff. A set of majolica platters, plates, urns, and jars was described as "of fine quality." For cooking, saucepans, cooking pots (including two designed for poaching eggs), cauldrons, frying pans, and baking trays were listed. Three circular iron racks held the pots. For the fire there were iron tripods, grills, drip pans, roasting spits, andirons, tongs, forks, and shovels. The kitchen also had a well with chain rope and pulley and a chicken coop.

Next to the kitchen was a kitchen pantry or, in today's usage, a "butler's pantry" (folio 53r). It was equipped with a cabinet four feet wide, a credenza used as a table, eight feet long, two storage chests, and two stools. In it were kept a set of majolica dishes described as "from Montelupo, beautiful," 301 plates and dishes, and a variety of metal vessels, urns, and basins. Also stored here were "twenty-eight beautiful oil lamps from Pistoia." The pantry had a clock with counterweights that could strike the hour.

The next room in order was designated as belonging to Madonna Mea, an otherwise unknown person. She may have been the chief cook, judging by the room's location between the pantry and the bread room (folios 53v–55r). In addition to being Madonna Mea's private room, the room was used for storing table linens, many of them expensive, including cloths, napkins, hand towels, and runners. A curiosity are the ten roller towels, each 11.5 feet long, stored here. The room was outfitted with a wooden shelf all around, forty-six feet long, a plain bed, 8.5 feet long, a cabinet and a cupboard, two *cassoni,* and a number of smaller boxes and chests. In the chests were many sets of sheets and towels distinguished by their use for face, feet, hair, and so on.

The next room in the kitchen suite was the bread room (folio 55r). Standing against the wall was a wooden table 7.5 feet long and a shelf above of the same length. The room was equipped with another table of the same size used to roll out the dough, a bench-settle to lay out the bread for rising, two kneading troughs, two flour casks, nine large bread planks, seven flour sifters, and three smocks to wear when using them. Also in the bread room were five barrels of oil ranging from "pinkish to vinegary to chamomile [color] to others."

The chamber of the servants was a poor sleeping room (folio 55r). It had two large bedsteads, an old-fashioned bench-settle, and two crude *cassoni* in poor condition. Completing the run-down picture were blankets in poor condition, a broken plate, and an old polyptych with many saints. The fruit storeroom followed (folio 55v). It had two shelves on the wall that ran the circumference of the room, sixty-one feet in all, on which the fruit was stored, a wooden cabinet, a crude walnut cupboard containing "provisions of various kinds," and a short bench. This room may have been used for the preparation of candied and preserved fruit, an important part of the diet of wealthy families. A large amount of table service was stored here, including majolica dishes, plates, pitchers, basins, and wine coolers, as well as a great deal of pewter, brass, and copper tableware and urns.

Following this, the clerk entered the chamber of the wet nurses (folio 55v) (he had already inventoried the antechamber of the same suite). Compared to the servants' quarters, this was a much more refined room, larger and decorated with inlay on the furniture and paintings on the walls. The paintings included a four-foot-square *Calumny of Apelles* and an equally large *Moses Crossing the Red Sea,* also anonymous, inventoried as a matched set with two small paintings of "fat singers" (*cantori grassi*). The bedstead had walnut moldings and intarsia work and a daybed with a *cassone* attached at its foot. Also in the room were three more *cassoni,* a gilt storage chest, two old coffers, and a

pair of trunks covered in animal skin. Spinning was done here, as evidenced by the presence of eight wool-winding spindles and their bases and a carved cedar chair. A "beautiful" gilded and painted cradle reflects the original usage of the room. Two notable items are a picnic set for two, complete with dishes and cookware, and a set of nets for snaring birds.

From the servants' and utilitarian rooms on the third floor, the clerk ascended to the floor above. This was actually another set of rooms with its own terrace, set back from the exterior walls of the palace. Several rooms were of significance. He began with a room described only as "On the terrace above," which, judging by its equipment, may have served as a kind of watchtower (folio 56v). It was equipped with four benches and two large wooden tables, as well as lances, pikes, banners, and fifty-three red body shields decorated with the Medici arms and with streamers attached. Stored on the roof, these may have been deployed as decoration on the façade on special occasions or as processional equipment.

The Sala Grande comprised a suite of rooms similar to the great rooms on the ground floor and the *piano nobile*. The clerk began in the bedchamber of the Sala Grande (folio 57r), which was furnished with a large bed (10.5 feet long) with intarsia work and bench chests all around. There was also a box-settle with a *cassone* and a clothes rack, in walnut with a lot of intarsia. These were furnishings for a significant member of the family. One of the paintings on the wall depicted the stages of the moon, and two others had religious subjects. For storage the room held, besides the chests built into the two beds, another *cassone* with intarsia panels and six paired chests of smaller size. The chests held three horse-covering cloths painted with livery, a saddle cover, eight varied gowns (*vestiti*), thirteen doublets, some for use with armor, and four helmets covered in white damask. These sound like stored processional uniforms.

The antechamber of this suite was another matter (folios 57v–60r). On the walls were a bronze relief of the Madonna and a painting on canvas of the same subject. For furnishings it had a bedstead 8.5 feet long with benches attached all around, a clothes rack with three rows of pegs, plus no fewer than seven *cassoni* and two smaller storage chests. In the *cassoni* were stored a large quantity of unfinished bolts of material, including seven bolts of linen totaling 1,336 cumulative feet, nine bolts of cloth for sheets totaling 1,924 feet, eight bolts of cloth for tablecloths totaling 931 feet, and a large quantity of other rolls and pieces of cloth designated for household use, such as table runners and napkins. Another chest held an assortment of cloth and clothes for both men and women and for tournament wear. These included a remnant described as a nineteen-foot-long piece of white velvet with gold brocade of branches and garlands and the

Medici arms, and another of white velvet decorated with green parrots and gold brocade. Among the clothes were overcoats, doublets, gowns, and tabards for wearing over armor, some specified as for children, some used and worn, and some with Medici livery. The distinguishing characteristic of this list is the variety of materials and linings: green satin embellished with silver, high-low velvet in crimson and purple, sky-blue velvet lined in iridescent taffeta. This was followed by a list of clothes under the heading "Giuliano's clothes" (folio 59v): eight overcoats and three gowns (*turche*) in crimson and gray damask and satin, black or reddish or purple velvet or cotton cloth, all lined in fur of lynx, squirrel, ermine, or marten. Also itemized were three pairs of new silk Lucchese hose.

A small bathroom was attached (folio 60r). In it were a large *cassone* with towels and sheets, a large brass washtub, and an assortment of metal bowls, jugs, and pails. Above the bathroom was a mezzanine room in which were stored flax to make thread, utensils and tools, and forty-three small silver cases.

A priest resided in the palace (*camera del prete*), his modest quarters consisting of a fourth-floor bedchamber and antechamber that opened onto the roof terrace (folio 60r). In his bedroom were a bedstead and bed-settle, both with walnut frame and intarsia, a clothes rack, and a built-in *cassone*. Two box benches stood nearby. A "beautiful" wicker table and a number of chairs, including a carved cedar chair, an old armchair, and two upholstered "women's chairs," completed the furnishings. On the walls were a gold-framed adoration of the Magi on canvas, a portrait of Madonna Lucretia (Lucrezia Tornabuoni, Lorenzo's mother), and two other paintings. The location of the portrait of Lucrezia in the priest's out-of-the-way quarters recalls her reputation as a particularly devout woman who wrote religious poetry.[119] The priest's antechamber had another, smaller bedstead and two box benches, a lined window curtain, and an old broken copper pail, possibly a chamber pot.

The next room on the fourth floor was designated simply "the terrace room toward the street." It seems not to have been occupied at the time but was used for storage of family goods, primarily arms and armor. It was equipped with a walnut and intarsia bedstead with two decorated bench chests and a box-settle with built-in clothes rack and *cassone* decorated with the Medici arms. Four upholstered "women's chairs," a carved cedar chair, and two high-backed walnut benches completed the furnishings. No personal items were described. The attached antechamber held a collection of armor and weapons (folio 61r). Many of these were in a large cabinet with two doors: cuirasses, helmets, shields, scabbards, brassards, pauldrons, cuffs and gauntlets, back and hip armor, and tips and points for lances, most designated for tournament use.

The clerk wrote the heading for the next room, the library, but, as noted above, he left the page blank (folio 61v). The Medici library was a famous collection of books and manuscripts, begun by Piero and Cosimo, Lorenzo's father and grandfather, and continued by Lorenzo. The clerk failed to inventory this valuable part of the estate, probably because it was undergoing renovation.

The next room was described as a "large armory above, next to the roof" (folio 62r). This was the Medici private militia armory. It contained enough armor and weapons to equip a small army and included a field tent for use in warfare. It lists 115 helmets, chain mail for 156 foot soldiers, 111 pairs of arm armor (brassards), and 93 pairs of leg and thigh armor (cuisse and greaves). Among the weapons were 23 sword lances, 27 rapiers, 44 fixed-position crossbows, and 37 field crossbows. A notable addition was the five harquebusses, the ancestor to the modern rifle that was introduced into Europe in the second half of the fifteenth century and was destined to revolutionize warfare. On the landing of the stairs to the roof were kept other large military equipment and various objects (folio 62v). These included eight catapults and a cart for carrying them, a field bed, and a field wagon for transporting people. Also stored here were two large models of an old house, probably the original models for the palace. They recall the story that when Brunelleschi submitted his model of the palace to Cosimo de' Medici, Cosimo rejected it because it was too grand and would incite envy. Brunelleschi, angered by the insult, smashed the model with his cane.[120] One of the two models mentioned here might have been Brunelleschi's damaged model and the other Michelozzo's replacement. Also on the landing were the dismantled remains of the dais built for the celebration of Lorenzo's son Giovanni's elevation to the cardinalate, which had taken place in March of the same year (1492).

The location of the next room to be inventoried, the vinegar room (folio 63r), is not clear. Since its purpose was related to the kitchen, it was probably on the third floor below, so the clerk must have originally skipped it and returned at this point. It contained vinegar stored in barrels as well as a cask for salting meats. Also stored in the room were a variety of utensils and bowls, basins, and jugs.

The final room in the inventory is the most mysterious. It is called the chamber of the mute woman (*camera della muta*) and contained a cell 23 feet long and 9.5 feet high made of wooden bars built against the wall. Inside was a wooden bed eight feet long. No one knows who the original occupant was, but the twenty-five jousting lances stored here suggest that it was no longer used for the mute woman.

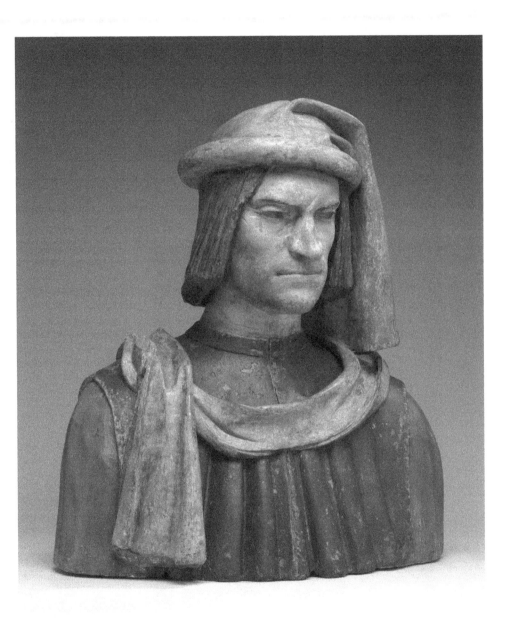

Fig. 1 Andrea del Verrocchio (or follower), *Bust of Lorenzo de' Medici*, possibly
early sixteenth century, based on an original of ca. 1478. Painted terracotta.
Samuel H. Kress Collection, National Gallery of Art, Washington, D.C. Lo-
renzo's expression and posture express intellectual involvement, as if the object
of his scrutiny were internal rather than external. The image is calculated to
represent Lorenzo as a man who lives primarily in the world of ideas.

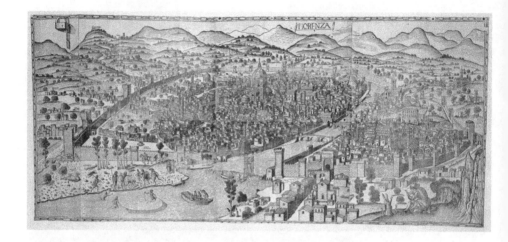

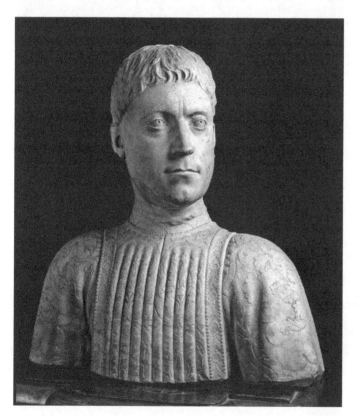

Fig. 2 *The Chain Map of Florence*, possibly by Lucantonio degli Uberti (after Francesco Rosselli), ca. 1480–1490. Woodcut. Kupferstichkabinett, Staatliche Museen, Berlin. The earliest bird's-eye-view pictorial map of Florence and the surrounding hills. The meaning of the chain around the border is unknown.

Fig. 3 Mino da Fiesole, *Piero di Cosimo*, 1453–1454. Marble bust. Museo Nazionale del Bargello, Florence. This portrait, the earliest preserved example of a marble bust of a living person since antiquity, is one of the busts placed over the doors of the suites in the Palazzo Medici. It is signed and dated on the bottom, "Piero, the son of Cosimo at the age of 37. A work by Mino the sculptor."

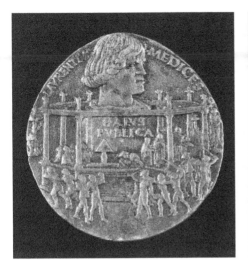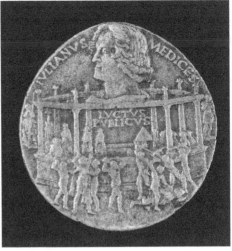

Fig. 4 (left) Bertoldo di Giovanni, *The Pazzi Conspiracy Medal: Lorenzo Escapes the Assassins* (reverse: *Giuliano Murdered*), 1478. Bronze, 2⅝ in. (6.6 cm) in diameter. Samuel H. Kress Collection, National Gallery of Art, Washington, D.C. The image of Lorenzo floats above the altar enclosure of the Duomo, where the assassination attempt took place. Lorenzo appears in the center, distinguished by the cape he used to ward off the attackers. The inscription SALVS PVBLICA ("deliverance of the nation") adroitly elevates the event from a family tragedy to a national victory. *Fig. 5 (right)* Bertoldo di Giovanni, *The Pazzi Conspiracy Medal: Giuliano Murdered* (reverse: *Lorenzo Escapes the Assassins*), 1478. Bronze, 2⅝ in. (6.6 cm) in diameter. Samuel H. Kress Collection, National Gallery of Art, Washington, D.C. The image of Giuliano with the inscription LVCTVS PVBLICVS ("the nation's grief") sits upon a graphic depiction of the actual murder, showing Giuliano attacked at left and then prostrate with an assassin astride and stabbing him furiously.

Fig. 6 Domenico Ghirlandaio, detail of Florentine scholars from *Annunciation to Zacharia*, 1485–1490. Fresco, Tornabuoni Chapel, Santa Maria Novella, Florence. Depicted *(from left to right)* are the Latin scholar and Dante expert Cristoforo Landino, the Greek scholar Marsilio Ficino, the Greek and Latin professor and poet Angelo Poliziano, and the poet Gentile Becchi, all members of Lorenzo's inner circle.

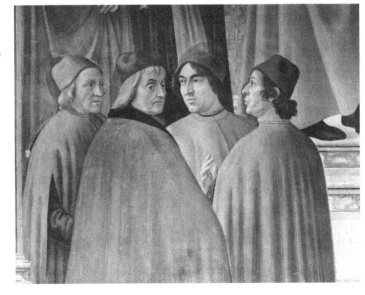

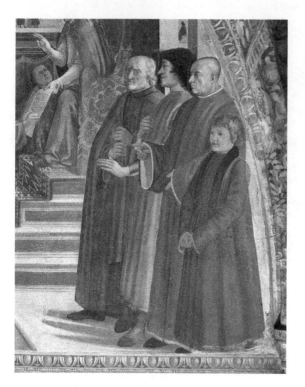

Fig. 7 Domenico Ghirlandaio, detail of Lorenzo from *Confirmation of the Franciscan Rule*, 1483–1486. Fresco, Sassetti Chapel, Santa Trinitá, Florence. Lorenzo is shown at age thirty-six (with dark hair) with members of the Pucci and Sassetti families.

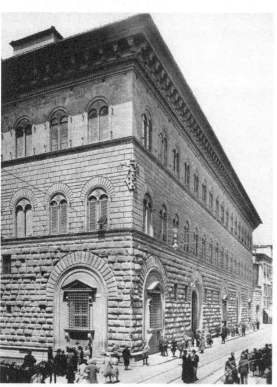

Fig. 8 Michelozzo, Palazzo Medici-Riccardi, 1444–1459. Façade and south-east corner circa 1890. The façade on the Via Larga, to the right, is one-third longer than the original, owing to the addition by the Riccardi family in the seventeenth century. The carefully distinguished styles of masonry of the three floors are united by the alignment of the windows and the steeply overhanging classical cornice, ten feet high and proportioned to the whole building.

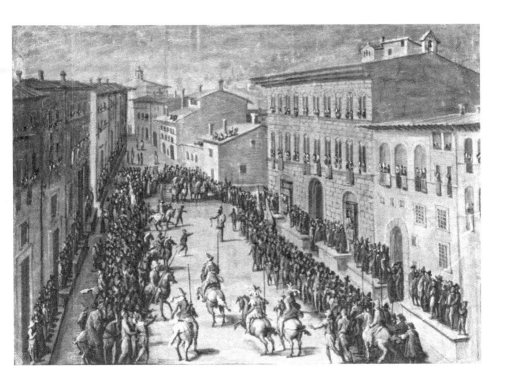

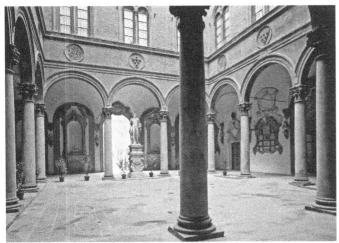

Fig. 9 (top) Giovanni Stradano (with Giorgio Vasari), *Joust of the Saraceni in Via Larga*, 1540. Fresco, apartments of Eleonora of Toledo, Palazzo Vecchio. This, the earliest image of the Medici palace with the original façade before it was extended in the seventeenth century, depicts a sporting event taking place before the palace in which the mounted contestants strike a target on a pivoting mannequin. The building on the right of the Medici palace belonged to Lorenzo and Giovanni di Pierfrancesco, Lorenzo's wards.

Fig. 10 (bottom) Michelozzo, Palazzo Medici-Riccardi, courtyard. The proportions of the columns and bays, as well as the capitals and moldings, are copied from those of Brunelleschi's Ospedale degli Innocenti. The medallions in the architrave frieze depict the Medici arms and copies of Lorenzo's ancient cameos.

Cosimo di Giovanni di Bicci de' Medici (the Elder)
(1389–1464)
m. Contessina de' Bardi 1414
(ca. 1390–1473)

Piero I de' Medici (the Gouty)
(1416–1469)
m. Lucrezia Tornabuoni 1444
(1425–1482)

Giovanni de' Medici
(illegitimate) (before 1444–?)

Maria de' Medici
(illegitimate) (1445–1472)
m. Leonetto de' Rossi

Bianca de' Medici
(1446–1488)
m. Guglielmo de' Pazzi

Lucrezia de' Medici
(Nannina)
(1448–1493)
m. Bernardo Rucellai 1466

LORENZO DE' MEDICI
(the Magnificent)
(1449–1492)
m. CLARICE ORSINI 1469
(ca. 1453–1488)

Giuliano de' Medici
(1453–1478)
assassinated in
Pazzi conspiracy

Lucrezia de' Medici
(1470–1553)
m. Jacopo Salviati 1488

Piero II de' Medici (the Unfortunate)
(1471–1503)
m. Alfonsina Orsini 1488

Maddalena de' Medici
(1473–1528)
m. Franceschetto Cybo 1487

Giovanni di Lorenzo de' Medici
(1475–1521)
Pope Leo X

Luisa de' Medici
(1477–1488)
promised to
Giovanni di Pierfrancesco, d. at 11

Contessina de' Medici
(1478–1515)
m. Piero Ridolfi 1493

Giuliano de' Medici
(1479–1516)
Duke of Nemours
m. Filiberta of Savoy 1515

Giulio de' Medici
(1478–1534)
natural son of Lorenzo's
brother Giuliano
Pope Clement VII

Fig. 11 Medici family tree.

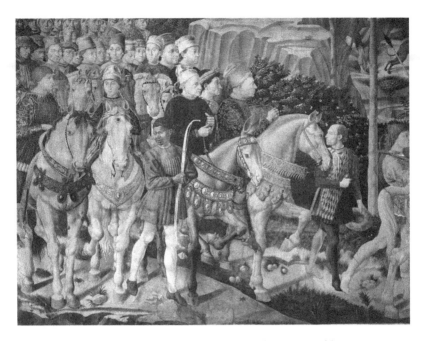

Fig. 12 Benozzo Gozzoli, detail of the Medici family from *The Procession of the Magi*, ca. 1459. Fresco, Medici palace chapel. Shown are Piero di Cosimo at the lower right on a white horse, Cosimo on the brown mule, and, in the crowd behind, Lorenzo at age ten with a red hat and a turned-up nose. Gozzoli has included his own self-portrait in a red hat directly above Lorenzo.

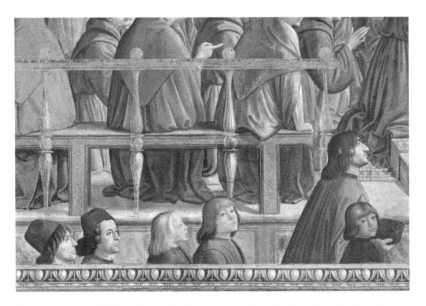

Fig. 13 Domenico Ghirlandaio, detail of Lorenzo's sons from *Confirmation of the Franciscan Rule*, 1483–1486. Fresco, Sassetti Chapel, Santa Trinitá, Florence. Angelo Poliziano, tutor to Lorenzo's sons, is shown leading his charges *(right to left)* Giuliano at age seven, Piero at fourteen, and Giovanni at ten, followed by Luigi Pulci and another scholar.

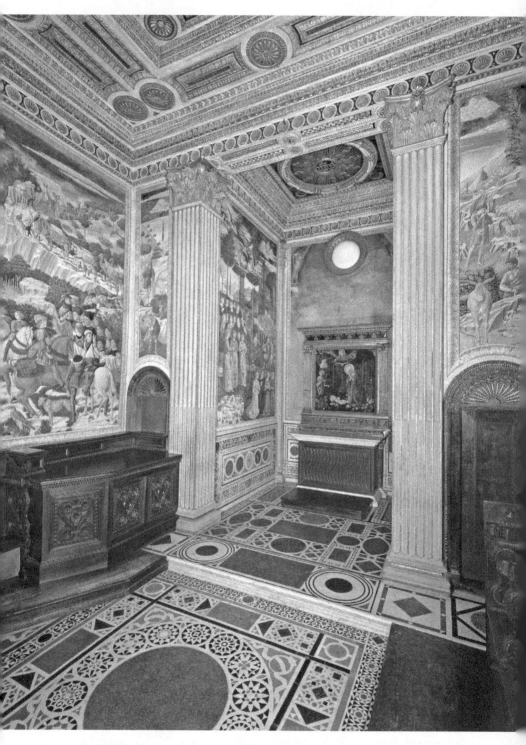

Fig. 14 The Medici palace chapel, showing the *Procession of the Magi* fresco by Gozzoli, some of the original wooden furnishings, and a Renaissance copy of Lippi's *The Virgin Adoring the Child with St. Bernard*.

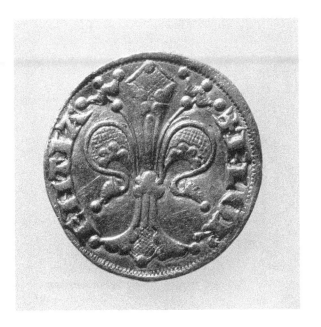

Fig. 15 Gold florin, after 1252, ¾ in. (20 mm) in diameter and weighing fifty-four grains. Muenzkabinett, Staatliche Museen zu Berlin.

Fig. 16 Tazza Farnese, Roman sardonyx-agate bowl, 8 in. (20 cm) in diameter, second or first century B.C.E., obtained by Lorenzo in 1471 from Pope Sixtus IV. Museo Archeologico Nazionale, Naples. The figures depicted are Hades holding a cornucopia, and Isis and Horus at the right.

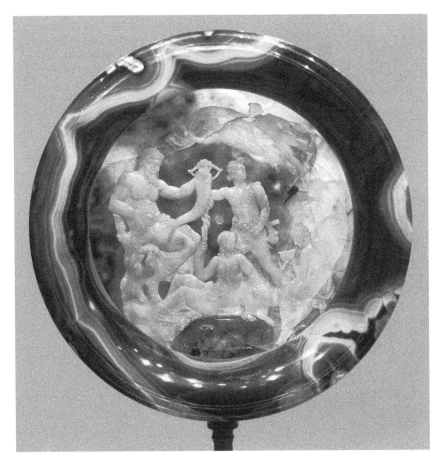

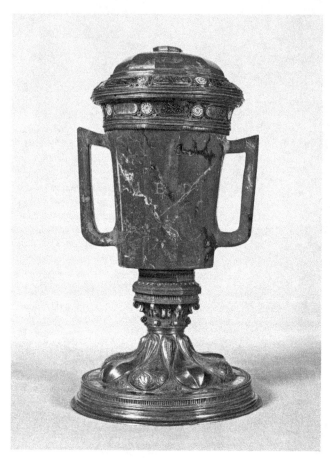

Fig. 17 Jasper cup
(called a wine cooler
in the inventory) with
fifteenth-century mount,
10½ in. (27 cm) high,
inscribed LAV.R.MED.
Museo degli Argenti,
Florence. At two thou-
sand florins, this impres-
sive work was the most
highly valued hardstone
vase in Lorenzo's collec-
tion. The precious metal
lid and base were added
in the fifteenth century.

Fig. 18 The Noah
Cameo (including
original gold mount), ca.
1204–1250, workshop of
Holy Roman Emperor
Frederick II. Onyx cameo,
2 in. (5.1 cm) wide. The
British Museum, London.
Inscribed on doors of the
ark: LAV.R.MED.

Fig. 19 *Apollo, Marsyas, and Olympus,*
1470–1480. Florentine bronze cast of
carnelian inscribed LAV.R.MED, 1½ in.
(4 cm) high. Widener Collection, National Gallery of Art, Washington, D.C.
(Roman original ca. 30–27 B.C.E., Museo
Archeologico Nazionale, inv. 26051.)
The original carnelian, of which this is
a cast, was first owned by Cosimo de'
Medici and then his son Piero. Lorenzo
inherited the gem and must have held it
in high regard because he had his initials
inscribed on it and commissioned a
number of casts.

Fig. 20 Apollonio di Giovanni, *cassone*
depicting the battle of Angora between
the Ottoman Turks and the Mongols in
1402 (formerly called the conquest of
Trebizond), 1450–1475. The Metropolitan
Museum of Art, New York. This is the
type of *cassone* with a painted front panel
that appears in almost all of the rooms
of the Medici palace. Said to have come
from the Strozzi palace in Florence.

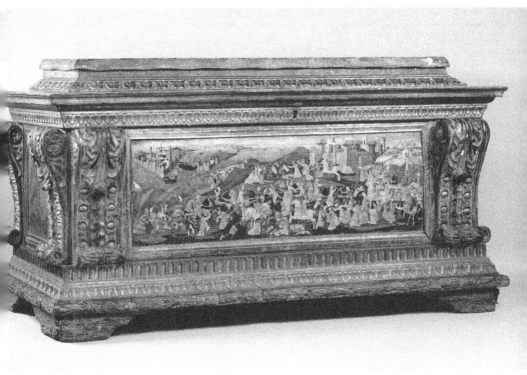

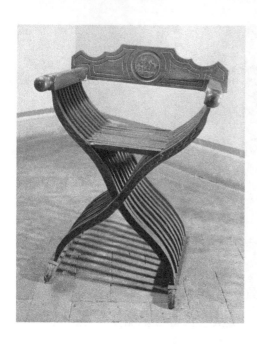

Fig. 21 Savonarola chair, early sixteenth century. Museo di San Marco, Florence. This type of X-frame chair is called a "cardinal's chair" in the inventory.

Fig. 22 Vittore Carpaccio, *Dream of St. Ursula*, 1495. Tempera on canvas, 9 × 8¾ ft. (274 × 267 cm). Gallerie dell'Accademia, Venice. The furnishings depicted in Saint Ursula's bedroom are similar to those of the suites in the Palazzo Medici: a four-poster bed surrounded by an inlaid wood plinth, wainscoting draped with a green fabric covering the walls to shoulder height, a built-in storage cabinet, a chair, a stool, a table with a carpet-weave covering, a *cassone*, and on the walls a sacred painting and two allegorical sculptures.

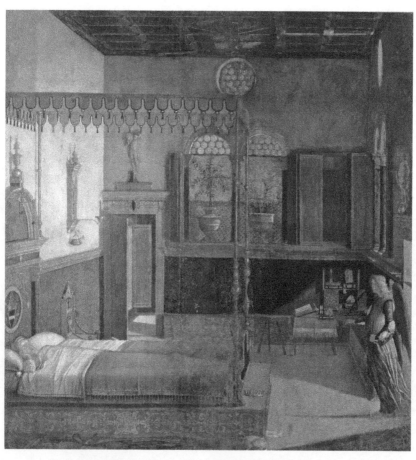

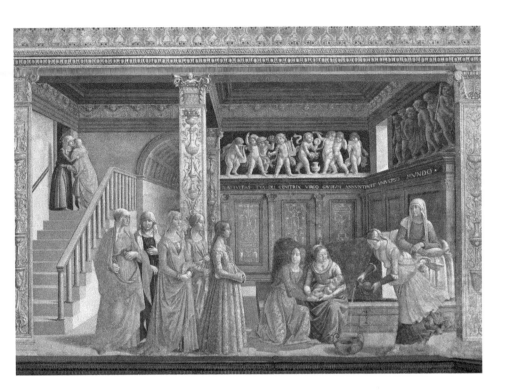

Fig. 23 Domenico Ghirlandaio, *Birth of the Virgin*, 1485–1490. Fresco, Tornabuoni Chapel, Santa Maria Novella, Florence. This largely imaginary view of a bedroom includes the unlikely staircase and vaulted corridor at the left and the awkward sculptural frieze of cherubs above the bed. The garments of the women, however, are portrayed accurately.

Fig. 24 Domenico Ghirlandaio, *Portrait of Giovanna Tornabuoni*, 1488. Tempera on panel, 30 × 20 in. (76 × 50 cm). Museo Thyssen-Bornemisza, Madrid. Giovanna's elaborate garment consists of a white undershirt over which is worn a red gown embroidered with flowers and appliquéd crisscross ribbons. The slit sleeves and laced bodice allow the puffy white shirt to show through. A yellow cut-velvet sleeveless overgown with a stiff, floor-length cape down the back completes the ensemble.

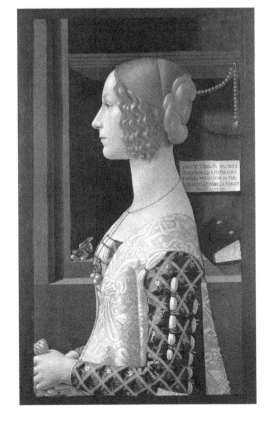

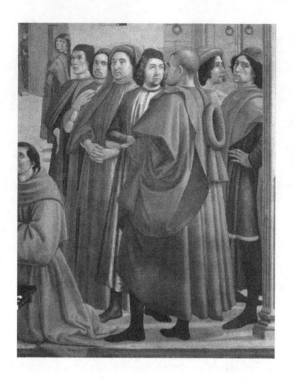

Fig. 25 Domenico Ghirlandaio, detail from *Miracle of the Boy*, 1483–1486. Fresco, Sassetti Chapel, Santa Trinitá, Florence. The group of men present at the miracle display the variety of deep-dyed colored hats, doublets, stockings, and gowns that constituted the dress of men in Lorenzo's Florence. The man at far right looking out at the viewer is the artist's self-portrait.

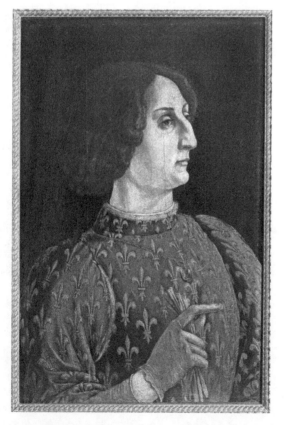

Fig. 26 Piero del Pollaiuolo, *Portrait of Galeazzo Maria Sforza*, 1471. Oil (?) on panel, 25⅝ × 16½ (65 × 42 cm). Galleria degli Uffizi, Florence. An important benchmark in the development of Florentine portraiture, this image is among the first to animate the aristocratic sitter by depicting him in three-quarter view and suggesting action and thought in his gesture.

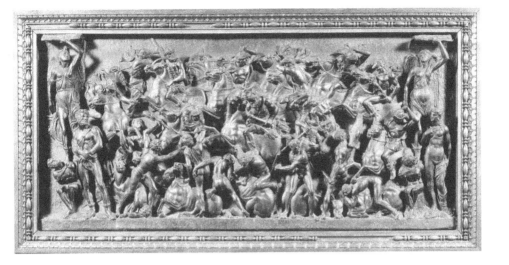

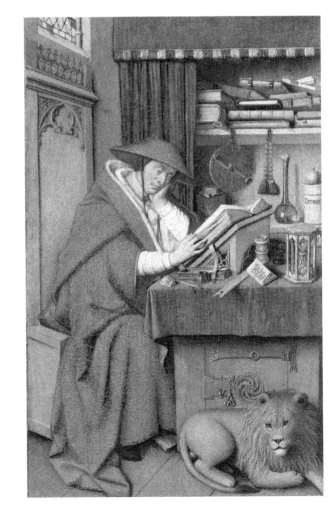

Fig. 27 Bertoldo di Giovanni, *Battle Scene*, ca. 1480. Bronze relief, 18 × 39 in. (45 × 99 cm). Museo Nazionale del Bargello, Florence. Originally placed over the fireplace in the Saletta (dining room) of the palace. The central figure in the scene is Hercules, and the work has been interpreted as an allegory of Lorenzo battling his enemies in the aftermath of the Pazzi conspiracy.

Fig. 28 Jan van Eyck/Petrus Christus, *St. Jerome in His Study*, 1442. Oil on linen paper on panel, 8 × 5 in. (19.9 × 12.5 cm). Detroit Institute of Art. Originally owned by Cosimo, this small portable picture was kept in a traveling case in Lorenzo's studio and was the basis for Ghirlandaio's 1470 fresco *St. Jerome in His Study in the Church of the Ognissanti*, possibly in homage to Lorenzo from Giovanni Tornabuoni, a political ally who commissioned the fresco.

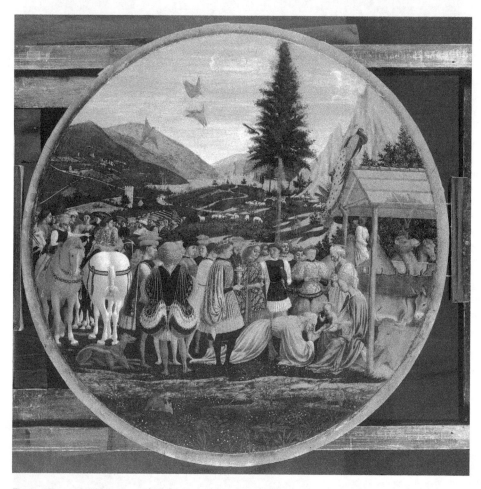

Fig. 29 Domenico Veneziano, *The Adoration of the Magi*, 1439–1441. Tempera on panel, 33 in. (84 cm) in diameter. Gemäldegalerie, Staatliche Museen zu Berlin. Some of the mottos on the garments of the figures can be identified with Piero di Cosimo, and his portrait has been seen in the standing figure in black and white in the right center of the composition.

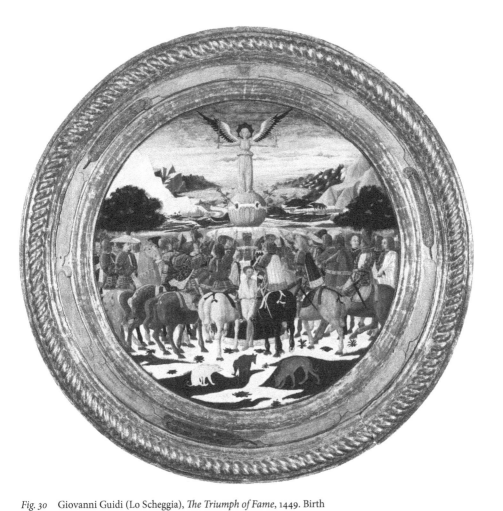

Fig. 30 Giovanni Guidi (Lo Scheggia), *The Triumph of Fame*, 1449. Birth
tray of Lorenzo. Tempera with silver and gold on panel, 36½ in. (92.7 cm) in
diameter. The Metropolitan Museum of Art, New York. The image loosely fol-
lows Petrarch, Boccaccio, and traditional paintings of the subject. The subject
suggests, with uncanny accuracy, the destiny of the newborn child Lorenzo. The
tricolor feathers of Piero's arms encircle the tondo; on the reverse, the arms of
the Medici and the Tornabuoni families, Lorenzo's lineage, are displayed.

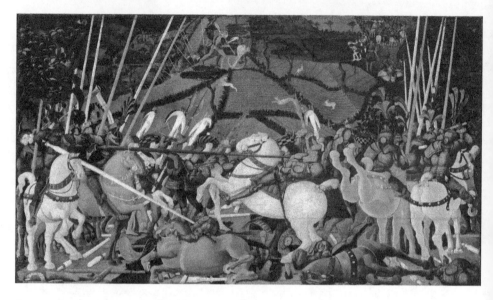

Fig. 31 Paolo Uccello, *The Battle of San Romano: Niccolò da Tolentino Unseats His Opponent*, 1430s–1450s. Tempera with silver leaf on panel, 6 × 10.5 ft. (1.82 × 3.23 m). Galleria degli Uffizi, Florence. One of three paintings of the battle, this shows the Florentine general Niccolò da Tolentino at the far left leading his troops against the Sienese and unhorsing the Sienese knight in the center. The three paintings in the series were a matched set and were hung above the wainscoting just beneath the coved ceiling in the Sala Grande on the ground floor.

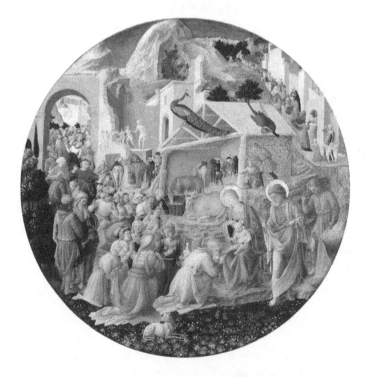

Fig. 32 Fra Angelico and Filippo Lippi, *The Adoration of the Magi*, 1440/1460. Tempera on panel, 54⅛ in. (137.3 cm) in diameter. Samuel H. Kress Collection, National Gallery of Art, Washington, D.C. At one hundred florins, this was the most highly valued painting in the inventory. The painting is the earliest to integrate the circular shape of the tondo into the depiction of a long procession winding into the background, a novelty that may account for the high valuation of the work.

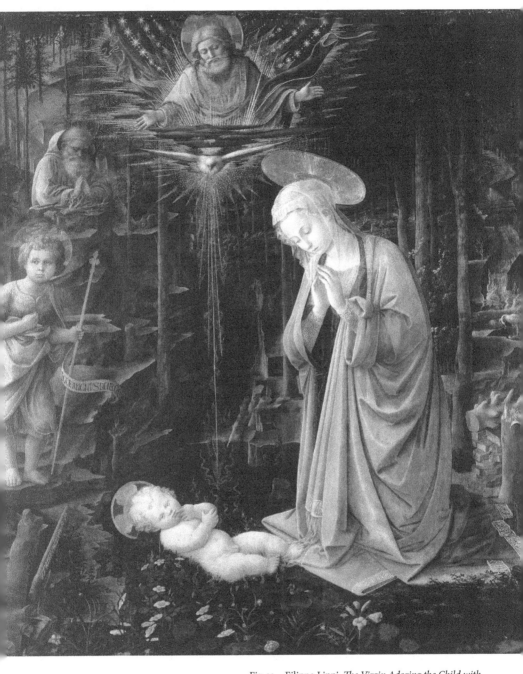

Fig. 33 Filippo Lippi, *The Virgin Adoring the Child with St. Bernard*, 1459. Tempera on panel, 51 × 46 in. (129 × 118 cm). Gemäldegalerie, Staatliche Museen zu Berlin. The painting was executed for the altar in the Palazzo Medici chapel but was removed in 1494.

Fig. 34 Filippo Lippi, *Seven Saints*, ca. 1459. Tempera on panel, 5 ft. (152 cm) wide. The National Gallery, London. The seven saints are (*left to right*) Francis, Lawrence, Cosmas, John the Baptist, Damien, John the Evangelist, and Peter Martyr, all name saints of the principal male members of the Medici family. The painting is not mentioned in the inventory but was bought directly from the Medici palace in 1861.

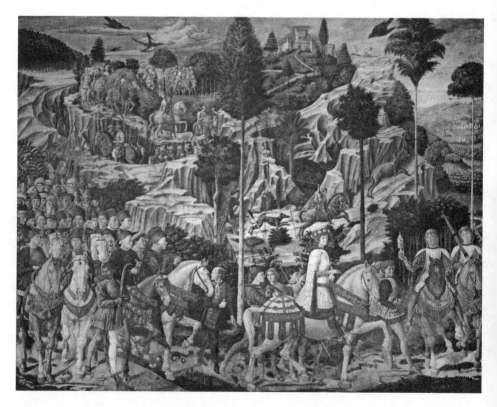

Fig. 35 Benozzo Gozzoli, *The Procession of the Magi*, ca. 1459. Fresco with gold leaf, Palazzo Medici chapel. View of the east wall showing the Medici family and supporters in the crowd following the youngest magus.

BOOK OF THE INVENTORY
OF THE GOODS OF
LORENZO IL MAGNIFICO
THE MEDICI PALACE

FILZA 165

MEDICEO AVANTI PRINCIPATO

ARCHIVIO DI STATO

FIRENZE

INVENTORY

1512

This inventory is copied from another inventory that was made at the death of Lorenzo il Magnifico de' Medici, copied by me, the priest Simone di Stagio dalle Pozze, today, December 23, 1512, commissioned by Lorenzo di Piero de' Medici.

[folio 1 recto]

INVENTORY OF THE PALAZZO IN FLORENCE AND ITS HOUSEHOLD GOODS

A palazzo located at the corner of the Via Larga, in the quarter of San Lorenzo, called the Palazzo of Cosimo, within its measured boundaries, and within which are the below-mentioned rooms with the below-mentioned household goods, as appraised and valued with an estimate.

IN THE VAULTED ENTRANCE TO THE ABOVE-MENTIONED PALACE

A poplar-wood table 3½ br. in length and three shelves, on which are several clay jars and a wooden lamp like a torch and several glasses f. 1

A poplar-wood plank bench and a spruce plank, 3 br. long, and six large clay jars and four iron candleholders with wooden handles f. 1

In the first vaulted room at the left

Wooden shelves all around, — br. long, on which are three large clay jars and three clay jugs, also other jars, a majolica wine cooler, a marble wine cooler with a base of three little lions, and several large flasks encased in willow-work and other stuff, and several wine kegs of pomegranate wood and two brass candleholders f. 4

In the other vaulted room

A storage cask holding 100 *barili*
A storage cask holding 40 *barili*
A storage cask holding 40 *barili* Total 197 *barili*
A storage cask holding 5 *barili*
Eight small kegs altogether holding 12 *barili* f. 24

A wooden shelf along the wall the length of the room and a winepress
of pomegranate wood and several baskets and hampers, total f. 6

Next to the well

A table about 2 br. long
A large copper basin weighing — lib.
A funnel and two wine strainers
A barrel plug and spigot
An iron hook and 2 mallets
A pair of buckets for the well with a chain for drawing water Total f. 6
 [running total] f. 42

[folio 1 verso]

Continuing in the same vaulted room and in the entryway

A storage cask holding 11 *barili*
A storage cask holding 19 *barili*
A storage cask holding 20 *barili*
A storage cask holding 20 *barili*
A storage cask holding 20 *barili*
A storage cask holding 23 *barili*
A storage cask holding 25 *barili*
A storage cask holding 24 *barili*
A storage cask holding 25 *barili*
A storage cask holding 26 *barili*
A storage cask holding 28 *barili*
A storage cask holding 27 *barili* Total 268 *barili* valued at f. 40

In the little vaulted room where the malmsey wine is kept

A storage cask holding 45 *barili*
A storage cask holding 44 *barili*
A storage cask holding 40 *barili*
A storage cask holding 32 *barili*

A storage cask holding 27 *barili*
A storage cask holding 30 *barili*
A storage cask holding 24 *barili*
A storage cask holding 44 *barili*
A storage cask holding 50 *barili*
A storage cask holding 75 *barili*
A storage cask holding 75 *barili*
A storage cask holding 75 *barili*
A storage cask holding 78 *barili* Total 639 *barili* valued at f. 98

Two overlapping barrel racks

[folio 2 recto]

In the summer vaulted room
A storage cask holding 8 *barili*
A storage cask holding 8½ *barili*
A storage cask holding 9½ *barili*
A storage cask holding 9 *barili* Total contents of these things,
A storage cask holding 9 *barili* the casks, 65½ *barili*,
A storage cask holding 10 *barili*
A storage cask holding 11½ *barili* valued at f. 10
 [running total] f. 148

Continuing in the same vaulted room, in the summer room
A storage cask holding 12 *barili*
A storage cask holding 13 *barili*
A storage cask holding 10 *barili*
A storage cask holding 11 *barili*
A storage cask holding 11 *barili*
A storage cask holding 11 *barili*
A storage cask holding 12½ *barili* Total contents of these
A storage cask holding 15 *barili* casks, 146 *barili*
A storage cask holding 17 *barili*
A storage cask holding 19 *barili*
Five little storage kegs holding 13 *barili*
A storage cask, or rather, vinegar keg of 1½ *barili* valued at f. 22

Two trestles and a ladder for straining

In the passageway that leads to the firewood rooms

Three small vats holding — *barili*
Three little white wine casks holding — *barili*
Sixteen kegs holding — *barili*
A tub holding — *barili* Total, — *barili* valued f. —

Two shelves as long as the room, of — br.
A table 4 br. long
A cask holding — *barili*
A number of household dishes of clay, glass, and crystal Total valued at f. 6

[folio 2 verso]

In the vaulted room that used to be the ground-floor stable

Six small casks of several kinds of white wine holding 20 *barili*
Five small storage kegs holding 7½ *barili*
Thirty-two *barili* holding 32 *barili*
Three half *barili*, 1½ *barili*
Four *barili* in the passageway to the firewood room, 4 *barili*

Total 65 *barili* f. 10

Seven spruce planks used as a table
A narrow table
Three trestles beneath the tables Total value f. 4

Continuing in the same vaulted room under the stair

Two iron shovels to dig, curved, 2 lib.
Five small kegs, f. 4
Four wine casks of pomegranate wood
Four earthenware apothecary jars
Twenty-two majolica plates Total value f. 11

A cask tap

On the shelf over the stair

Four leather-covered flasks
A pewter flask
Two crystal wine coolers
A candlestick of tin-plated iron
Two pruning hooks
Two billhooks
A garden rake

A bow saw
Pliers, hammer, and nail puller
Three rails for trestles | f. 5

3 little casks that Giovanni the cooper has at the moment | f. 20

[folio 3 recto]

CONTINUING THE INVENTORY INTO THE GROUND-FLOOR LOGGIA OF THE PALACE

Four pine benches around the walls of the room with walnut moldings
and panels and intarsia, 80 br. long | f. 20

IN THE SALA GRANDE SUITE OF THE ABOVE-MENTIONED LOGGIA

Two pine benches around the room, with walnut moldings and
paneling and intarsia, 40 br. long, valued at | f. 10

Two cypress tables, one 14 br., the other 7¾ br., framed in walnut,
and a little table of poplar wood 4 br. long, and five trestles | f. 4

A painting on cloth in a frame 2 br. square painted in the French style
with the story of two women fighting with a boy, and many other figures | f. 3

A painting in the French style of 2 warships
and another ship valued at | f. 2

A pair of large andirons decorated with 2 balls

Five sconces of tin-plated iron set into the wall | f. 2

IN THE BEDCHAMBER OF THE ABOVE SUITE

A marble relief in a tabernacle above the door from the little antechamber
with wooden columns at the side and gilt capitals, and in the tabernacle
a bas-relief of Our Lady with the child in her arms with four angels,
that is, two on either side | f. 25

Two painted wooden panels above the fireplace mantel depicting
Saint Peter and Saint Paul by Masaccio | f. 12

A painting of Italy | f. 25

A panel painting of Spain f. 12

A large round mirror in low relief f. 1

A helmet crest with a woman above a sconce in tin-plated iron,
fixed in the wall, and a jousting lance f. —

A poplar-wood bedstead with parapetted sides with walnut moldings
and spindle-wood panels, and seats around decorated in the same way,
and with a trundle bed underneath, totaling f. 15

[folio 3 verso]

A straw mattress, cane lattice mat, trestle
A sheepskin mattress full of wool Total f. 2

A featherbed, 2 pillows full of feathers weighing — lib. f. 20

A white counterpane with a meticulous pattern of lilies, 10 br. long f. 10

A thin bedcover of *bambagia* [cotton bombast] f. 1 s. 10
 [a rare use of *soldo* as a subunit of the florin]

Continuing in the trundle bed
A straw mattress
A mattress of green cloth f. 1

A featherbed and a feather pillow, weighing — lib. f. 5

A thin white bedcover
A white blanket f. 3

A white linen bed curtain f. 6

A poplar-wood bed-settle with walnut moldings and beveled
corners and spindle-wood panels, 6½ br., with a *cassone* f. 10

2 small mattresses, one of sheepskin full of wool, one of red linen
full of hemp, and a white bedcover for the bedstead f. 4

In the bedstead, specifically in the cassone
A carpet with a nap, worked in circles, 6 br. long f. 6

A tapestry-weave bed-curtain ensemble in a foliage design, of 4 panels
and valances f. 40

Two hatchets with handles at the side of the bed	f. 4

A small cypress reading stand with walnut moldings and intarsia
A cypress casket f. 1

Five leather chairs, cardinal style f. 8

A pair of andirons, tongs, a fork, and a fire shovel f. 1

Two poplar-wood *cassoni* veneered in walnut with geometric
box pattern, inlaid in spindle wood and intarsia, of 4 br. each f. —

[folio 4 recto]

A poplar-wood *cassone,* with walnut moldings and panels
with intarsia, 4½ br. long f. 10

In the first cassone
A tapestry wall hanging, 20 br. long and 6 br. high, depicting
a hunt by the Duke of Burgundy f. 100

A wall tapestry, of 12 br., of figures in a tournament f. 36

A tapestry of figures in a tournament, 14 br. long, 6½ br. high f. 50

A tapestry with figures and dogs and horses, 10 br. long,
8 br. high, to hang on the wall f. 30

An antique bench-back tapestry with figures, 14 br.
long by 4 br. high, depicting heraldic arms f. 15

Two bench-back tapestries of foliage and landscape lined in green
cloth, each 13 br. long by 3½ br. high f. 70

A small tapestry with figures and foliage and with a coat of arms
in the middle, 7½ br. long f. 20

A coverlet and a green blanket, with much embroidery
and all kinds of glitter, of br. — f. 3

In the other cassone
A carpet-weave table cover of damask, 14 br. long, 5½ br. wide f. 70

Another carpet-weave table cover with some of the pattern
worked in damask, 10 br. long, 3½ br. wide f. 30

A carpet-weave table cover with pattern of roses and a border,
7 br. long by 5 br. wide f. 60

A carpet-weave table cover with a satin border all around
decorated with balls, 5½ br. long by 3 br. wide f. 10

A beautiful carpet-weave table cover with the Medici arms in the
center, 5½ br. long by 2 br. wide f. 30

[folio 4 verso]

Another carpet-weave table cover of the same sort and size f. 30

Another carpet-weave table cover done in roses, 7 br. long, 3 br. wide f. 20

A carpet-weave table cover done in roses, and in the center the arms
of the Medici and of the Orsini, 6 br. long by 3 br. wide f. 20

Another carpet-weave table cover done in the same fashion, 4½ br. long f. 10

A large carpet-weave table cover done in roses, 9 br. long, 4 br. wide f. 35

A carpet-weave table cover done in roses, 5 br. long by 3 br. wide f. 18

A silk carpet-weave table cover in the Moorish style patterned with
squares, 7 br. long by 3½ br. wide f. 10

Another carpet-weave table cover of silk in the Moorish style,
patterned with squares, 10 br. long by 2½ br. wide f. 15

An old carpet-weave table cover with a heavy nap, in its own box,
6 br. by 3 br. f. 3

A small carpet-weave table cover on the writing table, 3½ br. long by
2 br. wide f. 4

In the other cassone
Two figured bench-back tapestries with the story of Narcissus,
with candelabra and the Medici arms, worked with silk, lined in
green linen, antique, each one 12 br. long f. —

Two seat covers to go with the above-mentioned tapestries
with diamond lacings and the Medici arms, each 12 br. long f. 80

Four bench-back tapestries, two with the Triumph of Fame
and two with the Triumph of Love, each 12 br. long

Two seat covers to go with the above tapestries with crested helmets and the Medici arms and feathers	f. 200
A door curtain on which is the Triumph of Fame, beautiful	f. 20
A door curtain with two figures, one a woman and the other a youth, worked in silk brocade	f. 20
Two door curtains with foliage and coat of arms	f. 16
A dog's door curtain with the Medici arms and a crested helmet A door curtain with the Medici arms and a crested helmet and a woman Another door curtain with crested helmet and arms Two door curtains with two armed men and arms	f. 20

[folio 5 recto]

Three old door curtains with figures *all'antica*	f. 3
A mule blanket for use as a door curtain with arms and feathers and diamonds A blanket for a small bed with feathers and with diamond lacings and with the Medici arms in the center	f. 15
Six bench-back hangings with figures and horses and arms and other things, that is, in one a wild-game hunt; in another, a bird hunt; another, fishing; another, dancing; another, musical performers; and another, games, each one 12 br. long	f. 150
A poplar-wood table 2½ br. long and a little walnut bench covered in leather to sit upon	f. 1

IN THE LITTLE ANTECHAMBER, THE STUDY OF THE
SAME CHAMBER

A little wood-frame daybed about 3 br. long, on which is a cotton-batting mattress and a pillow and a blue spread and a white spread, all totaling	f. 4
A pair of storage boxes painted with the Medici livery A pair of trunks strapped in iron and covered with pelts	f. 3
Nine swords of various types	f. 10
Four scimitars	f. 6

Two French daggers
A sharp two-handed sword f. 2

Four two-handed swords for defense and for attack
A skullcap helmet
A metal helmet f. 4

Three antlers trimmed in silver
A gong decorated with silver f. 8

A brass horn f. 1

Two large steel shields f. 1

Three Spanish-style daggers, beautiful f. 6

A case with four razors and a silver mirror, completely decorated
with silver f. 10

[folio 5 verso]

Two little silver boxes in a bag, to hold soap f. 5

Two swords in French-style scabbards, in silver, one with the scabbard in
tan leather and the other with the scabbard in gray and sky-blue leather f. 6

A Spanish-style belt, rich, with gold thread all along its length and on
which are falcons and branches in gold thread in relief f. 25

A Spanish-style belt, the strap of purple satin with branches and satin
and letters in relief in gold thread and the tongue and buckle of gold f. 25

A Spanish-style belt, of damasked gold thread brocade with the
tongue of gold f. 15

A leather belt embroidered in the Neapolitan style in silver f. 2

A garter of purple velvet in 2 layers
A garter of green velvet in 2 layers f. 1.10

A yellow *bernia* [coatdress]
A tan *bernia,* or rather, red f. 5

A velvet cap gashed in gold brocade
Another cap, all velvet
Ten linen caps of many colors f. 5

A poplar-wood cupboard with two shelves, against the wall
in the study, 3¼ br. high by 1¼ br. wide f. 1

A leather chair, cardinal style f. 1

[folio 6 recto]

CONTINUING THE INVENTORY INTO THE CHAMBER OF
LORENZO IN THE SALA GRANDE SUITE OF THE GROUND FLOOR

Cypress-wood wall paneling decorated with intarsia and panels
and framing all in walnut, with a built-in cupboard with 7 shelves
and two doors, each 3¼ br. high, and the whole length 24 br.;
and also a credenza on legs in one part of the paneling of the same
wood and workmanship, and the length of the said credenza [is]
15 br. and it has 5 doors, the whole valued at f. 30

Six paintings above the aforementioned paneling and above the
bedstead framed all around in gold, 42 br. long and 3½ br. high, three
depicting the rout at San Romano and one a battle of dragons and
lions and one the story of Paris, from the hand of Paolo Uccello, and
one in which is depicted a hunt by Francesco di Pesello [Pesellino] f. 300

Seven brass candelabra around the room, on which are mounted
two crested helmets and five lilies, prizes from the horse races
of San Giovanni f. 160

A large tondo with a gilt frame, depicting Our Lady and Our Lord
and the Magi who come to make an offering, by the hand of
fra' Giovanni [Fra Angelico] f. 100

A painting depicting the bust of Saint Sebastian and other figures
with the Medici arms in a tabernacle by the hand of Squarcione f. 10

A painting depicting the Communion of Saint Jerome with six
small paintings f. 10

A painting depicting the bust of the Duke of Urbino with a frame f. 10

A painting depicting the bust of Duke Galeazzo [Sforza],
by the hand of Piero Pollaiuolo f. 10

Two purple glass vases above the fireplace f. 1

A poplar-wood bedstead with a surrounding plinth with walnut
moldings and intarsia, straw mattress, and bedposts, a mattress
full of wool, the whole totaling f. 4

[folio 6 verso]

A down comforter and two pillows full of feathers, of 5½ br. f. 16

A white blanket, Catalan style
A quilt and a half f. 5

A white counterpane with little buttons, of 8 br. f. 15

A bed-curtain set in linen like a tent in two circles and
the pendants and all the accoutrements f. 10

A cypress-wood bed-settle decorated in walnut panels and intarsia,
with cupboards of the same workmanship at either end, 9¼ br. long,
and with four drawers underneath the aforementioned cupboards,
[and] on the bedstead are mounted 4 horse-race trophy lilies f. 45

Two mattresses on the bed, full of wool, each 4 br.
A white counterpane decorated with geometric shapes for the bed f. 3

A bed-curtain set of six pieces, of red twill for the big bed,
embroidered with herons and falcons f. 60

In the cabinet of the above-mentioned bed
Ten falchions of various sorts, including scimitars and
Neapolitan-style swords f. 20

Three swords of various sorts and one two-handed sword
Six rapiers and one French dagger and one little knife f. 18

Three daggers of the Bolognese type, an iron mace
worked in damascene f. 16

A half helmet and a large shield f. 1

Three cuirasses of damasked satin of various kinds f. 45

A chain-mail breastplate furnished with silver buckles
A coat of mail with a tabard of black damask and
A tabard of tan linen with mail sleeves f. 24

Two cuirasses and a doublet of Milanese armor plate, well made f. 50

[folio 7 recto]

In the other cabinet
Two damascene altar candleholders f. 6

Four damascene candleholders for big candles f. 30

Seven half-size torch holders, damascene f. 24

Four table candleholders for candles, damascene f. 8

Two large ewers without spouts, one of which has the
handle broken off, and an inkstand with four feet All of these
Five small ewers with handles are damascene
Two ewers with lids and spouts f. 30

Five damascene pails with handles, from large to small f. 32

Six [liturgical] collection plates and one plate for the altar and
one with a base
Two large water urns, one round and one with a base
Two bronze inkstands, of which one has a cover and crude statues
Seven small brass pulleys f. 24

Three small boxes and a small glass vial f. 10

A large flask with handles
Two large glass bottles
Three cups, two large and one small All this glassware is
Four vases with handles made of crystal of
A small vase several colors
A large jar with a broken spout
Two water urns, one small and one round f. 25

In the drawers under the aforementioned cabinets
A small box, within which is a stone from which spring
white flowers shaped like bells f. 4

Nineteen marble balls of several sizes from large to small
and one of shiny brass that reflects like a mirror

[folio 7 verso]

In the cupboard with seven shelves set into the paneling:
FIRST SHELF

Nineteen plates from large to small
A large vase
Two small vases all in [Chinese] porcelain
A terra-cotta vase of many colors
Four shallow cane bowls in a leather case f. 150

SECOND SHELF

Fourteen earthenware bowls
Eighteen small plates of various sizes, of which 4 are like cups f. 80

THIRD SHELF

Twenty small plates of white and blue porcelain f. 15

FOURTH SHELF

A large platter
Three vases like jars, of which one has a cover and another
is like a flask
Two large ewers all of
Three small casks to use as flasks porcelain
Three blue ewers
Four large white mugs f. 75

FIFTH SHELF

A barber's shaving mug
Eleven soup plates and a saltcellar f. 30

SIXTH SHELF

Nine large bowls of green porcelain
Two blue and white porcelain basins
Four small clay vases
A soup bowl of cane
An earthenware jug with two handles f. 30

[folio 8 recto]

FOLLOWING IS THE SEVENTH SHELF

Ten small footed bowls
A porcelain cup and a clay lamp | f. 20

Following in the same room
A table of cypress wood decorated in walnut with two carved
and inlaid trestles, 4½ br. long f. 4

A walnut stool
An inkwell of bone with little scissors and a sharpener
with a crystal handle trimmed in silver
A brush, a hat mold, and a marble head f. 2

A marble figure in high relief f. 8

An armchair with a moveable back and balusters, decorated in
walnut and intarsia f. 3

A pair of andirons, tongs, shovel, and fork for the fireplace f. 3

Two leather chairs, cardinal style f. 3

A round platter of *lignum vitae* with inlay work and footed
for use as a table f. 10

A boar-hunting spear and a hatchet f. 5

IN THE BATH AND TOILET OF THE SAME ROOM

Benches around totaling — br. in length with foot plinths and
other things belonging to it f. 2

A wooden rake with a handle about 3½ br. long
A box with several nested iron tools and utensils
A sounding gong f. 1

A brass notebook and a small box
Two candleholders and a brass lamp
A foot basin, in brass, and a bed-warming pan f. 3

[folio 8 verso]

CONTINUING THE INVENTORY IN THE ROOM ABOVE THE BATH

A pair of chests that make up into a bed, on which are two pallet
mattresses, one of flax and cotton and one coarse, and a pillow f. 3.10

A white counterpane with little buttons, used and torn f. 2.10

Two chests painted with the livery of the Medici
A cabinet used as a table with a decorated leather cover
A poplar-wood footstool, 1 br. or more long, to sit upon f. 3

Two elephant teeth weighing — lib. that were sitting on the
clothes rack [*cappellinaio*] of the room and were overlooked by me f. —

IN THE GROUND-FLOOR GROOMS' ROOM NEXT TO LORENZO'S ROOM

Four paneled poplar-wood benches ca. 58 br. long f. 4

A cypress-wood table 10 br. long
A poplar-wood table decorated in walnut, 7 br. long
Five trestles and a little cupboard
Many stone balls for catapults f. 3

IN THE ROOM CALLED THE CHAMBER OF THE CLERKS

A tabernacle with doors, within which is a lunette showing Our Lady
and several saints f. 3

A poplar-wood bedstead 6 br. long with walnut moldings and intarsia,
with box benches with 4 lids at the foot, and with cane lattice mat
and trestle and straw mattress and a bench behind the bed f. 5

A mattress on the bed, full of wool f. 2

A down comforter and two pillows full of feathers weighing — lib. f. 10

A blue bedspread, in the Venetian style f. 3

A white bedspread of — br. f. 8

A tapestry panel with figures 8½ br. long f. 8

[folio 9 recto]

A set of white bed curtains with a canopy f. 6

A poplar-wood bed-settle with a clothes rack paneled and painted
to look like walnut, 6 br. long, depicting many things, painted to
appear to be spindle wood f. 1

A thin mattress
A white bedspread f. 1

A bedside rug for the above bed f. 3

A table 8 br. long with two trestles, on which are three portable
writing desks
A bench 4 br. long f. 1.10

A *cassone* 4 br. long, with walnut moldings and intarsia, two
little benches, a cypress-wood chair, a coffer and document case,
several inkstands, scissors, and sharpeners for the use of the clerks f. 2

A head in marble with the features of Cosimo f. 1

IN THE ANTECHAMBER OF THE AFOREMENTIONED CHAMBER

A bedstead 4½ br. long with seat lockers with 2 lids and a straw mattress,
cane lattice mat, trestle, and mattress f. 2

A down comforter and two pillows weighing — lib. f. 5

A quilt made of cotton wool f. 2

A torn tapestry-work blanket f. 1

A white bedspread f. 4

A green coverlet f. 2

Two coffers f. 2

CONTINUING THE INVENTORY IN THE CHAMBER OF
THE TWO BEDS

A lunette painting depicting Our Lady with the child in her arms and
several standing saints, in a tabernacle with a gilt frame and 2 shutters

that open, painted with an Annunciation and a Crucifixion and
several saints, valued at f. 3

A marble head in high relief and a Christ at the foot of the said
tabernacle and above the clothes rack of the bed-settle f. 10

[folio 9 verso]

A poplar-wood bedstead with footlockers with 4 lids with
walnut moldings and intarsia, with a cane lattice mat, trestle
and bench behind the bed and a straw mattress f. 5

Another poplar-wood bedstead 5 br. long with footlockers
with 4 lids, with walnut moldings and intarsia, cane lattice mat,
trestle, and a bench behind the bed and a straw mattress f. 5

A mattress, half in sheepskin and half coarse material, of wool f. 2

A down comforter and two pillows full of feathers weighing — lib. f. 10

A blue bedspread embroidered in the Venetian style f. 2

A fish scale–patterned white bedspread with a frieze of peacocks f. 8

A poplar-wood bed-settle with a clothes rack above, 4½ br. long,
framed and stained to look like walnut and painted, as if inlaid with
spindle wood, with box pattern and peacocks f. 2

Two thin mattresses, one in sheepskin and one in rough cloth
One ornamental seat cover, in place of a carpet bench cover f. 1

Two sets of bed curtains with canopies and pendants and two pieces
of curtain, all in linen cloth, and two curtains for the beams for the
same bed f. 16

A *cassone* of wood, paneled in walnut with
intarsia, 4½ br. long, within which are: f. 2

A tapestry bed-curtain set decorated with figures, that is, a canopy,
two side panels and 4 curtains and a cloth panel; in the panel are figures
who are organizing a tournament and others who fight with lances and
weapons, ca. 9 br. long, and the canopy is of blue tapestry with birds,
herons, and falcons; one side panel has figures and foliage with the motto
"semper" and the other side panel has figures and women mounted on
horses with flowers and dogs, ca. 8 br. long, and six hangings with feathers

and diamonds and mottos that say "semper," all lined in green cloth
and called the bed curtains of Piero, and also two twill curtain sets
of white and red cloth, making 6 panels of 6 br. each f. 100

[folio 10 recto]

Continuing in the cassone in the same chamber with the two beds
An antique tapestry bed-curtain set decorated with figures, with
a panel 10 br. long, two curtains, or rather side panels, of 7 br. each,
one transparent veil 8 br. long and 7 br. wide, with [Medici] arms,
and 3 pendant sections with ducks, the whole ensemble valued at f. 40

Three tapestry bed-curtain hangings with foot soldiers and women f. 3

A bed-curtain set of red twill embroidered with foliage and roses
and, in the middle, figures, including a canopy, a bed blanket,
two side panels, two pendant panels with fringes, lined in red linen,
the whole ensemble f. 60

A bed-curtain set for the antechamber of red twill, 7 br. long, including a
canopy, two pendant panels, four curtains, the whole lined in red linen f. 10

Four curtains of green twill, two with figures and two without, each 8 br. f. 12

A tapestry panel with figures, all worn down to the underweave f. 3

Three bench-back tapestries		
Three benches for the same	with Medici arms between	
	two lambs, each 12 br.	f. 20

Two large panels of foliage, one with peacocks, 8 br. long f. 18

A beautiful carpet, ca. 4 br. long f. 4

Two red curtain pendants, with sheep
An old bench-back tapestry with figures shooting crossbows f. 6

A chess set and chess board all of walnut, inlaid with ivory and
decorated throughout with ivory and carved f. 1

A chess board and chess pieces, all of walnut
A chess board of walnut f. 1

Two *cassoni* of wood, one 3½ br. long, the other 2 br., to go into
the lavatory f. 2

Eight marble heads and one history fragment in a cupboard

Four crude heads in marble f. —

Fourteen coats of mail f. 14

[folio 10 verso]

A tapestry-work curtain with figures, of which no sense
can be made because it is written abnormally f. —

Two porphyry colonnettes, one 1½ br., the other 1⅓ br.
Two other porphyry colonnettes, broken, of 1½ br. each
Two pieces of a porphyry column these are
Two porphyry colonnettes, one 3¾ br., the other 1¼ br. underneath the
A piece of porphyry column three-sided bed
Three bases and three column capitals of porphyry
A slab of porphyry 1½ br. long by 1 br. wide
Three alabaster slabs, each 1 br. long by ⅔ br. wide f. —

A poplar-wood bench, or rather table, with three trestles under it f. 1

A relief of Our Lady with the child in her arms and angels,
all in bronze, one br. long and ⅔ br. wide f. 10

An organ of papier-mâché, well decorated with open fretwork by
the hand of maestro Castellano, on a beautiful base of carved walnut,
all heavily decorated and with the Medici arms and with four
candleholders on which are 4 cherubs, all of the same wood and
workmanship, and 3 bellows with leads f. 200

A papier-mâché organ made in a spiral shape, worked in fretwork
all around in a wooden case with two bellows f. 40

An organ of wood and pewter and with a bass stop, decorated with
foliage and fretwork, gilt, with two bellows, in a case f. 30

A pipe organ, with one pipe per key, in a case f. 50

A little pewter organ for one hand in a painted case f. 10

A harpsichord that functions also as an organ, missing the pipes,
on which are all the other mechanisms and a bellows f. 25

A simple harpsichord with stops in a spruce-wood case f. 25

A double harpsichord with stops, good condition, in a walnut
case and with ivory keys f. 25

[folio 11 recto]

Continuing in the same chamber with the two beds
Two simple harpsichords, small, one by Alexandro degli Alexandri,
in a painted wooden case f. 16

Three bass drones, of which one is in the German style f. 30

A viola with keys for use as a drone f. —

A harp with four strings f. 12

A large lute with eleven strings f. 8

A broken lute, small, in its case f. —

Three large violas of various sorts f. 6

A set of large flageolets in a case f. 12

A set of flageolets used as fifes with black and white rings,
altogether five pipes f. 10

Three pipes with silver rings in a case decorated with silver f. 8

A large tondo depicting a Last Judgment with a carved
walnut garland around, — br. in diameter f. 50

A painting on canvas of 2 br., with a frame, depicting
4 nude half figures f. 10

A painting on canvas of ca. 6 br., depicting the story of Saint Francis f. —

A painting on canvas of ca. 2½ br., depicting a cupboard with books f. —

A panel painting depicting a perspective scene, that is,
the palazzo de' Signori with the piazza and the loggia and
the houses around looking the way they are f. —

Two gilt wooden garlands of ca. 3 br. each f. —

Six poplar-wood racks with pegs to hold weapons f. —

A walnut chair and two little tables f. —

A credenza used as a table, 2½ br. long, of wood f. —

A leather cushion, worn f. —

[folio 11 verso]

IN THE DOORKEEPER'S CHAMBER

A common bed 3 br. long, with a cane mat, straw pallet, and mattress f. 2

A down comforter and a pillow full of feathers, weighing — lib. f. 4

A white blanket, a red cover
A clothes rack with pegs
A brass lantern f. 2

CONTINUING THE INVENTORY IN THE ROOM ABOVE THE STAIR THAT LEADS ABOVE THE LOGGIA, AND FIRST, THE CHAMBER OF BERTOLDO, THAT IS, THE SERVANTS' ROOM

A poplar-wood bedstead with a footlocker used as a bench, the bedstead,
5 br. long, a cane lattice mat, straw pallet, and mattress f. 4

A down comforter and a pillow full of feathers, old f. 6

A white bedspread and a red blanket f. 3

A little poplar-wood table and two trestles
A table on four legs, 1 br. square
An old chest [*forziere*] painted with figures
An open-front cupboard with shelves f. 1

A bronze water pipe weighing 80 lib.
A bronze statue of a nude man, which has one arm broken, 15 lib. f. 10

Two little brass candleholders and a gardening knife f. —.6

A painted panel depicting the Duomo of San Giovanni f. —

A painted canvas depicting the palazzo de' Signori f. —

IN THE GROOMS' CHAMBER

Two poplar-wood bedsteads, each 5 br. long, with a plinth around
A long cabinet—with 4 doors
Two cane mats and two straw pallets and trestles f. 5

Two mattresses filled with [lapsus] f. 2

Two featherbeds and 4 feather pillows, weighing 2 lib., a blue
bedspread, or rather a cover f. 15

[folio 12 recto]

IN THE HOUSEKEEPER'S CHAMBER

A poplar-wood bedstead 5 br. long with a bench locker around and
a cane lattice mat, trestle, straw pallet, and mattress f. 4

A down comforter and two feather pillows, weighing — lib. f. 6

Two bedcovers f. 3

A bench-settle with a clothes rack f. 1

CONTINUING THE INVENTORY IN THE ROOM CALLED THE STUDY HALFWAY UP THE STAIRS

A writing desk and a poplar-wood bench with a spruce-plank back,
and a portable writing desk and a plank shelf all around for the
documents and books belonging to the study, and a small table
of walnut, and a paper spike, all totaling f. —

A brass lamp with a wooden torch in a sconce of tin-plated iron,
fixed into the wall outside the study on the staircase landing f. —

IN THE PASSAGEWAY AT THE TOP OF THE STAIRS WHICH LEADS TO THE CHAPEL

A pine bench decorated in walnut and intarsia 28 br. long f. 4

A panel [actually the fresco by Gozzoli] showing the Nativity of
Our Lord with the Magi on horseback arriving to make their
offerings, 7 br. long, 5 br. wide f. —

Four sconces of tin-plated iron fixed in the wall f. —

IN THE CHAPEL AT THE END OF THE SAID PASSAGEWAY

An altar of red marble carved in front with fluting or rather waves,
on which is a marble slab for the consecrated area f. —

A painting on panel above the altar with columns at the side painted
with fluting like white marble, gilt capitals and gilt cornice and
architrave with a convex gilt frieze depicting cherubim; and in
the painting Our Lady adoring her son whom she has before her
at her feet, and Saint John and Saint Bernard and God the Father
with the dove before him, by — f. —

[folio 12 verso]

A small ivory crucifix fully in the round, with the cross above an ivory
structure which represents the tomb f. —

An ivory pax, on which is a head and a Christ in relief sculpture f. —

Two candleholders of silvered copper f. —

Upon the altar a large finished tablecloth, a large towel
striped in red and blue, a small one with blue stripes and
one of Rheims linen, decorated f. 2

A heavy velvet altar frontal, with an arched border ornament f. 3

An altar step on which is a carpet 3 br. long, old f. 1

Two brass sconces on the pilasters, beautiful f. 4

An altar bell and a bronze damascene lamp stand f. 2

Two ostrich eggs and 2 long-handled torches and candlesnuffers f. —.10

Two sections of wall paneling with seats and kneeling boards below,
with a balustrade, completely in walnut, used for the choir of the
chapel, totaling 22 br. in length and with 16 seats, all inlaid and
worked with spindle wood in a diamond pattern, with an inscription
and coats of arms and intarsia and many other kinds of decoration f. 20

IN THE SACRISTY OF THE SAID CHAPEL

A credenza used as a table made of wood veneered in walnut and intarsia,
within which are: f. 2

Two chalices and two patens of solid silver f. 12

A thurible, an incense boat, a pail with a cover, small, for carrying
holy water with a sprinkler, all these in silver f. 14

A small cypress-wood reliquary, one of ivory, one of brass,
and a little box in which are several relics f. 1

Three statues of the Christ child, of which one has a gown of crimson
satin with pearls and gold all over f. 6

[folio 13 recto]

A towel of linen with stripes of gold and silk
Two hand towels of nettle cloth striped in gold and silk
Two hand towels of coarse linen
Several veils of silk and other materials to cover the chalices f. 4

An altar covering of sky-blue satin, painted with a festoon in the
form of a garland and with the Lamb of God in the center surrounded
by more decorations with a fringe of silk and of gold f. 4

Two altar frontals, one of white damask embellished and studded
with gold, and one of velvet with two decorative borders in green
interwoven with gold f. 14

A velvet chasuble with a decorative border of woven gold f. 8

A velvet chasuble with a decorative border of woven gold f. 15

A chasuble of white damask embellished and studded
with gold with a border embroidered with the apostles
A communion cloth of white damask studded with gold, like above f. 30

A chasuble of crimson taffeta, bordered in white damask f. 4

Four albs, 4 amices, 4 stoles, 4 maniples, and chords to tie the
vestments and several cloths of gold and silk f. 8

Four corporal cloths, embroidered and brocaded, of several sizes,
and a small cushion of red satin embellished with gold in the middle f. 4

Six brass candleholders, from large to small f. 3

A small missal written in pen on vellum f. 10

A box in which is a sacred stone f. —

A marble ball on a colonnette
A marble holy water stoup on a column outside the chapel f. —

[folio 13 verso]

IN THE SALA GRANDE

Benches and paneling all around encircling the room,
ca. 80 br. long, of pine framed in walnut and intarsia,
with the legs of the benches in carved walnut f. 20

A painting on canvas above the door of the room, 5 br. long,
with a gilt frame, depicting a figure of Saint John,
by Andreino [Andrea del Castagno] f. 15

A painting on canvas, with a gilt frame, 6 br. square,
depicting Hercules killing the Hydra f. 20

A painting on canvas, with a gilt frame, 6 br. square,
depicting Hercules wrestling the lion f. 20

A painting on canvas above the door of the room,
4 br. long, with a gilt frame, depicting lions in a cage,
by Francesco di Pesello [Pesellino] f. 4

A painting on canvas, 6 br., with a gilt frame, depicting Hercules
crushing Antaeus, and all these labors of Hercules are by
the hand of Pollaiuolo f. 20

Seven shields with a number of arms of guilds and of the Medici f. 7

Twelve candelabra of tin-plated iron, large, around the room f. 1

Two tables
A large wooden water tub, portable f. 2

IN THE LARGE BEDCHAMBER OF THE SAME SUITE,
CALLED THE BEDCHAMBER OF LORENZO

A lunette tabernacle of carved and gilt wood, 4½ br. high
by 2½ br. wide, within which is Our Lady in marble f. 25

A wooden bedstead 5½ br. long with inlaid images in intarsia,
and carved gilt figures and heads, and a bench plinth around f. 25

[folio 14 recto]

A bed-settle of 5½ br. of the same workmanship f. 25

A *cassone* of 5½ br., of the same workmanship f. 10

A pair of gilt *forzieri* [clothes chests] of 3½ br. each, on which
are depicted the Triumphs by Petrarch f. 25

A back panel for the chests, colored in blue, with falcons
and arms in gold f. 10

A high-backed chair with balusters, in spindle-wood panels
and inlay, 4½ br. long f. 3

A cypress-wood table in spindle-wood panels and inlay, of 4½ br. f. 2

A box-settle with an intarsia pine back, 12 br. long f. 8

A lunette painting 3 br. long, depicting the Holy Land f. 6

A birth salver depicting the Triumph of Fame f. 10

A lunette painting of 2½ br., depicting Spain f. 8

A little tabernacle, depicting within the portrait of a woman
and on the doors, two figures f. 3

A marble bust over the arch of the door of the chamber, a portrait
from life of Madonna Lucretia [Lorenzo's mother] f. 10

A marble bust over the door of the antechamber, showing the head
of Piero di Cosimo [Lorenzo's father] f. 12

An alabaster slab in a wooden frame decorated with ivory, valued at f. 4

A carpet on the table of 5 br., with the nap, valued at f. —

Two panels, one small and one large, within which are
two heads of Christ, in mosaic f. —

Three mosaic panels, showing the heads of Saint Peter and
Saint Paul and one of Saint Laurence f. —

A round mosaic panel, depicting Giuliano di Lorenzo f. —

A square mosaic panel, depicting the head of a young boy f. —

[folio 14 verso]

A marble panel, with a wooden frame, depicting in low relief
the Ascension by Donato [Donatello] f. 15

A nude figure, standing, with a club, in marble, carved in the round	f. —
Another small figure in marble, carved in the round, half sitting down	f. 13
A Flemish painting on canvas, 5½ br. long and 4 br. high, showing architecture, a landscape, and figures	f. 25
A clock of gilt copper with its accessories, 1 br. high by ca. ⅝ br. wide, valued at	f. 25
Four sconces decorated with foliage, set into the wall	f. 4
A prize lily of gilt copper from the horse race of San Giovanni	f. 5
An ostrich egg and a mirrored ball with a silken cord	f. 1
A chair of blue-violet leather	f. 3
A fireplace set, that is, andirons, tongs, shovel, and fork	f. 3
A satin carpet table cover in its own box, 12 br. long	f. 6

On the bed of the same chamber

A straw mattress pad of toweling material	f. 1
Two mattresses full of wool, of which one is of sheepskin	f. 5
A down comforter and two pillows full of feathers, weighing — lib.	f. 10
A set of white-fringed bed curtains	f. 7
A delicate white bedspread A delicate white bedspread	f. 10
A set of bed curtains decorated with foliage, with a bed blanket decorated with figures in the chest of the bed-settle	f. 25

[folio 15 recto]

Two thin mattresses full of wool	f. 1
A white bedspread, 6 br. long	f. 2
A carpet cover for the bench, 6 br. long	f. 4
Two cushions of sky-blue velvet	f. 1

In the first forziere [clothes chest]

A purple *lucco* [man's gown] of English wool, lined with fine squirrel, valued at	f. 22

A *lucco* of rose-colored wool lined in ermine f. 25

A *lucco* of purple wool lined in beige leather f. 40

A loose-weave *lucco* of purple wool lined in crimson leather f. 60

A *lucco* of purple and crimson satin lined in white leather f. 40

A *lucco* of Lucchese silk twill lined in smoky green f. 30

A *lucco* of purple twill lined in crimson taffeta f. 14

A *lucco* of purple twill fully lined in crimson watered silk f. 15

A *lucco* of black twill lined in black taffeta f. 10

A long *vesta* [man's gown] of reddish wool lined in squirrel f. 15

A long *vesta* of purple and rose wool lined in sable f. 30

A *vesta* of purple and rose wool lined in squirrel f. 7

A *vesta* of Flemish gray wool lined in squirrel f. 8

A *vesta* in tan wool lined in sable f. 6

A *vesta* in tan wool lined in silk f. 10

A *turca* [Turkish-style gown] of Moroccan cloth lined in ermine f. 40

A *vesta* of purple twill lined in crimson taffeta f. 20

A *vesta* of purple wool from Brussels lined in crimson watered silk f. 50

A gray woolen *vesta*, on the bed-settle, from London,
lined in crimson velvet f. 40

A bed throw of rose cloth, 5¼ br. long, lined in squirrel f. 20

Another bed throw of gray material, 3½ br. long by 2½ br. wide,
lined in squirrel f. 4

[folio 15 verso]

Continuing into the second **forziere**
A *robetta* [short robe] of crimson damask lined in sable f. 30

One of black satin lined in sable f. 20

One of black damask lined in cat f. 15

One of black damask lined in ermine f. 10

One of purple crimson velvet lined in silk f. 16

One of gray wool lined with puppy f. 6

One of dark purple wool lined with fur f. 6

One of black twill lined in fur f. 6

One of gray Flemish wool lined in fur f. 8

One of loose-weave wool lined in fur f. 6

One of gray Flemish wool lined in fur f. 3

One of black camlet lined in squirrel f. 8

A *robetta* of black damask lined in squirrel f. 3

A *robetta* of loose-weave cloth lined in squirrel f. 10

One of tan wool lined in squirrel f. 3

One of purple camlet lined in squirrel f. 3

One of tan Rhenish wool lined in squirrel f. 4

One of black wool lined in black lambskin f. 4

One of loose woven wool lined in silk f. 7

One of gray wool lined in silk f. 3

A *gammurrino* [woman's short gown] of loose-weave wool lined in silk f. 3

A *pitoco* [cloak or cape] of crimson satin lined in silk
A *pitoco* of black satin f. 3

Six *cappucci* [hoods] of purple loose-weave wool
Four of loose-weave twill
One of dark purple wool
Two of black twill f. 26

Two lengths of purple cloth full of *calze* [stockings], one 15 br. long,
the other 2 br., altogether 17 br. f. 25

A length of dark purple cloth 15 br. long f. 30

A length of fine wool cloth 7 br. in length	f. 12
A length of Rhenish cloth 4½ br. long	f. 7
A *robetta* [man's short gown] of loose-weave cloth lined in black velvet	f. 4
One of gray Flemish wool lined in purple velvet	f. 6
One of black velvet lined in loose-weave cloth	f. 4
One of black velvet lined in black taffeta	f. 5
One of black twill lined in black satin	f. 4
One of pink cloth lined in crimson satin	f. 8
One of loose-weave cloth lined in red taffeta	f. 6
One of crimson damask lined in purple taffeta	f. 8
One of black velvet lined in crimson taffeta	f. 10
One of black damask lined in crimson taffeta	f. 6
One of purple satin lined in crimson taffeta	f. 10
One of black satin lined in purple taffeta	f. 3
One of loose-weave cloth lined in crimson taffeta	f. 3
One of tan camlet lined in purple taffeta	f. 1

A simple *robetta* of black camlet
One of black cloth
One of black cloth
One of black cloth
One of dark purple cloth
One of loose-weave cloth
A *robettino* [short gown] of dark purple cloth and
A *robetta* of dark purple cloth
One of purple cloth shot with pink f. 25

A *mongile* [man's wrap] of purple satin lined in purple taffeta	f. 2
One of black damask	f. 4
Three taffeta *mongili,* of which one is of black taffeta	f. 8

[folio 16 recto]

In the cassone

A *mantello* [cloak] of Lucchese [i.e., silk] cloth, new	f. 25
One of loose-weave cloth, new	f. 15
Two *mantelli* of loose-weave cloth, used	f. 20
A *mantello* of purple cloth, long, for wearing over the gown	f. 14
A dark purple *mantello*	f. 14
A hooded dark purple *mantello*	f. 8
A long *catalano* [long overcoat] of loose-weave cloth with pockets	f. 8
A *cappa* [cloak] of tan cloth with the hood lined in tan velvet	f. 7
A *cappa* of tan cloth, half-lined	f. 3
A *cappa* of pink cloth lined in cloth and with the hood in purple velvet	f. 6
A *cappa* of purple cloth fully lined in tan cloth to wear in the rain	f. 10
A *gabbano* [overcoat] of solid purple cloth lined in tan cloth and with a collar and a hood of black velvet	f. 10
An old *gabbano* of purple cloth lined in tan cloth, with a hood of purple velvet	f. 3
A *borgognone* [overcoat] of solid purple cloth, lined in black velvet	f. 10
A *catalano* of purple cloth with a hood	f. 3
Eighteen pairs of *calze* [hose], solid purple, including *solate e pedali* [soles and slippers] Three pairs of black *calze* Four pairs of pink *calze*	f. 14
One pair of blue *calze* Three pairs of *calzoni* [tights] and one pair and a half of *calze*	f. 2

Continuing in the same cassone

Four *pappafichi* [hoods], three purple and one black A *cappuccio* [hood], purple lined in velvet	f. 2
Two new pairs of *calze*, pink and purple	f. 2

Two *farsetti* [men's doublets] of shot silk material,
one purple and one crimson f. 8

Two *farsetti*, one of purple and one of black damask, new f. 8

Two *farsetti*, one of satin and one of black taffeta f. 3

Two *farsetti*, one of satin and one of watered silk f. 6

Two *farsetti* of crimson satin f. 4

Two old *farsetti* of purple satin f. 2

One *farsetto* of new damask, filled with chain mail f. 6

A box painted like a coffer
Thirty-three *berrette* [caps] of many colors
Two garters, one of purple velvet and one of black velvet
Two tan velvet purses f. 16

[folio 16 verso]

CONTINUING IN THE ANTECHAMBER OF THE SAME SUITE

A little panel painting, depicting Our Lord dead, with many saints
who are carrying him to the sepulcher, by Fra Giovanni [Fra Angelico] f. 15

A marble panel, by Donato [Donatello], depicting Our Lady
holding her child f. 6

A gilt bronze panel, depicting Our Lady with the child in her arms,
completely framed, by Donato [Donatello] f. 25

A panel painting with a gilt frame, depicting Saint Jerome and
Saint Francis, by Pesello [Pesellino] and Fra Filippo [Filippo Lippi] f. 10

A little panel painting, depicting Our Lord crucified with
three figures by Giotto f. 6

A marble panel with many figures in relief and other things in
perspective, that is, — of Saint John, by Donato [Donatello] f. 30

A tondo with Our Lady, small, by Fra Giovanni [Fra Angelico] f. 5

A tondo 2 br. high depicting the story of the Magi, by Pesello [Pesellino] f. 20

A lunette 1½ br. high depicting Rome f. 20

A lunette of 4½ br. depicting the universe [Last Judgment]	f. 50
A marble panel over the study door with five antique figures	f. 10
A little marble panel with antique figures	f. 8
A lunette of 3½ br. depicting Italy	f. 25
A lunette of 2½ br. with two portrait heads, that is Francesco Sforza and Gattamelata, by the hand of a Venetian	f. 10
A bench-locker 10 br. long, with a pine back, walnut panels, and inlay A brass candlestick with foliage decoration	f. 5
A plain poplar-wood bedstead, 4½ br. long, and a bundle of cane	f. 1

[folio 17 recto]

Three mattresses, that is, one of rough work and one full of wool on the bed and one of white cotton full of cotton batting	f. 6
One down comforter, two pillows full of feathers, weighing — lib.	f. 10
One half quilt One thin white bedspread	f. 7
A white bed-curtain set with all the pieces	f. 10
A cypress-wood bed-settle decorated in walnut and inlay	f. 4
A bench pad on the settle and a white spread	f. 5

In the cassone of the bed-settle
A set of embroidered red twill bed curtains	f. —
A bed quilt	f. 3
A carpet table cover, 5 br. long	f. 6

CONTINUING INTO THE STUDY

A large jasper wine cooler with two handles decorated with gilt silver, weighing 13½ lib., valued at	f. 2,000
A medium-size jasper wine cooler, similar to that above, without handles, decorated with gilt silver, weighing 5 lib., valued at	f. 500

A medium-size jasper wine cooler, decorated similarly to the one
above without handles, weighing 4½ lib., valued at f. 500

A sardonyx ewer with a handle of the same material, with base and
pouring spout of gilt silver, weighing 11 lib., 3 ounces, valued at f. 2,000

A crystal ewer with a handle and cover and spout, decorated with
gilt silver, weighing 9 lib., valued at f. 800

A cup of variegated sardonyx with handles, with a base of gilt silver,
weighing 2 lib., 9 ounces f. 600

[folio 17 verso]

A large cup made of agate and sardonyx with handles, with base
and cover of gilt silver, weighing 5 lib., valued at f. 650

A crystal goblet with a crystal cover framed in gold, on which on the
base are 6 sapphires, 6 balas [rose-tinted] rubies, and in which are twelve
large pearls, and three more balas rubies with three pearls each in three
figures of enameled gold and in the cover 7 sapphires and 7 balas rubies
and 14 large pearls and 27 rubies and among the rubies 12 pearls and
on top a diamond, weighing 3 lib., 4 ounces, valued at f. 800

A crystal cup on three feet, decorated with enameled silver, crafted
in the German fashion with the cover done in the same way,
weighing 6 lib., valued f. 150

A cup of crystal segments carved with foliage, decorated in silver,
base and cover finished and polished, weighing 2½ lib., valued at f. 50

An agate and sardonyx cup decorated in gilt silver,
weighing one lib., 5 ounces f. 50

A cup of jasper and amethyst with a cover, decorated in gold,
on the base 12 rubies, 18 pearls, and on the cover 18 rubies, 18 pearls,
weighing 2 lib., 4 ounces, valued at f. 400

A crystal pitcher with a crystal cover decorated in gilt silver,
weighing 2 lib., 5½ ounces f. 80

A jasper cup with handles and cover completely decorated
with gilt silver, weighing 2 lib., 8 ounces f. 400

A jasper bowl with a gilt silver base and rim, weighing
2 lib., 8 ounces f. 60

A jasper ewer with handles and cover completely decorated
with gilt silver, weighing 8 lib. f. 600

An amethyst cup, weighing 2 lib. f. 20

[folio 18 recto]

An agate urn embellished with a rim, handles, and a base of
gilt silver in an ivy pattern, weighing 9½ lib. f. 400

A cup of jasper, chalcedony, and amethyst, with a gilt silver
rim and base, weighing 2 lib., 4 ounces f. 150

A goblet of jasper streaked with yellow and chalcedony with cover
and rim and base decorated with silver and gold and one pearl
at the top of the cover, weighing 2 lib., 3 ounces f. 200

A jasper urn, not too large, with a base and rim of gilt silver
in segments, weighing 5 lib., 10 ounces, valued at f. 200

A cup of jasper and amethyst with the rim and the base of silver,
weighing 5 lib., 10 ounces f. 50

A goblet with a crystal cover with three little cherubs for a base,
decorated with gilt silver, weighing 1 lib., 3½ ounces f. 80

A cup of green jasper and sardonyx, with cover, smooth finished
rim, and base of gilt silver, weighing 3 lib., 8 ounces f. 150

A two-handled cup of jasper streaked with white, with base and
rim of gilt silver, weighing 3 lib., 10 ounces f. 300

A bowl of sardonyx, chalcedony, and agate, within which are
several figures and on the outside a head of Medusa,
weighing 2 lib., 6 ounces f. 10,000

A unicorn horn, 3½ br. long, rough estimate f. 6,000

Cameos
A cameo framed in gold, with four figures and the story of Icarus
and Daedalus, incised on the reverse with diamonds and arms
and an inscription, valued at f. 400

A cameo framed in gold, depicting three figures leaving a forest,
on the reverse incised branches and roses f. 100

A cameo framed in gold, depicting women who lead a baby seated
on the back of a lion, incised on the reverse with diamonds,
feathers, and an inscription f. 450

[folio 18 verso]

A cameo framed in gold, depicting a man and a woman who comprise
an emblem, carved on the back with branches and flames f. 120

A cameo framed in gold, depicting a man kneeling and a seated
woman who leans on him and a child at the feet of the woman,
and on the reverse a carving of branches and roses f. 100

A cameo framed in gold, on which are two cherubs with a column
in the middle; at the side of one of them is a cock and he holds
a palm frond in his hand, and next to the other another cock,
with a red background, and on the reverse carved foliage f. 100

A carnelian framed in gold carved out with a sea monster with
a woman on his back, without a reverse on the other side, valued at f. 50

An amethyst framed in gold, on which is carved out a figure with
a kithara, nude and with a mantle on his back and at his side a javelin
and a little figure, without a reverse, transparent f. 60

A carved amethyst, no frame, on which are two sea monsters
in the water, with busts of horses, transparent, without a reverse f. 80

A cameo framed in gold, with reclining figures and 2 children
placed in the middle and 2 at the feet who embrace each other,
and green foliage, black background without a reverse, with an
inscription of golden letters on a black background f. 30

A green, white, and black agate with a female monster reclining
with a child in the sea, with an inscription on the reverse f. 25

A cameo framed in gold, depicting three children who are
working at handcrafts with a tent above from which hang various
instruments which they produced, red background, on the reverse
a niello carving of a deer f. 200

A cameo framed in gold, with 2 half figures, one a faun,
the other a young man, black background, on the reverse
incised branches and roses f. 30

[folio 19 recto]

A cameo framed in gold, with a centaur in sardonyx on a white
background carrying a bowl of fruit on his shoulder, dressed in
a lion skin, a thyrsus in his hand, and carved on the back with
a diamond, feathers, and an inscription f. 500

A sapphire framed in gold, carved out with the head of a woman
dressed in a wild animal skin, transparent, no reverse f. 100

A cameo framed in gold with two half-nude women, the one seated
with a child in her arms, the other standing, leaning against a tree,
carved on the reverse with a diamond, feathers, and an inscription f. 300

An amethyst framed in gold, carved out with the head of a woman,
nude, with an abundance of hair, transparent, no reverse f. 100

A cameo framed in gold, on which is a figure carved in more than
half relief, rising from a kneeling position, and a child wearing a
lion skin, black background, reverse carved with branches and roses f. 150

A cameo framed in gold, with two figures carved in more than half
relief, one a nude woman leaning on a rock with her clothes half-off,
with 2 cherubs at her feet, and the other a nude monster standing
before her with a bit of cloth in his hand, carved on the reverse
with diamonds and feathers f. 200

A large cameo framed in gold, with two figures in half relief, a man
and a woman with a tree between, with two serpents at its foot,
black background incised on the back with a falcon, a diamond,
and an inscription f. 800

A large cameo framed in gold, called the Ark, depicting 8 figures,
4 men and 4 women, an angel in the sky, a pair of horses, 2 lions
and many other animals, carved on the reverse with foliage f. 2,000

A cameo framed in gold, with two figures, one tied to a tree with
his hands behind his back, who is thought to be Prometheus,
the other with wings at his feet and the caduceus in his hand,
both nude, carved on the reverse with foliage f. 150

[folio 19 verso]

A cameo framed in gold, with two figures and a horse in more than
half relief, one figure nude and upright with one hand in the mane
of the horse and in the other a club, the other figure dressed and
standing on the ground, black background, incised on the reverse
with branches and roses f. 500

A cameo framed in gold, with two figures and a lion, and [one of them is]
Venus, who is seated holding a cloth, with Cupid at her feet, who leads
the lion with a bridle and a whip in his hand, black background, and
on the reverse incised foliage f. 300

A cameo framed in gold, with the head of a young man in relief
with the head and skin of a lion against a black background,
reverse incised with foliage f. 200

A cameo framed in gold, on which are four figures, two women and
two men, one man seated with a dog standing in his lap, and the
other figure with a staff in his hand leaning against a tree, and one
of the women wearing a mantle of sardonyx and the other dressed
in sardonyx and black chalcedony, the reverse incised with a
diamond, feathers, and an inscription f. 500

A cameo framed in gold, with the sea sculpted with a monster
with a nude woman on his back, with a mirror in her hand, black
background, the reverse incised with foliage and cherubs f. 200

A cameo framed in gold, with a sea on which is a bull carrying a
nude female holding a light cloth, a child hanging on the tail
of the aforementioned animal, black background, reverse carved,
or rather incised, with branches and roses f. 250

A cameo with two figures, one male and one female, embracing,
framed in gold, with fruit in their arms, red background,
reverse carved with foliage f. 80

[folio 20 recto]

A cameo framed in gold, carved out, depicting a nude figure in
front of a tree, a child with a wheel, a figure at the side with arms
extended, a cherub on a rudder who spews fire, dragged by two
figures barely dressed with veils, red, carved with branches f. 1,000

A chalcedony half carved out, with a figure seated on an altar with
one foot beneath him and his left leg extended, one arm behind
holding a knife, wearing clothes, and one arm straight out holding an
armed man [framed] in gold, transparent background, no reverse f. 1,500

A large carnelian with three figures carved out in more than half relief,
one partially clothed and standing with a lyre in his hand, with a nude
figure kneeling at his feet, the other with the head of an old man, seated
with his hands behind him tied to a tree, no reverse, transparent,
framed in gold f. 1,000

A carnelian framed in gold on which is carved out a wagon with a
figure aboard drawn by 4 horses running over two figures, one lying
down and the other half-kneeling, transparent, no reverse f. 1,000

A cameo framed in gold, carved in more than half relief a nude
figure seated above, one foot on a rock, a child behind his left
shoulder, in his outstretched arm a bunch of fruit, at his feet on
the rock a shepherd's crook and a reed pipe, black background,
carved with a diamond and arms f. 800

A cameo framed in gold, carved in relief a bacchante with a lion skin
and head on his left arm and a staff of Bacchus in his right, carved
on the reverse with foliage f. 400

[folio 20 verso]

A cameo framed in gold, with a figure drawn by two horses,
carved on the reverse with foliage f. 500

A cameo framed in gold, carved with the figure of an old man seated
with his head down and in his hands a cherub to which another
figure of an old man, also seated, offers a stick, on the reverse a niello
inlay of foliage and a head f. 400

A cameo framed in gold, on which is a wagon carrying two figures
drawn by two lions, on one of which rides a cherub, the reverse
incised with a deer f. 500

A niccolite with an octagonal gold frame, incised with the head
of Vespasian f. 40

A carnelian incised with the bust of a young man from the shoulders up,
framed in gold f. 25

A cameo on which is a lion, red against a white background,
framed in gold, the reverse carved in branches and roses f. 20

A carnelian carved out with the bust of a woman as far as her breasts,
framed in gold, reverse carved with a monster and a figure on it f. 40

A carnelian carved out with the head of a woman with short hair
down to the base of the neck, framed in gold f. 20

A carnelian carved out with a head down to the beginning of the
shoulders, where clothes appear, with a scarf on its head, framed in gold f. 15

A small carnelian on which are many tiny things, framed in gold f. —

A stone streaked with many colors carved out with a Capricorn
with a cornucopia, framed in gold, undecorated on the reverse f. 10

[folio 21 recto]

Continuing in the same study with rings
A gold ring on which is mounted a green quartz carved out with the
head of an old man down to the base of the neck, where clothes
begin to appear f. 30

A niello ring with a mounted carnelian incised with a head,
including the neck f. 30

A niello ring with a green quartz on which is incised a beardless
head with the whole neck with foliage under the chin f. 20

A gold-band ring with a mounted green quartz on which is carved
out the port of Ostia f. 10

A serpent ring to which is attached a carnelian on which are incised two
figures, one riding on a he-goat, the other leading it by the bridle f. 20

A gold ring with a mounted carnelian incised with a figure seated
at the foot of a column, on which is an idol f. 15

A gold-band ring with a mounted carnelian on which is incised
a Pegasus with 5 letters f. 15

A gold ring with a niello inscription "L . o" mounted with a chalcedony
or niccolite on which is carved out a figure of a man who has in his
right hand a cornucopia below his waist and a symbol of faith, that is,
two hands that clasp f. 12

A gold-band ring with a mounted carnelian on which is carved a figure
of a seated woman leaning against a tree and another figure kneeling
on one knee who offers her a very small statuette f. 20

A gold ring with a mounted carnelian incised with the port of Ostia f. 10

[folio 21 verso]

A gold-band ring with a mounted carnelian on which is carved out
a figure lying down and another who throws himself upon him f. 10

A gold ring on which is mounted a jacinth incised with the bust of
Antinous from the top of the shoulders, where the clothes begin f. 10

A gold-band ring mounted with a carnelian on which is incised a head f. 25

A gold ring with a mounted cameo on which is carved in relief an
antique mask in profile f. 10

A gold-band ring on which is a cameo carved in relief of a child
seated on a cloth in the water f. 20

A gold ring with a mounted cameo on which is carved in relief
the bust of a woman down to the waist with a mantle slung over
her shoulder who expresses milk into a cone f. 20

An enameled gold ring with a mounted cameo on which is carved
in relief the head of a horse f. 10

A gold ring with a mounted cameo carved in shallow relief with the
head of an old bald man with the flesh all red and the hair white f. 40

A gold ring on which is mounted a cameo carved with a mask
seen full-face f. 20

A cameo brooch carved in very high relief with a sea monster
on which cavorts a winged cherub with antennae on his head f. 20

A gold-band ring on which is mounted a cameo with an antique lyre
carved in relief f. 10

[folio 22 recto]

An unmounted carnelian on which is carved out a head f. —

An unmounted jasper stone on which is carved out the bust of
a Victory down to the waist, holding a palm and winged f. —

An unmounted carnelian on which is incised a head down to the shoulders	f. —
An unmounted shell incised with a head which has another on the other side, that is, a Fortuna holding a cornucopia and a rudder	f. 10
A seal of silver on which is mounted a carnelian carved out with a head and another on the other side	f. 10
A gold-band ring on which is mounted a fine moonstone	f. 10
An amethyst in a gold frame with a suspended white spot in the middle that you would swear was air	f. 25
A shell mounted on a ring with 2 children who gather grapes, in relief, mounted by Piero	f. 15
A mother-of-pearl shell within which is a nascent pearl less than half-embedded, estimated at 15 carats, the shell weighing — ounces, 22 *denari*	f. 300
Another mother-of-pearl shell within which, in a similar fashion, is a pearl more than half-formed, estimated at ca. 14 carats, the shell weighing 1 ounce, 7 *denari*, edged in natural black around the shell	f. 300
A table-cut sapphire stone on a ring framed with a band with enameled studs	f. 400
A little diminutive ring framed in gold on which is a green quartz carved with an animal	f. —
A convex octagonal sapphire framed with a band with enameled studs	f. 250
A table-cut emerald framed in a slender band with studs on a gold ring	f. 100
A table-cut emerald framed in a plain band	f. 60

[folio 22 verso]

A cup ruby framed in a plain gold band	f. 80
A thin table-cut balas ruby framed in a plain gold band	f. 500
A table-cut diamond framed in a plain gold band	f. 120
A table-cut ruby in a gold band	f. 40
Another table-cut ruby in a gold band	f. 40

A perfect turquoise in a gold band f. 200

Another perfect turquoise in a gold band f. 200

A faceted diamond with eight lunettes in a plain gold band f. 60

A conical diamond cut in the shape of a lily f. 100

A pearl set in a thin-band ring enameled in black, ca. 5 carats f. 50

A pearl set in a gold band embellished with niello rosettes, ca. 3½ carats f. 18

A table-cut emerald in a gold band f. 25

A ruby in a gold band, small f. 12

Ten loose round pearls weighing 2½ denari f. 10

Three round pearls without holes, 12 carats f. 90

A table-cut balas ruby in a bezel with gold niello work f. 60

A pair of gold sacks with 97 pieces, half silver and half gold,
each weighing 3 ounces, 9 denari f. 150

A small spinet used as a jewelry box for pearls and rubies f. 300

A golden reliquary in the form of a tabernacle with six shutters,
within which are 8 pearls of 3½ grains each and 6 balas rubies,
weighing altogether one lib. and 6 denari, with the case furnished
with door locks and chains and hinges and keys all in gold,
valued altogether f. 1,500

[folio 23 recto]

A square ebony panel on which are 40 heads of saints in forty frames f. 25

An enameled gold tondo on which is depicted the figure of Our Lady
with the child at her neck, weighing 2 ounces, 6 denari f. 30

A square gold plaque on which is God the Father in blue enamel with
robe and background in russet, and on the other side a Saint John the
Baptist in the desert, dressed in russet, weighing 1 ounce, 11 denari f. 30

Another gold plaque on which is Saint Catherine with her wheel,
dressed in reddish-blue enamel, and on the other side Our Lady
seated on a throne enameled in russet against a blue background f. 30

Gold buckle for a belt enameled in reddish roses with letters and
with belt decorations, weighing 5 ounces, 11 *denari* f. —

Another set of belt buckle parts enameled in roses with branches
and letters in relief, weighing 8 ounces, 6 *denari* f. —

Another set of belt furnishings enameled in red roses [*di roggio a rose*],
weighing 8 ounces f. —

A gold base broken from a vase enameled with red and white roses,
weighing 3 ounces, 15 *denari* f. —

A small gold box enameled outside and inside with roses and parrots,
weighing 4 ounces f. 60

A gold pomander ball with bars and roses enameled in white,
weighing ca. 3 ounces f. 40

A gold altar reliquary with 10 places for various relic holders and
in the middle a sapphire, carved in relief with the half figure of
God the Father, in an oval shape, with many letters in niello on the
reverse, and with the names of the relics f. 300

A large round gold Agnus Dei medallion surrounded with 13 pearls f. 16

Two book pointers in antique gold with eight pearls on each,
weighing 2½ ounces f. 20

[folio 23 verso]

A gold altarpiece with two closing covers, in one an enameled
Annunciation, and in the other a Crucifix with two Marys at the
side, on the outside a Saint John the Baptist and on the other a
Saint Catherine in enamel, weighing one ounce and 18 *denari* f. 20

An open bracelet embellished with gold f. 15

A gold Agnus Dei medallion with inscription, in niello work,
with 11 pearls around, weighing 11 *denari* f. 6

A little altarpiece with an image of Our Lady with the child
in her arms, in gold, in low relief f. 3

Six enameled Milanese gold-band rings, weighing 1½ ounces f. 10

A gold pendant with a small ruby and a diamond with 5 hanging
pearls, enameled on one side with the Annunciation in Greek
enamel and on the other, Our Lady with the child at her side f. 15

Four small Agnus Dei medallions in gold enameled in red, one
with a dark diamond and a little chain, weighing 1 ounce f. 20

Seventeen large and small gold belt decorations weighing 12 *denari*,
and a hood for a sparrow hawk f. 3

Two gold-band rings with a bezel, on one of which is a stone, enameled
on one side and nielloed on the other, and the other enameled on both
sides with a little enameled clasp, they weigh 18 *denari* f. 6

Three fish teeth with two ferrules, of gold
A loose throwing stone f. 2

A loose gold medallion, with the features of Cosimo
Another gold vase of Saint Louis of Pisa
Two Greek medallions
A Volto Santo [crucifix] f. 12

[folio 24 recto]

A ring with a niello inscription around and Saint Christopher on top f. —

A ring with a broken chrysolite
An Agnus Dei medallion with, on the other side, an Agnus
Dei in niello and an inscription, weighing altogether 12 *denari* f. 3

An Agnus Dei medallion with 9 small pearls around it, on one side
a crystal incised with a painted flagellation of Christ, on the other
side a crystal with the Madonna with child f. 2

A gold pendant for use as an Agnus Dei, on one side a Saint Catherine
in enamel with a red background, on the other Our Lady with a
standing child, worked with a burin, a circle of 28 little balls around,
weighing 8 *denari* f. 4

Fourteen enamels, of which 7 are angular shaped and seven almond
shaped, with foliage and piercings and gold frames, weighing
2 ounces, 20 *denari* f. 30

Two gold clasps for hat cords with enamel letters in relief and a gold
knob for a cord enameled and squared up, with enameled white and
red rosettes, weighing 1 ounce, 12 *denari* f. 12

An incense boat of chalcedony and sardonyx with a little gold base f. 8

A jasper cup in 3 pieces, from the middle down hexagonal and from
the middle up 12-sided, weighing 3 lib. f. 50

Two large striped cameo paternosters, one plain weighing 7 ounces
on a silk and gold cord and one of chalcedony, 4 ounces, 6 *denari* f. 2

3 sewing needles and 2 fish teeth like arrowheads
A gilt cameo frame
A silver nugget
A book lock
Sixteen silver Agnus Dei medallions
A mother-of-pearl shell
A cross with several relic compartments f. 8

[folio 24 verso]

A string and corals, on which are 15 gold buttons and a gold Agnus Dei
with a heart, within which are a Volto Santo and a crucifix,
weighing 2 ounces, 12 *denari* f. 8

A silver mirror weighing 1 lib., 5 ounces, on one side the infant [Christ],
on the other a diamond and coat of arms with branches around f. 14

A saltcellar in three pieces joined with gilt silver, weighing 7½ ounces f. 6

A small crystal goblet embellished with gilt silver, weighing 7½ ounces f. 10

A saltcellar with little of the crystal interior, the rest in gilt silver,
weighing 7 ounces f. 4

A sand clock [hourglass] embellished with silver, weighing 21 ounces f. 12

A clock in the shape of a tabernacle, with moving parts and casing
of gilt copper, that runs without a counterweight, with enameled
Medici arms and cherubs on the face where the hour is displayed f. 40

A clock embellished with gilt copper, in the form of a tabernacle,
that runs without a counterweight, with enameled coat of arms and
cherubs on the face which displays the hour f. 20

Another clock running in the same fashion and with a similar shape f. 15

Two box-shaped clocks, each with 8 faces, of gilt copper, running without
counterweights, with enameled arms on the face and figures in niello f. 50

Another box-shaped clock and with three faces, similar to the one above,
but without enamels or Medici arms f. 20

A triangular lantern decorated with gilt copper and silvered, in the
form of a tabernacle with a round crystal at the center f. 10

A goblet of gilt silver worked in the damascene fashion,
weighing 1 lib., 1½ ounces f. 15

[folio 25 recto]

Three damascene ewers with handle and spout, 2 with cover f. —

Another damascene jug without a spout f. 200

Three openwork damascene pomander balls for use as perfumers f. 100

Two lamps and one damascene cover with chains f. 60

A clock in a copper case for use as a poor box with a face of silver niello f. 25

Two perfumers, one with a handle, the other without, damascene f. 35

Three damascene inkstands f. 40

A perfumer with a handle mounted on 3 feet f. 25

An openwork German perfumer with 6 sides f. 3

Two bowls, one with a cover, the other without, damascene f. 15

An inkstand with two silver hinges and an enamel on the clasp with
the Medici arms worked in silver and gold f. 100

Another inkstand, square, hinges, clasp and corners in silver,
more roughly worked f. 50

Three long inkstands with round heads, ca. ½ br. each f. 100

A spice box in damascene work f. 25

A damascene pen case f. 8

Two little ivory barrels with hoops, spout, and feet of silvered copper f. 20

Two crystal spoons with enameled silver bowls and
a ferrule in the middle
A square panel with a Saint Michael Archangel carved in
relief surrounded by a gilt silver frieze with 8 busts of saints f. 20

[folio 25 verso]

Another square panel showing Saint John the Baptist in small mosaic
with a fretwork frame with a gilt silver inscription worked in
the Greek manner f. 25

Another larger panel depicting the figure of Saint John the Baptist
from the waist up, with mat and frame in pierced silver and with
Greek letters with 10 insets of half figures in mosaic f. 80

Another larger panel of ⅔ br. in which is depicted in mosaic a figure
of Saint Peter from the waist up, with a gilt silver frame with 10 inset
reliefs depicting many stories, Greek workmanship f. 30

Another smaller panel depicting in mosaic Our Lady standing,
a little damaged, with a gilt silver frame divided by lines with eight
insets of half figures in relief f. 20

Another panel all in silver and enameled, frame and insets, two figures
in the frame, one of Saint Peter and one of Saint Paul, in the middle
a figure of Christ standing, in mosaic f. 30

Another panel depicting two standing figures in mosaic, Saint Peter
and Saint Paul, with a gilt silver frame around decorated with foliage,
and inset compartments f. 40

Another panel of ⅔ br. with the image in mosaic of a saint,
gilt silver frame with much foliage and 12 compartments with
busts of saints in relief f. 30

A soapstone tablet carved in the center with Our Lady with the child
in her arms, standing, and a frame around in the same stone carved
in relief with half figures of the 12 Apostles and also a gilt silver frame
with much foliage and insets and with 4 reliefs inset in the corners
with champlevé enamels of busts of the 4 Evangelists and several
stories of Christ in the other compartments on the frame f. 40

[folio 26 recto]

Another panel of ¾ br. with surface and frame in silver, with insets
worked in lines, and on the frame worked in the same fashion,
12 compartments with relief figures and stories of Christ, in the
center a half figure of God the Father painted with a brush, with
a crown in relief made of silver f. 60

A panel with the story of Judith in mosaic with a silver frame
decorated with much foliage in relief, eight compartments depicting
half-length figures in relief f. 20

A panel of ½ br. depicting in mosaic an Annunciation, with a gilt
silver frame with eight inset compartments with half-length figures f. 40

A panel of ½ br. or more with a picture in the middle of Our Lady
standing with the child at her neck and two saints and angels at the
side, carved in relief in soapstone, the frame around with 16 pictures
carved with half figures in relief, partly in steatite and partly in ebony,
and another frame in gilt silver fretwork with eight pictures in
compartments in enameled silver, within which are many saints f. 40

A little panel of ¾ br. with a picture of the deposition of Christ
from the cross with nine figures from the hand of Giotto f. 10

Twenty-five paternosters of unicorn horn f. 100

A dagger, a little knife, a fork with a unicorn-horn handle,
decorations, and end pieces, and the case in gold f. 500

A damascene coffer, silver hinges and clasps, worked inside and
out with other gems and cameos, in length ½ br. or more f. 40

Another damascene coffer, silver hinges and clasps, worked inside
and out with other gems and cameos f. 40

[folio 26 verso]

A small panel ¾ br. wide by ½ br. high with 18 little pictures,
within which are carved in relief the story of Christ, a gilt silver
frame, an interlacing, insets, and pictures f. 40

A book written in pen on vellum, Bolognese quarto, of 100 novellas,
covered in scarlet velvet with 4 gilt silver clasps, with arms and
studs in silver f. —

A Sforza book of vellum, beautiful, with 4 silver clasps and in the
center and at the corners enamels and arms of the duke f. —

A book of Sonnets and Songs of Petrarch on handmade paper,
written by the hand of Boccaccio f. —

A small book ¼ [br.] long by ⅙ wide, covered in turquoise-blue
leather, silver clasps, the Canticles of Dante f. —

Another volume of the same work by Dante, ⅕ [br.] long by 1/12 wide,
perfect letters, written in pen on vellum, with a purple leather cover,
silver clasps and studs f. —

A book by Messer Francesco Petrarch, Songs, Sonnets, Triumphs,
pages of handmade paper, written in pen and richly illuminated,
with a cover in green velvet, silver clasps and studs f. —

A book of Dante, large, on handmade paper, written in pen and
richly illuminated, covered in green velvet, silver clasps and studs f. —

A book of the work of Petrarch, Songs and Sonnets, on pages of
handmade paper, covered in leather f. —

A book of sacred subjects, Offices and the Gospels, written in pen
on pages of handmade paper, covered in leather and with a wrapper
of purple velvet, clasps in silver f. —

A little book of Offices of Our Lady, with pages of handmade paper,
covered in crimson velvet, illuminated in many ways, a silver clasp f. —

[folio 27 recto]

A Psalter written in pen on pages of handmade paper, covered in
crimson velvet embellished with silver f. —

A Psalter in Greek, written in gold letters, with illuminations and
ornaments in Greek style, covered in crimson satin f. —

A little book of the Offices of the Madonna, with silver boards, pearl
accents, and the boards decorated with gilt silver fretwork with
rubies in place of bosses on each face, blue paper with gold letters
with many illuminations, and in the center of the covers a rock crystal
with seven miniatures f. —

Another little book of the Madonna, very small, with boards in
enameled gold, an Annunciation on one side and on the other a
Saint John the Baptist and a Saint Mary Magdalene in enamel f. —

A book of Petrarch's work, first the Triumphs, illustrated and illuminated,
written in pen on pages of handmade paper, and the Songs, Sonnets,
and the Vita of Dante, covered in crimson satin, with many insets,
that is, six on each side with Medici arms in enamel, 4 bosses on each
side, one at each corner, and 4 enamel medallions, within which are
the Muses, and one in the center depicting the sun, and gilt silver
framing pieces, altogether f. —

A book of epigrams from ancient sources, on pages of handmade
paper, that is, in Greek and Latin, covered in purple leather f. —

A little woman's book, with several Offices, covered in dark purple
leather, hinges in silver fretwork with niello jade f. —

One volume of a Bible, covered in crimson velvet with silver clasps,
transalpine, quarto, in vellum f. —

A little Psalter in pages of handmade paper written in pen with
illuminations and arms, symbols of the Medici, accented with little
pearls, covered in green satin and with a wrapper in red chamois f. —

A Pandects f. —

[folio 27 verso]

A string of corals with 15 silver beads strung on a line and an openwork
gilt pomander ball for musk, weighing 6 ounces, 6 *denari* f. 5

Another string of large corals with a chalcedony bead, weighing
13 ounces, 12 *denari* f. 4

More strings, that is, two of small corals, another string, one a
little thicker than the others, weighing 8 ounces f. 4

A string of chalcedony and jasper paternoster beads with a large
bead at the beginning, altogether 39 beads f. 2

A string of crystal paternoster beads with 3 large beads and a cross,
altogether 89 beads f. 2

Another string of chalcedony and jasper paternoster beads with some
glass beads mixed in, numbering 52, cord and tassel of green silk f. 1

Another string of large chalcedony paternoster beads, numbering 10,
with a cord f. ½

Five strings of medium-size paternoster beads, altogether numbering
104, of chalcedony f. 2

A string of black amber paternoster beads, large, 11 medium size,
gold and silver cord and tassel, crudely worked f. 2

Three strings of largish black amber paternoster beads, numbering 372 f. 6

A string of black amber paternoster beads, variously worked,
numbering 43 f. 1

A bowl of oriental conch shell and two mother-of-pearl medallions f. —

A string of large amber pieces, that is, numbering 20 f. —

Three strings of paternosters of small amber with crosses and roses
of the same amber, numbering 89, two strings of paternoster beads
of enamel set in gold, numbering fifty-two f. 4

A belt of damascene brocade, buckle and tips in silver enamel f. 8

A belt of damascene brocade and green attachments, weighing 1 lib. f. 7

[folio 28 recto]

A belt of silver damascene brocade, buckle and tips in whitened silver,
weighing one lib. f. 8

Four dog-collar sets, with gold brocade collars and with leash and tips
in silver, weighing one lib., 6 ounces f. 6

Two knives in a case, with jasper handles and gilt silver ferrules
and collars f. 4

An ivory tablet which closes like a book, ½ br. high or thereabouts,
one side carved in relief with many figures, that is, the story of Christ
on the cross, on one side with Mary and the Apostles and angels, on
the other Our Lady seated with the child suckling at her breast, at
the side a Saint John the Baptist and Saint James with several angels f. 20

A little panel in a cupboard, depicting Judith with the head of
Holofernes and a servant, the work of Andrea Squarcione [Mantegna?] f. 25

A little panel from Flanders, on which is a Saint Jerome in his
study with a bookcase with many books in perspective and a lion
at his feet, the work of Master John of Bruges [Jan van Eyck],
painted in oils, in a slipcase f. 30

A little panel depicting the head of a French woman, painted in oils,
the work of Peter Cresci of Bruges [Petrus Christus] f. 40

An ivory chess set which folds like a book, ¼ br. on one side and
1 br. the other, with several frames and compartments of ivory of
many shapes, and in the 4 corners compartments with Medici arms
and livery in enamel, with the chess pieces, the board, and dice f. 30

A little panel in the form of a cupboard in which is an alabaster
relief of Jupiter in the water in the guise of a bull with a woman
called Europa on him f. 10

[folio 28 verso]

A crystal jug used as a flask with neck, handles, body, and feet,
the lid and rim decorated in silver f. 40

A nude in bronze fully in the round, height ca. ¾ br., called
the Nude of Fear f. 6

A bronze nude with a mantle slung over his shoulder and wings
on his head, ca. ⅓ br. high f. 4

Another nude, a figure of Hercules, without legs f. 2

Two pieces of Syrian jasper, very thin, polished on all sides,
a square and a little pyramid ca. ⅔ br. long by ½ br. wide f. 40

An octagonal piece of jasper set into a wooden frame, broken f. 8

A little cup with a base enameled in silver in Parisian fashion
and on the bottom a silver rim and base f. 10

A mixing bowl for lye, damascene f. 6

Three small bronze heads

Two hundred and eighty-four antique silver coins, weighing 2 lib., 7 ounces, 12 *denari*

Two hundred coins of various sizes, weighing one lib., 3 ounces

A porphyry box without a lid or a bottom, thin, ⅓ br. square by ¼ br. high, polished — f. 10

A bronze shutter for a Eucharist tabernacle, weighing — lib. — f. —

One thousand eight hundred and forty-four bronze coins — f. —

An ivory box decorated in many colors, used as an inkstand — f. 1

A case for a balance scale inlaid with a diamond pattern — f. —

Another case for a balance scale, decorated in ivory — f. —

[folio 29 recto]

Another case for a large balance scale and a seal — f. —

A map showing Italy

Another map showing the castle of Milan

One showing the world

One showing the Holy Land

One showing the world

Two others showing the family tree of the empire and the King of France

A map showing the three kingdoms of India

Another showing the world

Another showing Italy

A navigational chart

Another showing the world

Another showing the Holy Land

Another, narrow and long, showing many countries

One showing Rome

An elephant tooth

Two silver saltcellars that fit together, one round, worked in gilt
relief in tiny leaves, in a gilt decorated case f. 6

A damascene basin with a cover f. 8

Gems in Piero's study
A pendant with a faceted diamond, held in a gold bezel which is
in a knot of serpents with a large pear pearl of about 38 carats,
clear and perfect in color and finish f. 3,000

[folio 29 verso]

A shoulder clasp with an inset balas cup ruby without clamps and
without a bezel, held in a branched frame and with two large pearls
mounted around, with a diamond in the cup, held in a bezel,
in all 4 pieces, valued at f. 2,200

A gold Agnus Dei, on one side a cross of 5 diamonds and 4 round
and clear pearls, and on the other side an Agnus Dei in red enamel,
valued at f. 200

A gold ring with enamel leaves with a mounted flat diamond,
valued at f. 600

Another table-cut diamond mounted on a gold ring, enameled
in red, valued at f. 300

Another table-cut diamond mounted on a plain gold ring, valued at f. 100

A table-cut diamond mounted in a torque mixed with gold f. 80

Another table-cut diamond mounted in a plain gold surround f. 25

A brilliant-cut diamond mounted in a plain gold frame f. 20

A shield-shaped diamond mounted in a plain gold frame f. 10

A cut ruby mounted in a gold frame for use in a ring band f. 400

A table-cut ruby mounted on a gold stem with an interlace
of red and white for use in a ring band f. 100

A table-cut ruby mounted in a gold ring f. 30

A table-cut ruby mounted in a plain gold ring f. 20

A convex table-cut emerald mounted in gold, with an enameled frame for use as a ring band	f. 500
A table-cut emerald mounted in a gold frame enameled in red	f. 100
A turquoise mounted in a plain gold frame	f. 12
A little woman's book with gold covers enameled in red and other enamels and [with] different figures of *libra* [*sic*], valued at 400 in 500 [*sic*]	f.

[folio 30 recto]

A gold jewelry box decorated with large and small pearls, weighing — lib., — ounces, valued at	f. 500
A French choker with 30 gold rings and many enameled leaves of red and green and blue and many small pearls, and on 10 of the rings 10 rubies mounted in gold bezels and on another 10 rings pearls mounted around and on the other 10 little enamel leaves in relief, valued at	f. —
A pendant for the above choker in the form of a heart, on which are three faces, one with a ruby, diamond-shaped, one a pearl and a little emerald, all, including the collar, valued at	f. 500
An Agnus Dei enameled and with reliefs on one side, and on the other a rose in red and white, with a table-cut ruby in a bezel mounted on a little double flat chain to hang around the neck with a pearl for a pendant	f. 50
Two little gold neck chains, the one with eight enameled pendants, the other with eleven similar pendants, composed of square links, all weighing 2 ounces	f. 30
A bunch of flat-link gold chains, weighing 2 ounces, valued at	f. 25
A neck chain composed of carefully arranged links, weighing — ounces	f. 6
Several gold chains, of weight and value — ounces	f. —
A gold headband with 81 double leaves and wasp wings, weighing — ounces, valued in gold xxx [*sic*]	f. 30

A gold brooch composed of circlets of gold, within which are roses
composed of open-work white enamel "a h e m," [*sic*] antique
enamels of red and black and, as a chain for the brooch, an interlace
of red and white and green branches, and a ball for a pendant,
composed of branches and points and diamonds enameled in
many colors, weighing 2 ounces f. 100

Another brooch of 16 multicolored enamel pieces with flaming
branches and enamel flowers and little pearls and a chain for
the brooch of 15 pieces in a circle enameled in many colors and
a little ball, weighing 2 ounces f. 70

[folio 30 verso]

A belt of crimson velvet on both sides with buckle and tongue
and 16 belt decorations of gold, weighing 2 ounces, valued at f. 10

A velvet belt of purple and green, gold buckle and tongue,
with belt decorations, weighing 2 ounces f. 10

A belt of white velvet on both sides, buckle and tongue of
enameled gold, weighing — f. 8

A belt of black velvet on both sides, with gold buckle and tongue
and little enameled vine scrolls, full of cherubs f. 20

A gold buckle and a gold tongue with 4 plaques enameled in red
and white flowers, weighing — f. 15

A black silk hat band with gold buckle and stud and 4 enamel
plaques in red and white, valued at f. 8

A little belt woven of gold and silver thread for use as an accent,
with an enameled gold buckle and tongue with 4 plaques of [*lapsus*] f. 3

A belt of open-work black silk with 4 little gold rings in place of
the buckle and two metal tips of gold enameled with many white
and blue flowers in relief, weighing 2 ounces, 3 *denari* f. 15

A brooch of black velvet with two little gold metal tips and
a ball weighing 1 ounce with a piece of chain of twelve links,
weighing 1 ounce, 3 *denari* f. 12

A little chain of gilt silver on the aforementioned piece of
little chain, weighing 3 ounces f. 1½

Ten gold buttons, 6 round buttons of red enamel, two pierced
gold pear-shaped pomander balls to hold musk, eight enameled
metal tips, eight pieces of hinges and links of various sizes, two
little enameled gold bells, all weighing 6 ounces, valued at f. 60

A little silver chest compartmented to hold jewels,
weighing 4 ounces, 12 *denari* f. 4

A little silver pannier compartmented for jewelry,
weighing 1½ lib., valued at f. 15

[folio 31 recto]

Six ounces of pearls f. 40

Three pearls on a string, one 45 ducats, another 35 ducats,
the other 20 ducats, altogether f. 100

One pearl of 6 carats mounted on a ring f. 60

One pearl on a ring of about 5 carats f. 55

Another pearl on a ring of about 5 carats f. 55

[folio 31 verso]

CONTINUING THE INVENTORY IN THE MEZZANINE ROOM
ABOVE THE ANTECHAMBER OF THE ROOM CALLED
THE LARGE BEDCHAMBER OF LORENZO

An image of Our Lady in glazed relief in an oval shape fixed in the wall f. 3

A small gilt tabernacle depicting Our Lady with the child in her arms f. 6

A small Flemish tabernacle depicting Our Lady from the waist up f. 20

A small tabernacle 1¼ br. high by ¾ br. wide, depicting Christ
crucified between the two thieves with Our Lady and Saint John
at his feet and a landscape and seascape f. 30

A canvas depicting Santissima Annunziata at Florence f. —

A red leather bedcover of Spanish workmanship, 5 br. long
by 4 br. wide f. 4

A white chamois bedcover, 4 br. long by 3 br. wide f. 2

A white chamois bedcover, already noted above

A poplar-wood cupboard with two doors framed with walnut panels
and inlay, 10 br. long by 3 br. deep by 4 br. tall, in one part of which
are the things itemized below, that is: f. 10

A poplar-wood chest with two lids, within which are:

A small square box made of ivory used as an inkstand f. 1

An inkstand and coin scale on 4 gilt silver feet, of Levant workmanship f. 10

A mirror ½ br. in diameter with a gold garland surround, in silk and
silver with flowers f. 4

A little box within which are an ivory seal, two boxes for musk, two
cylinders of ivory and of bone, for musk, the one white, the other green f. 2

A woman's jewelry box of ivory with many carved reliefs f. 4

A pannier within which are nine balls of several sizes, 5 tiles and
handles made of jasper, alabaster, and marble f. 3

[folio 32 recto]

A glass ball on which are depicted stories with figures, birds,
little houses, and animals, and other things all around f. 10

Two pairs of tongs, three shovels, three forks, all worked in the
Milanese fashion f. 3

A bag of crimson gashed satin, two horns of bone f. 1

A banner and pennant and a curved trumpet from the joust
of Lorenzo f. 30

Four small leather cushions

Eighteen cushions, including large ones for a bench and round
hassocks to sit on, all of leather f. 4

An altar set of 4 embroidered cloths, all in gold and silk, with many
stories, that is, in one part the Annunciation, in another the Nativity,
in another the Gift of the Magi, and in another a God the Father,
with two stories on each side and on the other cloths in the set many
stories with tiny figures f. —

A walnut casket, in which are:

Two large towels embroidered in silk and gold on nettle cloth,
each one of about 5 br. f. 30

A little panel of nettle cloth, 1 br. on each side, embroidered in silk
and gold with figures, foliage, and animals f. 8

Another little panel of the same cloth embroidered in gold and silk
with parrots f. 3

Two towels with embroidered edging worked in silk and gold,
2½ br. each f. 2

A towel of nettle cloth 4 br. long, worked in silk and gold, with fringes f. 8

A frieze of nettle cloth 5½ br. long by ⅓ br. wide, embroidered with
many figures and foliage in gold, silk, and pearls f. 30

Four little panels of nettle cloth, 1 br. on a side, worked with a frame
around displaying the Medici livery in silk and gold f. 12

Another little panel of the same fabric and the same size and workmanship

Ten towels of 2½ br. each of diverse fabrics worked in silk and gold
with many stripes f. 6

[folio 32 verso]

Three purple and white curtains with many fringes and gold lacings f. 3

A blue curtain one br. long by ½ br. wide with fringes and border
and laced with gold with many enameled spangles f. 2

A blue curtain one br. long by ½ br. wide, with fringes and border
and laced with gold, mentioned above, cancel this out

A vestment, or rather part of a hooded cape, a woman's garment,
all'antica, in gold f. 15

Three cauls of green and red-violet silk net, Neapolitan style f. 1

Four silk towels, or rather girdles, of Moorish fabric, about 5½ br. each f. 3

Two towels with silk and gold stripes of various sizes
One towel for use as a head wrap with fringe of silk and gold thread f. 3

A piece of narrow taffeta cloth 14 br. long, with selvage of gold and silk f. 7

Another small walnut casket, within which are:

A woman's head cowl *all'antica* with a delicate gold veil and
many strings of tinsel f. 5

A large coral branch f. 10

A thick coral branch with a gilt silver ferrule f. 4

A slender coral branch f. 3

A beautiful coral branch f. 3

A little coral branch made of three parts with a gilt silver ferrule f. 4

A little coral branch with a mother-of-pearl Agnus Dei and
a canine tooth f. 5

Two strings of large pieces of coral, the number of coral pieces 60,
weighing 6 ounces f. 2

One string of tiny coral pieces weighing 7 ounces f. 2

A string of medium-size amber paternoster beads with an Agnus Dei
A string of 25 large mother-of-pearl paternoster beads f. 2

[folio 33 recto]

A string of 16 [or 26] large amber paternoster beads

Four paternoster beads of jasper, or rather chalcedony

Twelve ivory combs, from small to large, weighing 20 ounces f. 3

A pair of little knives with a black case and silver tips f. 1

A pair of little knives with nielloed handles, a silver fork and
detangler comb and a case embellished in silver f. 2.10

A pair of thin little knives with a white case decorated in silver,
two silver forks f. 1

A little knife with a silver handle and a white sheath decorated with silver f. 1

Four little knives decorated with silver, without a case

A pair of small scissors, 2 pairs of chisels, all gilded f. 2

A little chest, within which are:

Thirteen French linen *camicie* [chemises] for men, worked in fine stitching	f. 13
Seven men's *convercieri* [undergarments] of French linen	f. 2
Five French linen towels with fringed edging	f. 2
Thirteen towels of local linen cloth with fringed edging and stripes of embroidered interlace stripes, 3½ br. each	f. 4
Six French linen towels for use as head wraps	f. 2
Four large towels with fringed edging and embroidered interlace	f. 1
Six French linen caps in the German style	f. 1
Six large hassocks with embroidered interlace in an oval pattern	f. 2
A French-style chest, within which are:	f. 3
Thirty-two long women's handkerchiefs, to be carried	f. —
Fifteen long women's handkerchiefs, to be carried	f. 1.10
Six towels with thin black stripes	f. 3
Eight flax linen towels with thin white stripes	f. 4

[folio 33 verso]

Fifteen large delicate widow's head scarves, of flax linen	f. 2.10
Four towels with thin white stripes	f. 1
Twenty-two large and delicate handkerchiefs	f. 4.10
Twenty-six face towels in a set	f. 4.10
Thirty-six light head towels in a set	f. 4
Eighteen face towels and 24 little towels in a set, altogether	f. 5
Seventeen towels in a set with white stripes	f. 3
Thirty-four light head towels	f. 3
Two large towels for a bench-settle in a set	f. 1

Seventeen delicate handkerchiefs	f. 1
Two large towels for a bench-settle in a set, 6 br. each	f. 1
Forty light scarves to wear on the head	f. 4
Forty light handkerchiefs	f. 5
Sixteen light towels and two handkerchiefs in a set	f. 5
Twenty-six light handkerchiefs	f. 1.10
Forty-seven light handkerchiefs	f. 5
Sixty br. of woven cotton cloth, for bandages	f. 5
A sheet set of 5 pieces with gold ribbons instead of embroidered interlace	f. 4
Fourteen br. of nettle cloth in three pieces	f. —.10
Eight and a half pieces of starched white linen, from Alexandria	f. 40
Three sets of light linen from Alexandria	f. 12
A man's shift of French linen	f. 1
A piece of French linen, beautiful	f. 15
Four linen flax towels with black stripes, delicate and beautiful	f. 8
Seven delicate and beautiful linen flax towels with black stripes	f. 21
Five towels with black stripes and 9 towels, square-patterned	f. 12

[folio 34 recto]

A handsome piece of French linen	
Ten towels with black stripes and 3 handkerchiefs in a set	f. 18
Two towels in a set and one alone of linen flax and without stripes	f. 3
Two large handkerchiefs and six small ones of linen flax, delicate	f. 4
Six towels and a handkerchief of linen flax, delicate	f. —
A coffer in the French style, within which are:	f. 3
Four women's caskets made of plaster, two oblong and two square	f. 2

Two clumps of silver thread, weighing 3¾ ounces	f. 4
Twenty-two French linen handkerchiefs with ladder work at the ends	f. 2
Three neat small bunches of head ribbons for women	f. —.10
A little woman's book covered in brocade with gold miniatures	f. 2
Three large purses worked in gold and silk	f. 3
A handbag and a purse in the Neapolitan style, in gold brocade	f. —.10
Two strings of paternoster beads, one in amber and one in jasper, alternating with 20 beads of gilt silver; the amber is yellow	f. 2.10
A small casket of ivory, within which is 2½ br. of well-made yarn, worth	f. 2
A piece of local linen, about 80 br. long	f. 12
A piece of linen from Lodi, light and beautiful	f. 12
A piece of French linen 27 br. long	f. 9
A piece of French linen 66 br. long	f. 20
Forty light flax linen handkerchiefs with white stripes	f. 3
Ten towels with thin black stripes	f. 4
Four towels and nineteen handkerchiefs in a set, lightweight	f. 13
Fourteen squares in two sets, lightweight and beautiful	f. 6

[folio 34 verso]

A piece of dimity linen cloth for aprons	f. 8
A little pine chest, framed in walnut, of 2 br., within which are:	f. 1.10
A piece of thin linen of about 70 br.	f. 13
A piece of thin linen of about 100 br.	f. 16
A piece of thin linen of about 78 br.	f. 12
A piece of thin linen of about 96 br.	f. 15
A piece of thin linen of about 93 br.	f. 12
A piece of thin linen of about 84 br.	f. 14

A piece of thin linen of about 80 br. f. 13

A piece of thin linen of about 72 br. f. 13

A piece of thin linen of about 68 br. f. 12

A piece of thin linen of about 80 br. f. 13

A piece of coarse linen of about 100 br., for sheets f. 12

Another little pine chest, framed in walnut, of 2 br., within which are: f. 1.10

Four pairs of sheets of 4 pieces, 8 br. each piece, well used f. 10

Four small spools, 2 of French linen and two of gauze f. 4

Eight half towels of gauze with black stripes in cotton f. 8

Twelve half towels without stripes

Twenty-seven *collarette* [little collars] for women to wear at the neck,
in gauze f. 2

Fourteen aprons for women, in French linen and in gauze, decorated f. 3

Twenty-four long bandages for women f. 1

Eleven light flax linen towels for hairdressing f. 3

Three flax linen half towels with stripes, beautiful f. 2

Eight women's shifts of linen f. 1.10

Sixteen large seat cushions for a bed-settle and 4 small ones f. 3.10

[folio 35 recto]

Eighteen handkerchiefs, much used
Twelve French linen *convercieri*, used
Twenty-seven mixed *cuffie* [nightcaps] and head coverings for women
Many ribbons and close-fitting *collarette*
Three little bags and 15 cushion covers, with and without decoration
Four pairs of sheets of 3 and 4 pieces, 8 br. each piece f. 7

A piece of *bombagia* [simple cotton] cloth, about 6 br. f. 8

Three large *cassoni* of wood, veneered and decorated with walnut,
4 br. each, with diamond-shaped inlay of boxwood, within which are: f. 8

A piece of Dutch cloth 8 br. wide and 19 br. long	f. 16
Two sheets of 4 pieces, 8 br. each piece, of foreign cloth, with decorated hems	f. 20
Three pairs of sheets of the same material and workmanship	f. 30
A pair of sheets of 5 pieces, 8 br. each piece, with wide embroidered interlace	f. 12
Three pairs of sheets of 4 pieces with wide weave, decorated with herringbone-and-cross pattern	f. 36
A pair of sheets of local cloth with a double band of embroidered interlace and decoration all around and all beautiful	f. 20
A pair of sheets of local cloth of 4 pieces with deer at the heads, 8 br. each piece	f. 5
Five pairs of sheets of 3½ and 4 pieces of 8 br. each piece	f. 20
One pair of cotton-wool sheets of 4 pieces	f. 4
Three pairs of French linen sheets, 6 br. square	f. 15
Five pairs of homespun cloth sheets of 4 pieces, 8 br. each piece	f. 25
Four pairs of sheets of three pieces, 8 br. each piece	f. 12
Two pairs of sheets of four pieces, 8 br. each piece	f. 16
One pair of sheets of three and one-half pieces, 7 br. each piece	f. 3

[folio 35 verso]

A set of sheets of 4 pieces of 8 br. each piece	f. 6
A set of sheets with a wide weave of two sizes	f. 6
A set of sheets of 4 pieces of 8 br. each piece and 6 br. wide, with ornament in gold and silk at the feet	f. 8
A set of nettle cloth sheets in 5 pieces, used	f. 6
A set of flowered small sheets in four pieces, 5 br. each piece, with silk ribbons of many sorts	f. 3
A silk towel with black stripes of many sizes A cotton-wool towel with interwoven silk stripes	f. 4

A towel 8 br. long all striped and decorated in silk
Another towel edged in silk ornament of all sorts

A piece of thin homespun linen, about 80 br. f. 8

A piece of thin homespun linen, about 92 br. f. 9

A piece of thin homespun linen, about 60 br. f. 6

A piece of homespun linen *di m.o* [*monachino*? (monk's cloth)],
about 84 br. f. 8

A piece of homespun linen, about 120 br. f. 13

A piece of homespun linen, 92 br. f. 11

A piece of homespun linen, 92 br. f. 10

A piece of homespun linen, 72 br. f. 8

A piece of homespun linen, 94 br. f. 10

A piece of homespun linen, more beautiful, 85 br. f. 10

A piece of homespun linen, 72 br. f. 9

A piece of homespun linen for shifts, of 100 br. f. 11

A piece of homespun linen for shifts, of 76 br. f. 8

A piece of homespun linen for shifts, of 84 br. f. 9

A piece of homespun linen for shifts, of 112 br. f. 12

A piece of coarse homespun linen, of 72 br. f. 6

[folio 36 recto]

A piece of homespun linen and towels for a bed-settle, 72 br. f. 5

A piece of homespun linen for shifts, of 76 br. f. 8

A piece of homespun linen for shifts, of 100 br. f. 9

A piece of homespun linen for shifts, of 110 br. f. 12

A piece of thin homespun linen for shifts, of 80 br. f. 9

A piece of homespun linen for shifts, of 100 br. f. 13

A piece of thin homespun linen for shifts, of 96 br. f. 8

A piece of thin homespun linen for shifts, of 130 br. f. 10

Among the cloths therein:

Twelve tablecloths	of French linen,	
Twelve runners	14 br. each, altogether	f. 75
Seven tablecloths	of French linen,	
Seven runners	12 br. each	f. 38
Three tablecloths	of French linen,	
Three runners	13 br. each	f. 25
Three tablecloths	of French linen,	
Three runners	12 br. each	f. 30

One tablecloth and a runner, 15 br. each f. 7

Two tablecloths and two runners, 48 br. each f. 14

Three tablecloths and three runners of French linen, 16 br. each f. 21

Three tablecloths without runners, 16 br. each f. 14

Two runners, one of 5 br. and one of 6 br. f. 1

Two runners, coarse and narrow, of 24 br. each f. 3

Two runners of French linen, one of 6 br. and one of 8 br. f. 1.10

A tablecloth with lilies, 8 br. long by 5 br. wide f. 4

Twenty-six napkins of French linen in two sets	
Thirty-three napkins of French linen in three sets	f. 15

Sixty napkins in five sets of twelve in each set, all in French linen f. 3.10

[folio 36 verso]

Seven tied-together sets of napkins of French linen, twelve per set f. 10.10

Twelve French linen napkins with a lily pattern, in one set f. 3

Twelve French linen napkins, each tied separately, beautiful and new f. 3

Eighty-nine separate and used napkins, eight separate and
used napkins, all of French linen f. 11

An altar frontal of woven tapestry of silk and gold with 5 stories
of Christ, 5 br. long f. 3

A small tapestry, 1¼ br. by 1 br., depicting a half length of Our Lady
with the child in her arms and three Magi, half figures f. 50

Another small tapestry, 2½ br. square, depicting Our Lady
seated with the child and with the Duke of Burgundy,
woven with silver, gold, and silk f. 60

Another altar frontal with three crucifixions, that is, Christ
between the two thieves, woven in silk and gold, 4 br. long f. 30

A woven cloth, 4 br. square, of gold and silk, in which are eleven
figures and many houses f. 100

A carpet with nap, used, about 3 br. long f. 2

In the other cupboard
A tapestry, depicting an Annunciation, 6 br. long by 5 br. wide f. 7

A pair of crimson velvet pillows with gold brocade and silk tassels
with pearl buttons f. 32

Two pairs of large white damask pillows, with gold brocade, with
covers of embroidered nettle cloth with a wide silk and gold border
around with many animals and heraldry and with sixteen tassels f. 50

Two pairs of red satin pillows with covers of gauze decorated all over
with thread in a wide rosette-patterned embroidered interlace f. 20

Three pairs of crimson damask pillows studded in gold with linen
covers, decorated as above and with tassels of crimson silk f. 20

[folio 37 recto]

Two pairs of cushions with covers of French linen decorated with
silk ribbons and gold, instead of embroidered interlace f. 6

Two pairs of red taffeta cushions with linen covers, in wide
embroidered interlace in an oval pattern and with red silk tassels f. 4

Four bare cushions with crimson taffeta covers f. 1.10

Six little cushions of crimson taffeta to put in the bodice f. 1

A little box within which are eight tassels of green-brown silk
with gold and with pearl buttons f. 2

A little bag within which are twelve tassels of white and red silk f. —.10

Eleven counterpanes with two bedcovers for the bed-settle,
about 4 br. by 6 br. each, decorated by hand f. 18

Five bedspreads of cotton wool, each 4 br. by 6 br. f. 6

A box within which are two dolls fully carved and painted in the
form of Our Lord God, and a candlestick, and an ivory spice box f. 2

A tied bundle containing two stoles, an amice, and several pieces
of cloth of many colors and three white cords f. —

A white bedspread, 8 br. long by 7 br. wide f. 12

Another bedspread, 8 br. long by 7 br. wide, of different workmanship f. 16

A bedspread, 8 br. long by 7 br. wide f. 15

A bedspread, 7 br. long by 5 br. wide f. 12

A bedspread, 8 br. long by 7 br. wide f. 6

A bedspread, 8 br. long by 7 br. wide f. 8

Another bedspread, 6 br. on a side f. 5

Another bedspread, 6 br. on a side f. 10

Another bedspread, 6 br. on a side f. 6

A long bedspread, 9 br. long by 8 br. wide f. 20

Another long bedspread, 7 br. long by 6 br. wide f. 10

[folio 37 verso]

Continuing in the cabinet
A bedspread, 8 br. long by 7 br. wide f. 10

Another bedspread, 8 br. long by 7 br. wide f. 8

Another bedspread, 6 br. long by 5 br. wide f. 5

Another bedspread, 8 br. long by 7 br. wide f. 10

A taffeta bedspread, faded, *all'antica*, embroidered with eagles
in fine gold f. 15

A bed-curtain set of cotton wool with foot hangings,
and all the trimmings f. 10

Two canopy curtain sets with domes, all in thin linen f. 14

Six miniature paintings on parchment from a large-folio Missal,
painted on both sides f. 50

Two bedspreads, 8 br. on a side, made of woven linen and
with curtain hangings f. 50

A green velvet bedspread with purple fringe all around,
embroidered in gold in the Byzantine fashion, that is,
glittering all over, 8 br. long by 7 br. wide f. 100

A crimson velvet bedspread, 7 br. long by 6 br. wide, fringed all
around with white silk and embroidered in the middle with a coat
of arms and the Medici livery with a large helmet f. 60

A canopy bed-curtain set in paneled nettle cloth of twelve pieces,
each 6 br. long, with two borders embroidered in gold and silk
in the opening and with a crimson taffeta collar at the top f. 16

Three mosquito nettings with domes of taffeta in several colors f. 20

Two white taffeta bed curtains with fringes of scarlet mixed
with gold, helmet and coat of arms and livery of the Medici;
they were from the damask bed-curtain set belonging to
Monsignore [Giuliano, son of Lorenzo] f. 10

Two oblong boxes, 1 br. long, all gilded f. 2

A desk, all in walnut, about 2 br. long, all inlaid, for use as a writing
desk, with a cupboard beneath, within which are: f. 1

Seventeen books, large and small, of many kinds, with bindings,
including one of scarlet velvet with four silver boards that are broken f. —

[folio 38 recto]

CONTINUING INTO THE *SALETTA* OPPOSITE THE SALA GRANDE

Pine-paneled wainscoting all around, 18 br. in length, with centers
and framing in walnut and inlay f. 12

A high-backed pine bench framed in walnut with balusters and
intarsia, 5 br. long, for use in front of the fire f. 3

One cypress-wood table 9 br. long and another of pine 11 br. long
with six trestles f. 5

Two pine benches framed in walnut and intarsia, one of 5 br.
and the other 12 br. f. 2

A used and worn cane mat for wainscoting f. 2

A windbreak of poplar wood at the door to the room, with an
attached cupboard, framed all around with walnut panels and
intarsia, 4½ br. high by 4 br. wide by 2 br. deep f. 8

A bronze relief above the fireplace with many horses and nude men,
that is, a battle scene, 1⅔ br. long by ⅔ br. high f. 30

A pair of large andirons, fork, shovel, and tongs, weighing 100 lib. f. 3

A lunette on panel depicting a nude figure asleep on a bench and
two dressed figures, with houses, by maestro Filippo [Lippi] f. 10

A canvas depicting a half-nude figure seated in a niche holding a skull,
by Domenico Veneziano, painted in oil, simulating marble f. 10

A Flemish canvas with a gilt frame, showing many Bacchanalian
figures at carnival time, on the wall above the water basin f. 10

A large brass candlestick in the middle of the room with twelve
places for candles and many branches, figures, and foliage,
3 br. high by 2 br. wide, weighing about 400 lib. f. 50

Four torchlike tin-plated iron candle sconces fixed in the wall f. 1

A damascened bronze vessel with a spout, used as a water pail f. 3

A large bronze chain kept beneath the water basin

A copper jug, altogether weighing 30 lib. f. 2

[folio 38 verso]

In the cupboard of the aforementioned saletta

A brass basin and ewer with two enamels of the arms of the Medici
and the Tornabuoni, valued at f. 3

Eight brass candleholders and two lamps with brass bases f. 1.10

Twenty-one table knives and one large carving knife, all with
ivory handles, and three iron forks f. 1

Eighteen spoons and one small copper saucepan
Eighteen plain forks all of silver, weighing
Six little compartmented saltcellars — lib. and — ounces
An enameled spice box f. —

(I was told what was in the cupboard)

IN THE ROOM THAT OVERLOOKS THE STREET, CALLED THE CHAMBER OF MONSIGNORE, WHERE GIULIANO LIVES

A lunette in a wooden tabernacle with gold decoration,
4½ br. high by 2⅔ br. wide, showing Our Lady seated with
the child at her neck, in relief and glazed f. 30

A small lunette with a gilt frame within which is depicted
Our Lady seated with the child in her arms with two angels at her
feet, by Francesco di Pisello [Pesellino] f. 10

A small lunette with a gilt frame depicting the head of Christ,
a Flemish work f. 4

A bronze relief, 1 br. square, depicting Christ crucified between
the two thieves, with eight figures at his feet f. 10

A lunette with two doors depicting the bust of a woman by
Domenico Veneziano f. 8

A little lunette showing a *poesia* [mythological scene] with two
figures in a large landscape f. 5

A bronze nude holding a golden ball, 1 br. high f. 8

A Hercules crushing Antaeus, all in bronze, ⅓ br. high f. 2

A marble bust above the door of the antechamber, showing
Giovanni di Cosimo de' Medici from life f. 25

[folio 39 recto]

A helmet crest of a woman in gold wearing a dress embroidered
with pearls f. 12

A jousting lance layered in relief, all gilded, with a collar f. 4

A pair of tongs, a shovel, and a rake, weighing 60 lib. f. 1

A pine bedstead of 5½ br. with a step-plinth all around, all framed
and inlaid with much decoration in spindle wood f. 20

A pine bench-settle with two cupboards decorated with walnut
and intarsia, all connected together, with much decoration in
spindle-wood panels, altogether 13 br. long by 4⅔ br. high f. 40

A high-back bench at the fireplace that can be flipped over, framed in
walnut and intarsia with arms, 3½ br. long f. 3

Two *forzieri a sepultura* [oblong chests], richly decorated, with brackets
and architrave moldings, all gilded with fine gold, and decorated
with the story of the victory of Marcus Marcellus of Sicily f. 50

A pine *cassone,* 4 br. long, framed and embellished with walnut
and intarsia and much decoration in spindle-wood panels,
the aforementioned chests and the *cassone* sitting on a walnut
plinth decorated with intarsia f. 12

Spalliera paintings, 13 br. long and 1½ br. high, above the aforementioned
chests and *cassone,* depicting the story of the joust of Lorenzo, divided
into three parts by gilt frames and colonnettes, by Lo Scheggia f. 60

On the bed
A mattress of coarse material full of wool
Two sheepskin mattresses full of cotton batting f. 10

A down comforter and two pillows full of feathers f. 25

A large bedspread, 9 br. long by 7 br. wide, decorated in compartments f. 16

A canopy bed-curtain set of linen f. 10

A simple thin bedcover f. 4

[folio 39 verso]

Two mattresses, one of sheepskin and one of coarse material, full of cotton batting, and a white bedspread	f. 3
A bed quilt, full of cotton padding	f. 2
A set of tapestry bed curtains of foliage A tapestry panel of foliage	f. 35 [or 25]
A cover with a nap for the bench-settle	f. 6
A Moorish satin table cover in two pieces in its own box, 10 br. long A table cover in its own case, with nap, 4 br. long A table cover with nap on the table next to the fireplace	f. 12

In the forziere a sepultura [oblong chest] next to the window

Five and a half pieces of pink prize cloth Another length of the same pink cloth	f. 100
Five br. of well-finished pale cloth	f. 2
Three lengths of purple cloth, delicate	f. 5
Two lengths of Flemish cloth, blended, of 3¾ br.	f. 3
A length of black twill for hosiery, 5 br.	f. 6
A lot of little pieces and remnants of cloth of various kinds	f. 3
Two pieces of satin of 2½ br., one scarlet and one peacock blue	f. 3
A piece of camlet, thin Six pieces of camlet cloth of various colors, making 20 br.	f. 10
A piece of white silk, or rather, challis, of 36 br.	f. 6
Seventeen little remnants of cloth of many kinds	f. 8
Six little remnants of Lucchese [silk] cloth for *cappucci*	f. 6
A *cappetta* [short cape] of light gray wool lined in green cloth	f. 3
Nine *catalani* of loosely woven cloth with six hoods lined in purple camlet	f. 20
A *robetta* [man's short gown] of black damask lined with wolf and sable	f. 4

[folio 40 recto]

A green velvet *gabbanella* [gown] lined in white cloth	f. 4
A black velvet *gabbanella* lined in white skins A black velvet *gabbanella* lined in white skins	f. 4
A tan camlet *gabbanella* lined in squirrel	f. 4
A gray velvet *gonnellino* [ceremonial tunic worn over armor], worn out, lined in green	f. 3

In the forziere a sepultura *[oblong chest] next to the one above*

A purple damask *gabbanella*, brocade in gold, rich	f. 32
A green satin *cotta* [woman's gown or tunic] decorated with eight pieces of gold brocade	f. 20
A white satin *cotta* with stripes and compartments and borders of black velvet, that is, decorated all over	f. 10
A *turca* of purple raw silk lined in purple taffeta	f. 6
Two *cotte,* of which one is for a little girl, both in red taffeta with a yellow plaid pattern in the Neapolitan style	f. 4
A *cotta* of crimson taffeta	f. 4
A simple *cotta* of purple camlet	f. 4
A simple *gabbanella* of purple camlet	f. 4
A *mantello* of purple camlet	f. 4
A *gabbanella* of blue silk	f. 1
A short *gabbanella* of tan cloth lined with squirrel A short *gabbanella* of tan cloth lined with silk	f. 3
A *gabbanella* of loosely woven cloth, old, lined in squirrel	f. 2
A *gabbanella* of light blue cloth lined in white lambskin	f. 2
A *gabbanella* of ivory color lined in the same	f. 3
A *gabbanella* of loosely woven cloth, simple	f. 3
A *gammurra* [gown] of tan cloth without sleeves	f. 2.10

A girl's *cioppa* [gown] of loosely woven cloth	f. 4
A *gabbanella* of monk's cloth	f. 2
A *gabbanella* of loosely woven cloth without sleeves	f. 1.10
Four-quarters of a *roba* [gown] of sky-blue velvet	f. 7
A *bernia* of tan velvet lined in green taffeta	f. 7

[folio 40 verso]

In the cassone

A purple *lucco* lined in red taffeta	f. 6
A purple *lucco* lined in white taffeta	f. 10
A black velvet *cotta* without sleeves	f. 14
A *robetta* of black velvet	f. 12
Two *mongiluzzi* [short wraps], one red taffeta, the other green raw silk	f. 2
Eight pairs of hose in the colors of Duke Galeazzo [Sforza], that is, one [leg] white and one purple	f. 3
One pair of new hose for Lorenzo, with soles, of purple cloth	f. 1.10
Two pairs of sheets of four pieces, 9 br. each piece	f. 12
Three pairs of sheets of three pieces, 6 br. each piece	f. 12
Five pairs of sheets of four pieces, 9 br. each piece	f. 55
Three pairs of sheets of four pieces, 9 br. each piece, woven interlace	f. 27
One pair of French linen sheets of three pieces, 8 br. each piece including the hems, worked in herringbone and oval shapes	f. 16
One pair of sheets of local cloth worked in the same fashion	f. 14
Two pairs of sheets of 5 [or 4; one is overwritten by the other] pieces, 9 br. each piece, with wide interlace and every piece woven	f. 10
Three pairs of sheets of four pieces, 8 br. each piece, with embroidered interlace	f. 24
Forty-eight handkerchiefs in a set, for carrying in the hand	f. 2.10

Eleven handkerchiefs and six towels in a set	f. 1.10
Seventeen towels in a set, delicate	f. 2.10
Thirty large to small towels for feet	f. 2.10
Twelve face towels with black stripes	f. 2
Twelve hair towels with black stripes	f. 6
Six pillow covers of decorated French linen	f. 2.10
Twelve pillow covers of local decorated cloth	f. 4
Two covers for large cushions embroidered with wide interlace	f. 2
Four large covers embroidered with wide and large interlace	f. 2.10
Eight covers for small cushions	f. 3

[folio 41 recto]

A pair of small French linen cushions with edging in gold and silk instead of embroidered interlace	f. 1.10
A pair of red taffeta cushions, with linen covers with wide embroidered interlace and red silk tassels	f. 1
A pair of large crimson velvet cushions brocaded in gold, with silk and gold tassels and with pearl buttons, altogether	f. 32
A sheet set of nettle cloth of 6 pieces, 10 br. each piece, decorated with several red satin friezes of flowers and with a border on each side ¾ br. wide, with many silk and gold family arms embroidered and of many varied colors	f. 25

IN THE ANTECHAMBER OF THE AFOREMENTIONED CHAMBER

Pine wainscoting around the room 20 br. long by 4 br. high, with panels and framing of walnut and intarsia, with a chest in the same workmanship at the entrance to the room, — br. long, and one part of the wainscoting is a bench-settle, and one part a cabinet with two doors, and also the side and the foot of a bedstead built into the wainscoting used as a bed, decorated in the same manner, in all	f. 20

Three mattresses, one coarse and full of wool, two of sheepskin
full of hemp f. 2

A down comforter and two pillows full of feathers f. 6

A thin white bedspread for the same bed f. 8

A linen canopy bed-curtain set in the form of a tent with a fringed
valence above the cornice of the above-mentioned wainscoting f. 3

A small mattress full of oakum | for the bed-settle
A white bedspread f. 1

A bed quilt f. 2

A tapestry cover for the bed decorated with foliage f. 6

A bed-curtain set of green twill f. 5

A bench cover with a nap for the bed-settle, of about 4½ br. f. 3

A bronze basin and chain weighing 18 lib. f. 2

A bronze pail with a cover shaped like a box f. 1

Two bronze candleholders and two bronze lamps
A copper pitcher, weighing 4½ lib.
A small pewter bed warmer and a pewter jug f. 2

[folio 41 verso]

CONTINUING THE INVENTORY IN THE LITTLE SHRINE ON THE WAY UP TO THE MEZZANINE ROOM

A lunette used as an altarpiece, 2 br. long by 1⅓ high, with a gilt frame,
depicting the story of the Magi, by fra Giovanni [Fra Angelico] f. 60

IN THE MEZZANINE ROOM ABOVE THE AFOREMENTIONED ANTECHAMBER

A plain bedstead, on which are a straw mattress, two mattresses
full of wool, and a pillow full of feathers, weighing — lib. f. 4

A mule blanket in livery white and purple f. 1.10

A poplar-wood cupboard, with frontals, or rather panels,
of walnut and two doors, within which are: f. 6

A damascene basin, 1½ br. in diameter, very shallow f. 25 [or 26]

A damascene basin, doubly decorated on the bowl as well as the rim f. 60

A damascene basin, 1½ br. in diameter f. 30

A damascene basin, 1¼ br. in diameter f. 15

A damascene basin, 3¼ br. in diameter f. 20

A damascene basin, 1⅙ br. in diameter, with little depth,
doubly decorated on both the bowl and the rim f. 25

A damascene basin, 1 br. in diameter f. 15

A damascene basin, ¾ br. in diameter, decorated with gold f. 30

A damascene basin, ⅔ br. in diameter f. 15

A damascene basin, ⅞ br. in diameter, completely decorated
with a frieze of horses in compartments f. 20

A damascene basin, ⅞ br. in diameter f. 12

A flat dish with three feet, ⅞ br. in diameter, decorated in silver and gold,
with a decorated cover, in silver and gold, with a silver pyramid f. 40

A wine cooler with a rim and a flat bottom decorated inside and outside f. 12

Twelve Moorish candleholders for holed candles f. 4

Two large damascene candleholders, for torches, ¾ br. each, decorated f. 30

A bronze statuette of a nude, 1 br. in height f. 10

Another bronze statuette of a nude, holding in its hand a fish and a snake f. 6

[folio 42 recto]

Continuing the inventory in the other cupboard in the antechamber
Four other nudes of ⅓ br. each
Two little bronze angels in relief f. 8

A marble head, carved in the round, by Desiderio [da Settignano] f. 3

A scarlet satin set of horse and wagon trappings for the Ferrarese cart, that is, including all these things:

A scarlet satin cover for the cart, 4 br., lined with
green taffeta, embroidered all around with gold decorations
Two red satin cushions to sit on in the cart
A thin mattress full of *bambagia* [cotton wool batting]
Two saddle blankets for the horses, of white and purple velvet
An equifolio for the horses covered in the same satin f. 30

Two mats of Barbary rush, beautiful f. 12

A pair of worn little coffers and a cypress-wood chest f. 3

A pair of billhooks decorated in gilt silver and other things f. 6

A French spear decorated in silver f. 25

A hatchet with several silver hilt guards and studs and other things f. 25

A thin steel hatchet decorated in gold f. 10

Three boar-hunting spears with inlaid green handles f. 1

A one-handed hatchet
A billhook
A spear
A pike
A half pike
Two triple-bladed spears altogether valued at f. 2

A poplar-wood table of 3 br., framed in walnut
A poplar-wood cupboard, 3½ br. wide by 3 br.
high, within which are boxes, a clothes rack, a large
Flemish mirror, and a Moorish shield all valued at f. 3

A little panel on which is painted the portrait of
Madonna Bianca [sister of Lorenzo] f. 1

A birth salver depicting a battle scene by Masaccio f. 2

[folio 42 verso]

CONTINUING THE INVENTORY IN THE CORRIDOR WHICH GOES TO THE CHAMBER OF PIERO ABOVE THE *SALETTA*

A wooden panel of about 4 br. by Fra Giovanni [Fra Angelico]
depicting many stories of holy fathers f. 25

A story [in relief] about fauns and other figures by
Desiderio [da Settignano] f. 10

IN THE CHAMBER OF PIERO

A wooden tabernacle 3 br. high with columns at the side and
cornices, depicting Our Lady with the child standing, in high
relief, or rather, fully round, completely gilded f. 25

A little panel depicting an Annunciation, a Greek work
Another little panel depicting the story of Christ on the
Mount of Olives f. 6

A canvas in a gilt frame, about 4 br. high by 2 br. wide, depicting
a figure of Pa[llas] with a shield before her and a jousting lance
by Sandro di Botticello f. 10

A prize from a joust of a silver helmet with the figure
of Pallas and a helmet crest on top f. 40

Another prize of a silver helmet with a crest on which is the
figure of Saint Bartholomew f. 25

Another jousting prize of a helmet with a crest on which is a
nude Cupid with his hands bound to a laurel tree f. —

Another prize of a helmet with a crest on which is a ship's mast
with a sail with a pennant and weathercock

A bronze figure on horseback, weighing — lib.

A bronze centaur by Bertoldo [di Giovanni], weighing — lib.

A walnut bedstead with a step-plinth all around, of 5½ br., with
sides decorated in images in intarsia and inlaid with spindle wood f. 25

A walnut bed-settle with a built-in *cassone* and clothes rack,
decorated with images, with two large gilt bronze balls f. 25

Three mattresses, two of cotton wool and one of wool f. 10

A down comforter and two feather pillows, weighing — lib. f. 15

A white quilt of cotton wool
A white blanket of Catalan cloth f. 5

A decorated white bedspread, beautiful f. 25

A white bed-curtain set, in the shape of a tent f. 10

[folio 43 recto]

Two little mattresses for the bench-settle, of cotton and wool
A white bedspread, two carpet pillows f. 5

Two *forzieri a sepultura* [oblong chests] with gilt cornices
and painted pictures f. 24

A poplar-wood credenza in the shape of a *cassone,* with beveled
corners and walnut veneer and spindle-wood panels f. 10

A walnut cabinet with two doors, spindle-wood panels, of 6 br. f. 2

A high-backed bench that folds, in front of the fire, with walnut
moldings and intarsia and balusters f. 3

Two leather chairs, cardinal style f. 1

A steel hatchet with a bone handle and several silver hilt guards f. 10

A pair of andirons, tongs, shovel, and fork f. 2

Three carpet covers for *forzieri*, one with a nap, of 6 br., two
without nap, Moorish style, all used and worn, of 6½ br. f. 10

In the first forziere *next to the door to the terrace*
A green taffeta bedspread with an almond-shaped pattern, of 6½ br. f. 25

A green taffeta dog's bed, decorated in the same fashion f. 12

A pair of crimson satin cushions, embroidered and laced with gold,
with several gold compartments in relief, with eight gold tassels f. 30

A pair of crimson velvet cushions in two textures, with the background
enriched with gold with ornaments, with borders and patterns,
with many birds and animals in gold thread, and eight tassels with
buttons of gold thread and with pearls f. 80

A pair of cushions, smooth, with covers of netting with transparent
cloth and gold f. 12

A pair of crimson taffeta cushions, with covers of fine linen,
with eight gold and silk tassels f. 8

A pair of cushions of the same sort, small, without tassels f. 2

A pair of crimson taffeta cushions with covers of netting with
animals, Neapolitan style, with eight tassels of gold and silk f. 8

Two pairs of cushions with linen covers, netting in the Neapolitan style f. 3

A pair of cushions with a cover in fine linen and network
and with eight tassels and gold buttons f. 3

Two little caskets painted in the Neapolitan style, with more
tassels inside for the above-mentioned cushions f. —

[folio 43 verso]

A pair of large red satin cushion covers with a border around of many
flowers and animals, worked in gold thread with a frame in the middle
in which is a shield with the Sansoverino [Roberto Sanseverino] arms f. 30

A small cushion cover, split at the seams, with a raised pattern in gold f. 3

Two sacks within which are sixty-seven cushion covers
with yarn netting f. 16

In the other forziere

Eleven pairs of sheets of four pieces, 10 br. each piece, of many sorts f. 110

Eight pairs of sheets of four pieces, of 9 br. each piece,
with fancy embroidered interlace f. 160

Four pairs of French linen sheets of three pieces, 7 br. each piece,
decorated in the middle f. 50

A pair of sheets of four pieces, 9 br. each piece, all decorated
A little sheet of three pieces, decorated in the same manner f. 50

Twenty towels completely decorated in the Neapolitan style	f. 8
A piece of thin cotton linen for shifts, of 109 br.	f. 16
A piece of thin cotton linen, of 90 br.	f. 16
Two thin towels in a set for the bench-settle	f. 1
Four small sheets used as a curtain, of thirteen pieces, each piece 5 br.	f. 25
Three light cotton sheets of three pieces used as a bed-curtain set, with the canopy fringed and crisscrossed by yellow silk squares	f. 30
A canopy bed-curtain set of veil cloth of 20 herons with embroidered interlace in gold all over	f. 80
A French linen and taffeta canopy bed-curtain set decorated with fine gold thread and enamels, instead of embroidered interlace, with the dome of white taffeta of the same workmanship	f. 100
A French linen canopy bed-curtain set of eighteen pieces with beautiful embroidered interlace	f. 30
A French linen canopy bed-curtain set in the same style, with gold thread instead of embroidered interlace	f. 25
A linen canopy bed-curtain set with embroidered interlace	f. 18
A linen tent bed-curtain set in Neapolitan style with fringes and gores	f. 10
All the aforementioned bed-curtain sets have their domes in the same workmanship as the hangings	

[folio 44 recto]

Continuing the inventory in the credenza in the form of a cassone

A *turca* of crimson satin lined in lynx	f. 36
A *turca* of crimson satin lined in sable	f. 36
A *turca* of silver-gray satin lined in martin	f. 50
A *turca* of crimson damask lined in lynx	f. 40
A *turca* of black camlet in the French style lined in ermine	f. 25
A *turca* of black satin lined in suckling animal	f. 15

A plain *turca* of purple velvet	f. 12
A plain *turca* of purple velvet	f. 12
A plain *turca* of green-yellow satin	f. 12
A *turca* of crimson velvet lined in purple satin	f. 25
A plain *turca* of crimson satin	f. 10
A plain *turca* of green-brown satin	f. 10
A *turca* of crimson silk velvet	f. 15
A plain *turca* of green-yellow satin	f. 10
A *turca* of loosely woven cloth in the French style	f. 10
A plain *turca* of purple velvet	f. 12
A *lucco* of Milanese twill from Lucca [silk] lined in ermine	f. 50
A *lucco* of loosely woven material lined in squirrel	f. 30
A *lucco* of crimson-purple velvet lined in crimson taffeta	f. 25
A plain *lucco* of purple satin	f. 14
A *lucco* of Milanese twill from Lucca [silk] lined in green-yellow taffeta	f. 18
A *lucco* of plain twill [silk] from Lucca	f. 6
A plain *lucco* of green-yellow satin	f. 5
A plain *lucco* of red satin	f. 6
A *tabarro* [overcoat] in the Spanish style, of crimson damask lined in green taffeta and decorated in gold	f. 25
A pink *mantello* of beautiful fabric	f. 25
A *mantello* of purple loose-weave fabric	f. 10
A *mantello* like a monk's cape	f. 8
Two *catalani* of loose-weave fabric	f. 12
A *cappa* of pink cloth lined in black velvet and with a gold and silver ruffle	f. 40

A pink *gabbano* lined in black velvet, with a hood f. 12

A green-brown *cappa* lined in pink f. 8

[folio 44 verso]

A *gabbano* of tan cloth lined with loose-weave cloth f. 6

A green-brown *cappa* lined in pink f. 8

A plain *cappetta* with a Neapolitan collar f. 4

A *vesta* in the French style, of Flemish wool f. 16

A *vesta* in the French style, of tan fabric lined in white cloth f. 8

A *robetta* of purple velvet lined in squirrel f. 20

A *robetta* of purple satin lined in lambskin f. 12

A *robetta* of tan satin lined in Spanish cat f. 10

A *robetta* of gray satin lined in lynx f. 10

A *robetta* of gray fabric lined in black leather f. 4

A *robetta* of loose-weave fabric lined in black leather, poor condition f. 3

A *robetta* of tan fabric lined in sky-blue velvet f. 8

A *robetta* of gray Flemish fabric lined in black velvet f. 10

A *saia* [man's gown] of tan fabric with black velvet gores, lined in Spanish cat f. 10

A *saia* without sleeves of the same material, gored all over f. 8

A *saia* of purple loose-weave fabric lined in white damask f. 6

A *saia* of tan fabric lined in gray satin f. 6

A *saia* of pink fabric lined in green-yellow satin f. 8

A *robetta* of loose-weave fabric lined in green-yellow taffeta f. 6

A *robetta* of loose-weave fabric f. 2

A *robetta* of dark purple fabric f. 2

A lining for a *turca* of purple raw silk f. 3

Two *mongili* of red taffeta f. 3

A *mongile* of purple damask f. 5

A *mongile* of black taffeta f. 2

A *mongile* of flesh-colored tabby f. 3

A lining for a *robetta* of silvery green velvet f. 12

A lining of red damask for a *robetta* f. 4

A lining of crimson taffeta for a *robetta* f. 5

A *cioppone* [large gown] of black cottony fabric lined in martin f. 12

[*folio 45 recto*]

A *pitoco* of purple velvet lined in silk f. 3

A *pitoco* of black velvet lined in sable f. 16

A *pitoco* of red satin shot with gold lined in sable f. 20

A *pitoco* with sleeves, of pale satin shot with silver lined in squirrel f. 8

A *pitoco* with sleeves, of crimson satin shot with silver
lined in Spanish cat f. 10

A *pitoco* of tan wool velvet lined in lambskin with
four enameled gold buttons f. 5

A *pitoco* of black velvet lined in black lambskin f. 2

A *pitoco* of white damask with gold brocade f. 8

A *pitoco* of sky-blue damask with gold brocade f. 8

A *giornea* [jousting tunic, or tabard] in the Lombard style, of gray satin f. 2

A *cazzotto* [codpiece] of green-brown satin f. 2

Four *farsetti* of satin, three red and one black f. 7

Two *farsetti* of tabby, one tan and one red f. 3

Three *farsetti* of gray damask f. 6

Two *farsetti* of taffeta, one white and one green-brown f. 2

One *farsetto* of purple satin shot with gold f. 10

Two *farsetti* of velvet, one purple and one black f. 14

One *farsetto* of green-brown satin without sleeves f. 1

One *farsetto* of black damask with velvet sleeves, embroidered all in gold f. 6

One *farsetto* of white satin f. 1

One *farsetto* of purple satin f. 2

One *farsetto* of gray satin and one of green-brown satin f. 3

One *farsetto* of gray satin f. 1

A *saia* of scarlet damask [with] brocade in gold, gashed in black velvet f. 8

A *pitoco* of purple satin shot with gold with black velvet gashing
and lined in sky-blue taffeta f. 3

Twelve pairs and a half of hose, of fabric of many colors,
with the family livery and branches f. 5

In the cabinets
Seven pairs of beautiful hose f. 10

Two pairs and a half of hose, half purple and half pink f. 3

[folio 45 verso]

Several pieces of wool velvet and a *farsetto* of black cloth f. 1

A little piece, 3 br. long, of white satin shot with silver f. 6

Four *braccie* of purple yarn for hosiery f. 8

Five *braccie* of the lightest Flanders cloth f. 10

A piece of dark purple cloth for hosiery, of about 39 br. f. 39

A little piece of Lucchese twill [silk] of about 6 br. f. 14

A carpet-weave table cover of 3½ br., striped, of many
colors in the Moorish fashion, of silk and wool f. 5

Ten *cappucci*, three worn pink ones, five of loose-weave cloth,
two of black cloth f. 15

A *guardacuore* of Lucchese silk, that is, a bodice with sleeves,
to wear at night f. 1

Seven *berrette*, from purple to rose, both double and single f. 1

IN THE WATER CLOSET OF THE SAME CHAMBER

A cedar table with a trestle base, — br. long f. 10

A washtub on feet		
A barber's bowl	all of brass,	
A basin for hand washing	weighing 30 *libbre*	f. 3

A brass candlestick	
Two lamps with brass bases	
A round bronze bucket with two funnels	
A pewter jug	f. 2

IN THE ARMORY OF PIERO ABOVE THE WATER CLOSET

A man's suit of jousting armor, of plain iron, that is, helmet,
pauldrons, cuirass, brassards, greaves, and cuisse f. 20

A suit of armor made for Piero de' Medici, complete with everything,
that is, a helmet with two visors, a cuirass with two breastplates,
two pairs of pauldrons, two double and two single ones, a pair of
brassards with double guards, a scabbard, cuisse, greaves, a pair
of gauntlets, and a sallet with a visor, and an accessory for a lance,
all of it with gilt decoration f. 90

A jousting cuirass made for Lorenzo, covered in sky-blue velvet,
decorated with vine scrolls, and lance rest and pauldrons and straps f. 15

A jousting cuirass made for Giuliano di Piero [Lorenzo's brother],
covered in white velvet, decorated with vine scrolls, with lance rest
and pauldrons f. 15

[folio 46 recto]

Two jousting cuirasses in the Neapolitan fashion, one covered with green
velvet, the other with sky-blue velvet, both decorated with vine scrolls f. 20

Three jousting plastrons covered in leather, that is, two covered
in white leather and one in red leather, all decorated with vine scrolls f. 20

One plain cuirass, burnished and decorated with buckles and
silver studs f. 6

Two plastrons, one covered in purple velvet, the other in tan velvet f. 20

A pair of greaves and a pair of cuisse for Lorenzo, gilt and with
decoration of red satin f. 6

A half suit of armor with many gilt accessories, made for
Giuliano di Lorenzo [Lorenzo's son], as described here and estimated:

A bare gilt cuirass
A pair of gilt greaves
A pair of gilt cuisse
A pair of gilt sleeves
A pair of gilt elbow guards
A pair of gilt pauldrons
A pair of gilt gauntlets
Head armor and a collar for a horse, gilt | all the above f. 40

A collar of gold brocade with silvered chain-mail shirt,
with two silver buckles and tongues f. 1

A back and hip protector of iron chain mail with the front
piece in brocade f. 8

A steel sallet helmet with an iron gorget, all decorated in silver f. 25

A shield and horse-head armor in the Turkish fashion decorated in
gold and with the colors of the Duke of Calabria f. 8

A gilt and silvered iron mace with a gold and silver strap f. 2

A set of head feathers for a horse, with fringes in the middle of
silver and gold f. 1.10

A sallet helmet plumage, in gold thread f. 4

A *farsetto* of pale satin shot with silver and a *farsetto* of sky-blue
satin, both for Giuliano [Lorenzo's brother] f. 4

A *giornea* in the Lombard style to put over the cuirass, of purple
satin, all embroidered in gold and silver thread, and with the
colors of the Duke of Calabria, that is, with the inscription and
rings and the name "Giuliano" f. 50

[folio 46 verso]

A sallet helmet with a visor, and a brass San Giorgio	f. 2
Two steel visors	f. 1
A jousting helmet with the arms of the Medici and the Tornabuoni, with foliage and vine scrolls and a diamond, in gilt silver	f. 100
A jousting helmet with the arms of the Medici and others, with vine scrolls and foliage, in silver	f. 60
Two Neapolitan jousting helmets	f. 30
Six large jousting helmets	f. 120
Two jousting shields covered in steel	f. 20
A vambrace [forearm guard] with a silver sun at the elbow	f. 12
A large jousting shield covered in bone and gilt	f. 10
A blue jousting shield covered in bone	f. 6
A silvered and gilt shield with the arms of the family	f. 8
Five gilt Spanish-style knives	f. 30
A back and hip protector of torn chain mail for Piero di Lorenzo [Lorenzo's son], decorated with vine scrolls	f. 20
Four tips for jousting lances, one of which is gilt	f. 4
Two gilt points for lances	f. 4
A Spanish pike, painted and gilt	f. 1
Three pairs of side armor and back and hip armor	f. 24
A steel breastplate, beaten up	f. 6
Two jousting back and hip armors of thick chain mail	f. 4
A pair of chain-mail leggings	f. 2
Five gorgets, four small and one large	f. 1
An iron jacket, that is, of iron chain mail	f. 2
Two pairs of brassards with silver buckles	f. 1

Two pairs of gauntlets in the German fashion f. 6

A woolen *giaco* [jacket or overcoat] covered in briarwood cloth f. 3

A layered cuirass, that is, of thin plates, to be worn underneath f. 3

Two shields for jousting f. 1

[folio 47 recto]

Nine lance points, f. 1, and 27 tips, f. 4, altogether f. 5

Seven points and five hand guards for lances f. 6

Four pikes decorated with gold f. 1

A brass one-handed hatchet with a gilded handle
An iron mace with spikes f. 2

Six jackets and tunics for jousts f. 6

Seven headdresses for horses
Seven bridles for horses Made in the Turkish fashion f. 3

Ten pairs of spurs, both for jousts and for other uses f. 3

Seven pairs of stirrups of several kinds f. 1

Seven horse bits of several kinds f. 2

A piece of surcingle and ribbons to make up a horse's tail f. 1

A poplar-wood cupboard with two doors, of about 4 br.,
within which are: f. 1

Eleven large mule bells f. 2.10

Thirty small bells f. 6

Seven large bells and twelve iron bells f. 1

Two hundred iron bolts for crossbows f. 2

Nine very ingenious door locks with keys, of several kinds f. 9

Two beautiful hooks to hang scales f. 2

Eleven two-handed swords decorated in gold f. 20

Four large rapiers and one small, one of which is three-sided f. 8

Thirteen swords of various kinds, both gilt and not f. 13

Two horns of black bone

Thirteen beautiful crossbows f. 70

Three steel swinging maces f. 14

Sixteen Turkish bows, beautiful f. 60

Thirteen crossbow stocks with several metal bows and bolts f. 6

Four targets and one Turkish crossbow target f. 8

Five crossbow winches and a double crossbow winch f. 8

Two cases of crossbow bolts

[folio 47 verso]

Three large battalion batons and one small one f. 16

Six levers and two belts f. 3

A chest with many boxes, one beak cover, a pair of pliers, and
a needle case, and several tools for birdcalls and to cut the beaks
of birds, and in the drawer several hoods and hood molds for birds f. 6

A cabinet, or rather chest, within which are:

Three taffeta banners, on one of which is painted a woman, and on
another a figure of Fortuna, and on the other a falcon, and lots of livery f. 50

Three square flags of yellow taffeta, all decorated with balls f. 12

Four pennants and two trumpets and a little trumpet f. 10

Six horse drapes and six *giornee* for riders, that is, all in taffeta
and with much painted decoration and livery colors f. 40

A decorative bridle set and a [horse's] breast piece and a rump cover,
all embroidered in silver, and a saddle cover with a frieze of gold
around, and a headpiece for a horse, embroidered in the same
fashion, that is, in square pattern, and other pieces of silver and
also plaques, and we estimate all the silver at about 3 *libbre* f. 40

Several fine gold embroideries, an estimated 30 ounces
of gold thread, valued at f. 10

A *pitoco* [cloak] checked with stripes in a connected pattern,
embroidered entirely with plaques of silver, as above f. 6

CONTINUING THE INVENTORY INTO
THE ANTECHAMBER OF PIERO

A pine wall paneling with walnut panels and borders and intarsia,
about 7 br. long, with a cornice above for a bookshelf, and below
cupboards with two doors decorated in the same fashion f. 10

A little bookcase with several books, and a drawer and a writing
stand, all of walnut f. 1

A cypress table, 4 br. long, with a trestle base f. 1

A carpet table cover on the table, 5 br. long f. 3

A coffer chest with much intarsia, 1½ br. f. 1

A tabernacle of ivory with twelve glazed compartments, within which
are stories of Christ and in the middle a picture of the Crucifixion f. 10

[folio 48 recto]

A round mirror with an ivory frame with seven compartments,
within which are seven Virtues f. 10

A little square panel by Fra Giovanni [Fra Angelico] of Christ on
the cross with nine figures around f. 12

A plain bedstead, 4 br. long, with a step-plinth around, of walnut
and intarsia, and bedposts and straw mattress f. 1

One mattress of wool and one of cotton batting
A down comforter and a pillow full of feathers, weighing — lib. f. 10

A thin bedspread and a white Catalan-style cover f. 3

A white counterpane, beautiful, for the same bed f. 7

A pine bed-settle with a *cassone*, framed and inlaid in walnut,
with a balustrade back f. 8

Two bench pads, one of green fabric full of cotton batting and
the other of sheepskin with wool f. 2.10

A white bedspread for the bed-settle　f. 1

An ivory horn, 1 br. long, with rings of silver　f. 6

A steel hatchet hanging from the bench　f. 2

A white spread for the bed in the *cassone* of the bench　f. 2

A tapestry panel of foliage　f. 6
A beautiful carpet table cover　f. 5　　f. 11

An alabaster plaque put into a frame, the frame of ivory inlay　f. 4

A painting of a portrait from life of the head of
Madonna Alfonsina [Orsini, wife of Piero]
A Flemish painting in which is the head of Christ and the Madonna　f. 1

Two panels of pale taffeta, painted with inscriptions in gold
and fringed in pale silk　f. 4

A statue of Saint Francis in the round　f. —

A tabernacle in a diamond shape, depicting Our Lady with
the child in her lap　f. 2

Three cocoanuts above the cornice of the writing desk

A bed tester over the bedstead in the bedroom, depicting Fortune
by Sandro di Botticello

A bronze relief, the Triumph of Bacchus, with twenty-one figures　f. 10

A mirror with plaster decoration attached to the shelf　f. —

Two little women's books written in pen and illuminated in gold　f. 10

[folio 48 verso]

A pair of little silver knives with a fork
A large silver cast of a lamb　f. 4

Sixteen women's *camicie* [shirts], beautiful, of linen
Sixteen women's aprons, of linen　f. 20

Eight thin flax towels, some old, some new, and eight coarse
ones from large to small　f. 8

Six French linen handkerchiefs and twelve bandages　f. 1

Two pairs of paternosters, one pair in amber with seven gold beads,
the others with seven silver beads, altogether f. 6

IN THE MEZZANINE ROOM OF THE ANTECHAMBER OF THE *TASCHA* [BANK ASSETS]

A poplar-wood bedstead of 5 br., surrounded with bench lockers
with four lids with a trestle base and cane lattice mat f. 3

| A straw mattress | Of white flax and cotton, | |
| A mattress | full of cotton batting | f. 2 |

A down comforter and two pillows full of chicken feathers f. 6

A white bedcover, poor
A blanket serving as a coverlet
A red fringed coverlet, old f. 3

A poplar-wood bed-settle with a *cassone* with two
lids and with a clothes rack, 3½ br. long f. 1

A thin mattress full of hemp
A carpet-weave cover for the bench f. 2

Eight mattress covers, all of white Neapolitan cotton flax f. 16

A little piece, 18 br., of thin white cotton flax f. 1.10

A duvet, 8 br., crisscrossed with blue cotton wool f. 5

A poplar-wood cupboard completely veneered in walnut with eight
doors, 5 br. long by 1½ br. deep by 4 br. high, within which are: f. 8

Three *mantellini* [short capes] for children, of light gray cloth, doubled f. 1

A *mantellino* of Montvilliers cloth, lined in fine squirrel f. 5

[folio 49 recto]

CONTINUING IN THE SAME MEZZANINE ROOM OF THE ANTECHAMBER OF THE *TASCHA* [BANK ASSETS]

| A blanket of satin lined with silk | f. 1 | |
| A blanket of Montvilliers satin lined with squirrel | f. 3 | f. 4 |

A *mantellino* in gray damask lined in ermine f. 12

A blanket of gray damasked satin lined with ermine	f. 10
A cover of tan velvet satin in two pieces, lined in fine squirrel	f. 16
A cover lined in green taffeta and tan velvet	f. 4
A *mantellino* of tan velvet lined in young animal fur	f. 10
Several pieces and sheets of satin	
Three gilt Neapolitan-style boxes, within which are:	f. 2
A bolt of thin cloth of 64 br.	f. 6
Fifty br. of coarse linen in several pieces	f. 4
Thirty br. of coarse linen	f. 1
Five coarse linen towels	f. —.14
Thirty towels in the Neapolitan style, in a set	f. 4
Three large Neapolitan-style towels in a set, 8 br. long	f. 4
Five large family [household] towels in a set, 7 br. each	f. 3
A *bernia* dyed with madder	f. 1
A copper basin, jug, and pitcher, weighing 25 lib.	f. 2
A brass candlestick and a lamp with a base and an iron lamp	f. 1

IN THE ROOM ABOVE THE ANTECHAMBER OF PIERO

A cypress chest of about 3½ br., within which are:	f. 2
Five cotton-wool quilts, 7 br. long by 6 br. wide	f. 20
Two blue duvets full of cotton batting with tablecloth decoration, each 5 br. long by 6 br. wide	f. 12
A dog's bed of green taffeta of Levant workmanship	f. 4
Nine gilt boxes in the Neapolitan style, within which are:	f. 9
A canopy bed-curtain set with a draw cord of purple damask and embroidered at the opening in gold and silver	f. 20
Two sets of napkins, twelve napkins per set, altogether twenty-four	f. 8

A French linen tablecloth, 4 br. wide by 16 br. long f. 8

Four sets of tablecloths of many sizes
Three sets of tablecloths of many sizes
Four sets of runners of many sizes f. 28

[folio 49 verso]

A piece of French linen of 30 br., a little narrower and beautiful, f. 10
A piece of French linen of about 32 br., f. 10 f. 20

Five pieces of white linen cloth from Cairo f. 50

A remnant of the same thin linen cloth from Cairo, of 14 br. f. —

Eight thin handkerchiefs in a set f. 3

Ten hairdressing towels in a set and with a fringe of thread f. 5

Eight thin towels of 3½ br. each, in a set, for hairdressing f. 3

Twenty wide towels of 2½ br. each, for the bed-settle f. 3

Ten face towels, rounded, 3½ br. each f. 2

Twenty-five face towels, thin, of — br. each, with white stripes f. 2

Three and a half thin towels, for widowed women f. 12

Three pairs of old sheets, well used f. 4

Twenty-four *camicie,* both men's and women's f. 24

Eighteen French linen handkerchiefs, with fringe of thread f. 3

Six towels without fringe, of thin cloth, 3 br. each f. 2

Seventeen French linen towels with fringe of thread and wide
embroidered plaid pattern f. 8

Fifteen French linen pillow covers, from large to small f. 4

Thirty face towels from large to small
Twenty-four shaving towels from large to small
Eight thin towels without stripes f. 10

Three towels with decorated fringe
Six women's aprons f. 4

Seven bandages to wrap around, three handkerchiefs — f. 1.10

Forty-five *camicie* of French linen, half-length — f. 10

Nine *vestiti* [dresses] of tan cloth for the use of
Clarice of Piero [Lorenzo's wife?] — f. 5

Seven pillow tassels with pearl buttons
Eight pillow tassels with buttons of gold and silk twist — f. 12

Pieces of fabrics of many kinds of velvet and satin — f. —

Twelve pairs of satin *maniche* [sleeves] of several colors and sizes — f. —

A half br. of Lucchese [silk] cloth — f. 10

[folio 50 recto]

Three caskets inlaid and decorated with ivory in the Damascus style — f. 10

A *mantellino* of green French linen cloth of eight sections and a
border with gold embroidered interlace studded with enamels — f. 25

An apron of sheer cloth edged in silk with cords and fringes — f. 4

A *camicia* decorated by hand with sides of gold and silk — f. 10

A large towel of nettle cloth, decorated at the top with vine scrolls
of gold and silk — f. 20

Two towels of nettle cloth that have, instead of stripes, gold and silk
foliage, with symbols of the Medici and Medici livery and gold fringe — f. 12

Three towels of nettle cloth, one with a gold band around and
a fine gold fringe — f. 9

Two brass spittoons — f. 1

IN THE CHAMBER OF THE *TASCHA* [BANK ASSETS]

A marble tabernacle, within which is Our Lady in relief — f. 10

Four panel pictures, depicting four and a half figures, or rather, four — f. —

A poplar-wood bedstead, 5½ br., with walnut moldings and intarsia with
a step-plinth around, and a trestle, cane lattice mat, and straw mattress — f. 6

A poplar-wood box-settle of 4 br., with walnut moldings and intarsia f. —

A poplar-wood cabinet, ⅔ br. high by 2½ wide, with an assortment
of pharmaceutical herbs and other things f. 2

An antique walnut *cassone*, in which are kept the assets of the bank f. 3

A sheepskin mattress full of wool f. 2

A down comforter and two pillows full of feathers f. 10

Two white quilts full of cotton batting f. 4

A coarse white bedspread, plain f. 2

One bench mattress full of wool and one full of stuffing,
for the bed-settle
A white bedspread and a leather pillow f. 1

A white quilt full of cotton batting f. 2

A worn tapestry panel of foliage, 8 br. f. 5

A large tapestry-weave table cover of 4½ br., and one of 3 br.,
and one of 2½ br., making three in all f. 6

A green bedcover, painted, 8 br. long f. 1

A bed-curtain set, or rather, two pieces of hanging curtains and
an iron frame around the bed with a blue painted canopy f. 3

**Continuing in the box-settle *cassone* of the chamber of the
tascha *[bank assets]***

[folio 50 verso]

A rose *gammurra* without sleeves f. 10

Two *gammurrini* for women, pink f. 3

A *guardacuore* [tunic] of pink cloth, lined in purple high-low velvet
[velvet pile cut at different heights to create a pattern] f. 2

A *cioppa* of Lucchese silk with facings of purple
satin and with seven enameled buttons in front f. 18

A *cioppa* of purple loosely woven cloth with four
buttons of the same kind as above f. 8

A *cioppa* of mixed fabrics f. 5

A *gabbanella* of gray Flemish cloth f. 3

A *gabbanella* of purple cloth, worn and without sleeves f. 3

A *robetta* of rose cloth lined in scarlet satin with six enameled buttons f. 16

A *robetta* of wool from London, beautiful f. 6

A *cioppa* of loose-weave fabric lined with sable, worn f. 12

A *robetta* without sleeves, of purple fabric, worn f. 3

A *turca* of purple fabric, lined in silk f. 6

A *bernia* of Frisian wool f. 2

A *cotta* of white damask with sleeves of crimson satin f. 8

A *cotta* of gray damask with sleeves of crimson satin f. 8

A *cotta* of white camlet with sleeves of tan satin f. 8

A *cotta* of green-yellow camlet with sleeves of black satin f. 8

A *robetta* of tan satin with sable facings f. 15

A *cappa* of purple fabric with the hood in green velvet f. 6

A *robetta* of fine black twill f. 4

A *cioppa* of fine monk's cloth f. 4
A *roba* of fine monk's cloth f. 4

A *cotta* of tan satin with sleeves of black satin f. 8

A *roba* of purple velvet with facings of Spanish cat f. 22

Clothes of Giuliano and other things
A *mantello* of black twill f. 7

A *mantello* of black fabric f. 6

A *gabbanella* of black fabric f. 2

[folio 51 recto]

A black cloth *cappa* f. 4

A black cloth *gabbano* f. 4

Two *pitochi*, one of black velvet and one of cloth, and a silk *farsetto* f. 2

A brass chain for legs weighing 20 lib.

A copper jug, weighing 7 lib.

A candlestick, a lamp with a brass base

A pair of andirons, tongs, shovel, and a fork f. 2

A bronze head of a child f. 1

A scimitar in the Bolognese style, with the hilt of silvered
copper, and a scabbard, altogether f. 3

IN THE ANTECHAMBER, THE CHAMBER OF THE WET NURSES

A wooden flat lunette with a painting of Our Lord, with a marble
frame around f. 4

A poplar-wood bedstead of 5 br., decorated with walnut and intarsia
with benches around, straw pallet, cane lattice mat, and trestle f. 3

A bench-settle with a canopy, of 4½ br., with walnut veneer
and many garlands of spindle wood, and intarsia f. 2

Two poplar-wood *cassoni* with walnut back panels and intarsia,
7½ br., altogether f. 3

Two coffers strapped with iron
A poplar-wood casket of 1¼ br.
Three upholstered women's chairs
A hat press
A small chest in the latrine and a cabinet f. 3

A bronze infant weighing 28 lib. f. 8

A chain and two copper pitchers weighing 20 lib.
Two brass candleholders f. 1.10

On the bed
A mattress of sheepskin full of cotton batting f. 4

A down cover and two pillows full of feathers, weighing — lib. f. 10

A blue bedspread with Venetian embroidery f. 2

A plain white bedspread in a herringbone pattern f. 1

Two pieces of bed curtain of green cloth, painted f. 2

[folio 51 verso]

A bench mattress full of wool
A carpet-weave cover for the bench f. 2

Two bedspreads for the bench, torn, 2 lib.

A bed quilt, 8 lib.

A white Catalan-style blanket, 12 lib.

A tapestry-weave blanket of foliage, trees, and animals, 7 br., 18 lib.

Two leather pillows

A child's *turca* of scarlet taffeta, padded with cotton batting f. 7

A pair of andirons, a shovel, tongs, fork, and a lamp, — lib. f. 1

A lance, 7½ br. long, for various purposes f. 6

In the cassoni
Two pieces of white damask for the lining of a *cioppa* f. 3

A *giachetta* [woman's overdress or overcoat] of black taffeta f. 4

A *giachetta* in the form of a *giornea* in the Neapolitan style,
of white satin lined in iridescent taffeta f. 6

A *cotta* of tan-gold satin, without sleeves f. 10

A *giachetta* of green taffeta f. 5

A *giachetta* of crimson taffeta f. 8

A *giachetta* in the form of a *cioppa* with a bodice, all in crimson taffeta f. 7

A *cotta* of crimson taffeta with purple satin sleeves f. 8

A *cotta* of Levant taffeta with faded black decoration f. 4

A *cotta* of green silk with tan satin sleeves f. 4

A *cotta* of purple satin, stained all over f. 6

A *cotta* of black satin lined in purple taffeta, stained f. 8

A *giachetta* of sky-blue satin lined in red taffeta f. 8

A *cotta* of gray camlet with sky-blue satin sleeves f. 4

A purple satin *roba* lined in red taffeta, new f. 16

A *cioppa* of Milanese twill of Lucchese silk with taffeta facings f. 6

A *cotta* of faded tabby with purple satin sleeves, stained f. 4

A *roba* of purple tabby, beautiful f. 12

[*folio 52 recto*]

A *roba* of crimson tabby, half-length f. 8

A *bernia* of green satin shot with gold, lined in gray wool velvet f. 16

A *cotta* of tan velvet with sky-blue satin sleeves f. 10

A *roba* of tan velvet lined in fine squirrel f. 28

Four *busti* [bodices] for women with newborns, one of white damask,
two of silk, and one of white cloth f. 1.10

Four quarter pieces of a *gabbanella* of gray satin, old f. 2

Three sacks, within which are numerous cuttings of cloth
and fabrics of many sizes and colors f. 4

A pannier within which [are] three pairs of beautiful scissors,
decorated in gold, and two pairs of little shoes decorated in gold f. 2

A *cotta* of purple high-low velvet	Belonging to
A *roba* of black velvet,	Madonna Clarice [Lorenzo's wife]
without sleeves, well used	f. 20

Linens in the two chests

Nine pairs of sheets in two pieces for the dog's bed, each piece 5 br. f. 4

Seven *camiciotti da bagno* [bath shifts], both torn and intact f. 1

Twenty-three pieces of cloth of many kinds, about 6 br. each
Two *camiciotti da bagno* and many pieces of linen of various kinds f. 3

Flax yarn

Fifty-two lib. of coarse raw flax, 10 s. per lib. f. 4

Fifty lib. of white flax thread of three kinds, almost the same thing f. 13

Nineteen lib. of fine white flax thread, almost the same,
at 3 lib. and 10 s. [*sic*] f. 11

— lib. 2 ounces of the thinnest flax thread for towels f. 2

One and ½ lib. of coarse black cotton thread for embroidery f. 1.10

Five assorted boxes and caskets painted in the Neapolitan fashion
A Moorish cane basket, and a book in the shape of a box f. 2

IN THE CORRIDOR THAT LEADS FROM THE CHAMBER OF THE *TASCHA* [BANK ASSETS] TO THE VESTIBULE OF THE CHAPEL

Five poplar-wood and pine benches, some with walnut moldings and intarsia panels, some not, altogether 30 br.	lb. 12 [*sic*]	
A pine table, 12 br. long, with a trestle base	lb. 12 [*sic*]	
A poplar-wood cabinet, 2 br. high by 1½ br. wide	lb. 2 [*sic*]	
A painted birth salver	lb. 6 [*sic*]	
A walnut table of about 1½ br.	lb. 1.10 [*sic*]	f. 5

[folio 52 verso]

A painted canvas on which are depicted a dinner table with
many figures, a fountain, and other things, French, about 6 br. long f. 3

A tinned iron candle holder, holding a torch-shaped
wood-and-brass lamp, and four upholstered women's chairs f. 1

IN THE DINING ROOM WHERE THE SERVANTS EAT

A poplar-wood slab table 12 br. long, with three trestles
Two poplar-wood benches 11 br. long
Two cabinets, one 4 br. high by 2 br. wide and the other 1½ br. on a side
An oak table, about 2 br.
A sconce of tinned iron fixed in the wall, and two pewter lamps
Two buckets for the well in the room, with an iron chain
and a rope and pulley f. 7

IN THE KITCHEN

A poplar-wood slab table, 5 br. long, with two trestles
A table of 3 br. and ten stools and a chair
A table cabinet with three doors and two shelves, of 7 br.
Two benches to sit on of 12 br. both together f. 4

Twelve plates, that is, four large, four medium-size, and four small
Thirty-three pewter plates, or rather platters,
altogether weighing 115 lib. f. 10

Thirty-five soup bowls	Of pewter and belonging	
Thirty-five bowls	to the masters,	
Forty soup bowls and four family small bowls	weighing 130 lib.	f. 11

Two large pewter jugs, or rather pitchers, weighing 20 lib. f. 2

Thirteen copper bowls, assorted from large to small,
weighing 126 lib.
Two copper tubs to hold water 24 lib.
Seven assorted copper pitchers from large to small 46 lib.
Three large copper saucepans and one pot 13 lib.
Ten assorted copper cooking pots from large to small,
of which two are to make poached eggs 45 lib.
Four cauldrons, three large pots, and a saucepan 90 lib.
Eight assorted cast-iron frying pans from
large to small, weighing 40 lib. 8 lb. [ounces?]
Eight pot covers and eleven baking trays 50 lib. 10 lb. [ounces?] f. 25

[folio 53 recto]

Eleven iron tripods of various sizes 51 lib. 6 lb. [*sic*] f. —

Four iron grills 32 lib. 4 lb. [*sic*] f. —

Two iron drip pans 17 lib. 4 lb. [*sic*] f. —

Three graters, twelve ladles, five copper saucepans — lib. 6 lb. [*sic*] f. —

Eighteen assorted iron roasting spits from
large to small 200 lib. 20 lb. [*sic*] f. —

Three wooden roasting spits with iron ferrules — lib. 1 lb. [ounces?] f. —

Three pairs of andirons, one pair of tongs, two forks,
two shovels, one fire chain, altogether 200 lib. 20 lb. [*sic*] f. 13

Six assorted majolica plates, from large to small f. 1

Many earthenware plates, soup bowls, dishes, and large bowls
Many shallow wooden bowls and trenchers
A wooden hen coop
Four rough kitchen knives
Three circular iron pot racks to hang things on f. 8

A pair of buckets for the well with a chain, a rope, and a pulley f. 2

In the kitchen pantry
Nine large platters
A majolica wine cooler with a base
Six majolica plates All of fine quality
Another majolica wine cooler with a base
Five majolica jars of many uses f. 8

Four wine coolers All this tableware is
Two large dark-colored jars terra-cotta from
Many plates, soup bowls, bowls, and Montelupo, beautiful
other vessels f. 4

Four brass chafing dishes, weighing 14 lib. f. 1

A basin for hand washing and a wine cooler, both of brass
and with silver enamels, all broken, in all
A brass barber's basin
A brass water pail
A brass watering can f. 3

Twenty-eight brass candleholders of many sizes, old
Two brass lamp bases in the form of candleholders
Three brass oil lamps f. 4

A small wine cooler and a wine cooler with a base, damascened f. 10

A small bronze mortar and a pestle, weighing 20 lib. f. 1.10

[folio 53 verso]

Two copper jugs and two pitchers			
A barber's pail		All these are	
A basin to wash feet in		of copper	
A cauldron and a copper saucepan			f. 4

Twenty-eight beautiful oil lamps from Pistoia f. 1.10

A large pewter platter, weighing	20 lib.	
Twenty-two plates, a little smaller, weighing	140 lib.	
Twenty-four middle-size plates, weighing	90 lib.	
Fifty-three flat plates, or rather round dishes	90 lib.	
Fifty-five soup plates with wide rims, weighing	100 lib.	
Twenty-four smaller old soup plates, weighing	37 lib.	
Forty-four dishes weighing	37 lib.	

Thirty-two soup plates	Small, for		
Thirty-two dishes	the family	42 lib.	
		556 lib.	f. 46

Fifty-seven pewter vessels, of many sizes, old and broken f. 4

A poplar-wood cabinet, 2 br. wide by 1½ br. high
A credenza used as a table, of 4 br. of spruce wood
A poplar-wood casket, 2 br. long
Two stools to sit on, also several barrels and panniers and boxes
A little chest paneled in walnut, of 2 br. f. 4

A clock to strike the hour in a little cabinet, with all its
counterweights and apparatus f. 2

IN THE CHAMBER OF MONA [I.E., MADONNA] MEA

A bedstead of plain poplar wood, 4½ br., with trestle, cane lattice
mat, and a straw mattress f. 1

Two poplar-wood *cassoni* with three lids, each 11 br. by 1½ br. high f. 4

A shelf around the room of wood planks, of about 24 br., with a cornice f. 1

A poplar-wood cabinet with two doors, 5 br. long by 2 br. high f. 2

Seven caskets of various woods of about 1½ br. each
A little cupboard ⅔ br. on a side
A small chest of 2 br., with a walnut lid
Two little antique chests used as coffers f. 3

A pair of little knives decorated with silver in the antique fashion f. 1

A sheepskin and canvas mattress full of wool f. 2

A down comforter and two pillows, full of good feathers f. 7

[folio 54 recto]

A blue and green quilt full of cotton batting
A white bedspread, poor condition f. 2

Twenty-one large pillows full of feathers, for a bed-settle f. 7

Sixty-three little pillows full of feathers f. 11

One pair of large brocade pillows, full of feathers f. 10

Ten and a half pairs of sheets of three pieces each, 8 br. each piece,
from good to poor condition f. 16

Five pairs of sheets of 4 pieces each, beautiful, 8 br. each piece f. 40

Nine pairs of sheets of 4 pieces, 8 br. each piece, from good to poor f. 40

Twelve large bench-settle towels, of 5 br. each, high quality f. 3

Thirty face towels of 3½ br. each, high quality f. 4

Twenty foot towels, 3 br. each f. 2

Thirty-one head towels, that is, for drying the hair f. 1

Twenty-one hairdresser's towels, of which ten are of linen f. 5

Thirty-three pillow covers from large to small, beautiful f. 6

Twenty-one pillow covers, large and beautiful f. 4

One hundred and seventeen pillow covers, from small to large f. 10

Fourteen new small pillow covers, ready to be sewn f. 1

A small white spread, to cover baskets f. —.10

Thirty-three pairs of sheets for the family, of three or four pieces
each, 6½ br. each piece, from good to very bad condition f. 33

Ten pairs of sheets for the clerks, of three or four pieces, 7 br.
each piece, from good to very bad condition f. 15

Two and one half lib. of pure silk and 6 ounces of doubles, in all 3 lib. f. 5

Three pieces of red Moroccan leather f. 1

Seven old laundry bags f. 1

A beautiful fireplace set fashioned in the Milanese style,
including shovel, tongs, fork, and rake f. 2

Nineteen family towels of assorted sizes f. 8

Nineteen coarse hand towels for the family f. 2

Fourteen linen tablecloths	From small to large, used,	
Fourteen linen runners	in all br. 400	f. 100

Fifty napkins and two round tablecloths, of linen f. 6

Two tablecloths in the Parisian style, with the runners, 14 br. each f. 4

Eleven beautiful tablecloths, decorated f. 4

[folio 54 verso]

Eleven table-linen sets for the masters, in which are the below-mentioned
prominent items, that is:

A tablecloth of linen, and a runner, 8 br. each
Two tablecloths, one of French linen, the other not, 7 br. each
Twenty napkins, half of French linen, the other half Parisian
Two roller towels, 6 br. each
One tea towel, a salad sack, and a napkin for knives f. 120

A French table-linen set, which is without napkins and everything else f. 7

Two table-linen sets, in the first of which the tablecloth and the runner
are in the Parisian style, the tablecloth and the runner 12 br. each, 24 br.
in all, another set carried by Lorenzo when he went riding and includes
tablecloth, runner, twelve French linen napkins, one homespun credenza
cloth, a tea towel, a hand towel, a sack, and a napkin f. 14

A French table-linen set, including a tablecloth and a runner of 12 br. each, twelve French linen napkins, a credenza cloth of 6 br., locally made, in the Parisian style, a roller towel of 6 br., a tea towel, a salad sack, and a knife napkin f. 6

Five table-linen sets of local tablecloths, with these things, that is:

A tablecloth and two runners of 12 br. each, in the Parisian style
A credenza cloth, of 8 br.
A roller towel of 6 br.
Two napkins of 6 br. each, to wash the hands
Fourteen napkins and one tea towel and one napkin for the knife f. 20

Six tablecloths with runners in the Parisian style, 12 br. each, all used f. 8

Six table-linen sets for the table of Lorenzo, for a change
Two tablecloths of 3 br. each, poor condition locally
One tablecloth of 3 br. and two napkins made f. —

Six roller towels, 6 br. each, of local cloth f. 2

Sixteen French linen *camicie* [shirts] for Piero, from good
to poor condition f. 8

Five French linen *convercieri* [undershirts] for Piero
Seven French linen handkerchiefs for Piero, and seven French
linen caps in the German style for Piero
Several French linen collars to attach to a *farsetto* f. 3

Fifty-one lib. of combed linen thread, and a round
wine cooler with a damascene base f. 8

[folio 55 recto]

CONTINUING THE INVENTORY IN THE BREAD ROOM

A new kneading trough, handsome, 4 br.
An old kneading trough, 3 br.
A *cassone* with two lids, 4 br.
A table to flatten the bread, 4 br.
A box to hold the bread
Two flour casks both together holding 40 bushels
Ten barrels and nine large bread planks
A bench-settle to lay out the bread for rising, 7 br., with a big sack f. 10

An iron stove and a copper bed warmer
Two copper pots and two copper pitchers, weighing 60 lib. f. 5

A bushel and a half of wood
A large iron tripod, weighing 24 lib. f. 1

A large steelyard, weighing 400 lib. f. 2

Seven sifters, from good to poor condition
A large shaggy spread
Three *camiciotti* [smocks] to wear when using a sifter f. 1

Seven cloth pieces and towels for the bread, and four torn
aprons, white, gray, and red, and a box for ashes 3 br. high f. 2

Twelve earthenware jars to hold oil
Eight earthenware pitchers to hold oil f. 2

A plank shelf, 4 br.
A wooden table, 4 br.
Two copper saucepans to extract oil f. 1

Five *barili* of oil in the room, assorted from pinkish to vinegary
to chamomile to others f. 5

IN THE CHAMBER OF THE SERVANTS

Two poplar-wood bedsteads of 4½ br., with straw mattress, trestles,
and cane lattice mat, and a cupboard with two doors f. 3

Two crude *cassoni*, four lids, poor condition, 3½ br. each
A bench-settle of poplar wood, 3½ br., old-fashioned f. 1

Two sheepskin mattresses full of stuffing f. 1

Two down comforters and four pillows full of feathers f. 12

A red bedspread and a white bedspread and a red blanket,
poor condition f. 1

A majolica wine cooler and two plates, one whole and
one broken, two jugs f. 3

An old polyptych with many saints f. —

[folio 55 verso]

CONTINUING FROM THE CHAMBER TO THE FRUIT STOREROOM

Two spruce wood shelves running all around, 32 br. in all,
for the fruit f. 1

A poplar-wood cabinet, 4 br. long by 2 br. deep f. 1

Twenty baskets, four baskets, many other panniers of various
kinds and sizes and a number of pieces of wood for various purposes f. 6

A crude walnut cupboard, in which are more than four bushels
of provisions of various kinds, that is, altogether ten bushels f. 2

A bench of poplar-wood boards of ¼ br., with walnut moldings
A pair of flax combs and a pair of wool carders
A pair of painted cases, to hold silver f. 2

Two majolica wine coolers with flat bottoms f. 2

Five majolica plates, two large and three midsize f. 2

A majolica basin and three majolica wine ewers
Twelve majolica soup plates and eleven majolica dishes f. 3

Eight pewter plates, assorted from small to large
Three pewter jugs, assorted from small to large f. 2.10

A pair of large andirons and several small andirons, tripods,
shovels, and forks, in all weighing 100 lib. f. 2

Two damascened bronze wine coolers, decorated
A damascened bronze basin and wine cooler f. 12

Three brass wine coolers with bases, decorated in damascene,
weighing 30 lib. f. 6

Two brass wine coolers, with flat segments, decorated in damascene,
weighing 16 lib. f. 5

A brass pail 1 lib.
A wine cooler with a brass base f. 2

A brass candlesnuffer
Sixteen old brass candleholders of two sizes, and
three broken brass lamp bases, and four brass lamps f. 3

Three jars, from large to small
Two large jugs All of copper,
Four pots, or rather pitchers weighing 70 lib.
A water bucket f. 3

IN THE CHAMBER OF THE WET NURSES, NEXT TO THE ABOVE
STOREROOM

A lunette panel depicting a Saint Jerome f. 2

A lunette panel depicting Our Lady and many saints, broken f. —

[folio 56 recto]

Four canvases, consisting of four pictures painted in the French style,
one of about 2½ br. on each side, with the story of the Calumny [of Apelles],
the next of 2 br. by 2¼ br. with the story of Moses Crossing the Red Sea,
and the other two of 1 br. on a side with fat singers f. 4

A poplar-wood bedstead with walnut moldings and intarsia, and
a bench bed with a *cassone* attached to its foot, the bedstead 4½ br.,
straw mattress, and cane lattice mat f. 2

Three poplar-wood *cassoni* framed and paneled, with four lids,
altogether 11 br. f. 2

An old-fashioned chest [*forziere*] of 3½ br., all gilt f. 1

Two old coffers, antiques
A pair of trunks covered in skin with the hair f. 2

A poplar-wood casket of 1½ br.
A carved cypress-wood chair
Eight wool-winder spindles with their bases f. 1

A child's cradle, completely gilded and painted, beautiful f. 3

A large leather covering of 12 br., to put on a table
A leather cover for a bench-settle of 4 br., and two tanned bearskins
Three leather pillows, poor and torn f. 4

Two small pots and a copper tub, weighing 30 lib. f. 2

Four pieces of cotton/silk net, 70 br. each	f. 4	
A large thrush snare, of 100 br.	f. 4	
A net for doves, of — br.	f. 2	With six sacks, half
A large stork net, of — br.	f. 8	red, half white
Two songbird snares of green silk, 40 br. each	f. 4	
A net for doves, of — lib.	f. 2	
		Altogether f. 24

A picnic chest used as a table, within which are things to
use in the countryside, here below:

Two pewter plates	
Two pewter soup bowls	Altogether weighing
Two square pewter flasks	36 lib.
Four triangular pitchers	
Four small square pewter plates	f. 3

Two copper saucepans and a copper pan, weighing 6 lib., and a tripod, a
roasting spit, a skillet handle, a grater, a pair of tongs, and a shovel, in all f. 2

[folio 56 verso]

CONTINUING IN THE SAME CHAMBER OF THE WET NURSES: NEXT, MANY ARTICLES OF CLOTHING AND OTHER THINGS

Thirteen mule covers, old and torn, including six with white and
purple herringbone livery and six with vine scrolls embroidered
with foliage, and one black one embroidered with foliage f. 6

Two black saddle blankets f. 1

Two sky-blue velvet saddle blankets f. 3

Three old-style saddle blankets, two white and purple
and one green and gashed from the bottom up f. 1

An antique *giornea* with blue and red livery	
A black *cioppa* printed in antique style, with a collar	
A sack with belts and linings for *gammurre*	f. 2

A blanket, or rather a coverlet, for the bed, 5½ br., embroidered
in silk with foliage and four figures f. 3

A *turca* lining of lynx	f. 12
Fifty sable skins for linings and sleeves for *veste*	f. 12
Four squirrel-skin linings for *gabbanelle* and squirrel-skin linings for trousers, from good to poor condition	f. 4
Lining for a *turca* of white lambskin	f. 2
Lining for a *turca* of black newborn lambskin	f. 6
Thirty-nine beautiful new skins in a silk wrapping	f. 2
A beautiful goatskin with long fleece, or perhaps of another animal, all white Many pieces of skin, or rather linings of many kinds	f. 2.10
A *turca* of red satin, poor and old	f. 1
About 500 lib. of combed linen, from Pozzuoli and Viterbo	f. 40

ON THE TERRACE ABOVE

Thirteen long lances	f. 2
Two large lances for banners	f. 1
Four pikes with their handles	f. 1
Two short lances with handles	f. —.10
Three poplar-wood benches, about 16 br. A low bench and eight planks, all of beech	f. 2
Fifty-three red body shields with the Medici arms, with streamers	f. 53
A spruce table, framed in walnut, of 6 br., broken on one side and with four trestles	f. —.10

[folio 57 recto]

IN THE SALA GRANDE OF THE AFOREMENTIONED TERRACE

A pair of chests that make a table, with painted bases and two heraldic shields of fish and other things	f. —.10

IN THE CHAMBER OF THE SAME ROOM

A wooden lunette in which is begun the story of the Magi	f. —
A picture above the fireplace, in which are six figures of saints	f. —
Another picture in which is depicted the diagram of the moon, or rather the course of the moon in several stages	f. —
A poplar-wood bedstead of 5½ br., with moldings and frames in walnut, with many spindle-wood panels, with a bench chest around with four lids and a bench behind the bed, trestle, cane lattice mat, and straw mattress	f. 10
A sheepskin mattress full of wool	f. 2
A down comforter and two pillows full of feathers, weighing — lib.	f. 10
A blue bedspread embroidered in the Venetian style, 7 br. long by 6 br. wide	f. 3
A box-settle with a *cassone* and a clothes rack, all of poplar wood decorated in walnut, with much intarsia and spindle-wood panels, of 4½ br., with a leather cover	f. 3
Five pairs of coffers with heraldic arms, some covered with leather A pair of chests covered in leather with fur A wooden chest to store silver	f. 11
A *cassone* of poplar wood decorated in walnut with many spindle-wood panels, 3¼ br. long	f. 2
A wooden child's crib, with a little mattress and a down comforter	f. 1
A pair of andirons, a pair of tongs, a fork, and shovel	f. 1
Three horse coverings of pale taffeta, of which one is not sewn and the other two are painted with lots of livery and lined with blue canvas	f. 15
A saddle cover of white damask, edged in black velvet	f. 1
Eight taffeta *vestiti* of several kinds, with long gashed sleeves	
Two French-style *gonnellini* of sky-blue velvet, with silvered tinsel, and a *giornea* of pale cloth	f. 2

Four *camiciotti* [smocks] of white damask
Eleven white damask *farsetti* with the Medici arms and other things
Four half helmets covered in white damask, with four arms f. 20

[folio 57 verso]

IN THE ANTECHAMBER OF THE ABOVE CHAMBER

A poplar-wood bedstead of 4½ br. with a bench all around, straw
mattress, trestle, and cane lattice mat and a bench behind the bed f. 2

A down comforter and a pillow full of feathers, weighing — lib. f. 6

A blue bedspread embroidered in the Venetian style f. 2

A clothes rack in the old style, with three rows of pegs f. 1

A pair of poplar-wood *cassoni,* paneled in walnut,
with a compartment design f. 3

A pair of stepped-back *cassoni,* 3 br. each, with intarsia f. 3

A pair of *cassoni* with two perspective panels, 3 br. each f. 3

A poplar-wood *cassone,* with walnut frames and panels f. 1

A bronze lunette within which is Our Lady
A painting in the French manner, depicting Our Lady f. 2

A pair of little chests f. 2

Two white bedspreads, one for the bed in the chamber and
one for the bed in the antechamber, plain, without padding,
and a little bedspread for the box-settle f. 5

Linens and other things in the above-mentioned cassoni
A bolt of linen cloth of 5 br. per lib., 56 br. f. 6

A bolt of linen cloth of 6½ br. per lib., 104 br. f. 11

A bolt of linen cloth of 6 br. per lib., 96 br., very fine f. 10

A bolt of linen cloth of 4 br. per lib., 100 br. f. 10

A bolt of linen cloth of 4 br. per lib., 101 br. f. 10

A bolt of linen cloth of 4 br. per lib., 116 br. f. 12

A bolt of linen cloth of 6 br. per lib., 124 br., very fine f. 14

Fifteen towels in a set, for the head and for the feet,
coarse, and both small and large f. 2

A bolt of imported cloth to make sheets, 100 br. f. 8

A bolt of locally made cloth to make sheets, 80 br. f. 6

A bolt of locally made cloth to make sheets, 66 br. f. 5

A bolt of locally made cloth to make chemises, 140 br. f. 12

A bolt of locally made cloth to make sheets, 150 br. f. 24

A bolt of thin wool cloth, 7 br. per lib., of 70 br. f. 7

A bolt of coarse locally made cloth, 4 br. per lib., of 115 br. f. 9

A bolt of locally made cloth to make sheets, 104 br. f. 8

[folio 58 recto]

A bolt of locally made cloth to make sheets, 64 br. f. 5

A bolt of locally made cloth of the same thread, 64 br. f. 5

A bolt of imported cloth for sheets, 150 br. f. 24

A bolt of imported cloth to make sheets, 150 br. f. 24

Thirty-three towels for feet, in two sets f. 2.10

A bolt for tablecloths in the Parisian style, 54 br. f. 9

A bolt for tablecloths in the same thread, 48 br. f. 8

A bolt for tablecloths in the same thread, 76 br. f. 12

A bolt for tablecloths in the Parisian style, locally made, 80 br. f. 13

A bolt for tablecloths in the Parisian style, from the same thread, 100 br. f. 16

A bolt for tablecloths in the Parisian style, from the same thread, 32 br. f. 5

A length for table runners, woven in Parisian style, locally made,
totaling 120 br. f. 10

A length for table runners in a set, in the same style, 76 br. f. 16

Another length for several table runners in a set, in the same style, 76 br. f. 6

Another length for several table runners in a set, in the same style, 48 br. f. 4

Another length for several table runners in a set, in the same style, 44 br. f. 4

Another piece for several table runners in a set, in the same style, 48 br. f. 4

Another piece for several table runners in a set, the same, 36 br. f. 3

Another piece for table runners, the same, 74 br. f. 7

Another piece for table runners, the same, and there are also
some napkins, 124 br. f. 12

Eleven hand napkins, of the same thread as those above and
made with cutouts instead of stripes; they are 3¾ br. each f. 5

Sixteen napkins, 6 br. each, in the same thread, in a set f. 7

Fifty-five napkins in a set, of the same cloth f. 4

A piece of tablecloth material of locally made linen,
2⅓ br. wide, 80 br. long f. 25

A piece of tablecloth material in the above-mentioned
thread and width, 76 br. f. 24

A piece of table runner material in the same thread,
the one 54 br., the other 116 br. f. 19

A set of forty-six large napkins in the same cloth f. 4

A piece of imported French linen for tablecloths,
2½ br. wide by 60 br. f. 20

[folio 58 verso]

A piece of locally made cloth for table runners, in the
Parisian style, 88 br. f. 7

A piece of the same, in the same cloth, 110 br. f. 9

Five tablecloths in a set, each 6 br. f. 1

Eleven napkins in the same set, each 1¾ br. f. 1.10

Two coarse table runners in a set, almond-shaped, 20 br. f. 3

Two thin tablecloths in the Parisian style, 20 br. f. 6

Two more tablecloths of the same kind in a set, 20 br. f. 6

Two pieces of coarse tablecloth, for the family, 80 br. f. 4

Three remnants of white velvet with green parrots and gold
brocade, 8⅔ br. [*sic*]
A remnant of white velvet with gold brocade with branches
and garlands, and within each garland the Medici arms,
the whole piece 10 br. f. 40

A remnant of 2½ br. of crimson high-low velvet with gold brocade f. 8

A remnant of white velvet studded with gold,
patterned in diamonds and partridges, — br. f. 2

A remnant of green velvet woven with a gold brocade frieze
of plants, 1 br. f. 2

A remnant of crimson velvet, with gold brocade, woven
in an elegant fashion, 1¼ br.
A remnant of 1½ br. of very rich gold brocade damask f. 2

A remnant of purple damask, studded with gold f. 6

A dismantled *cotta* of purple damask with silver brocade f. 20

A *giornea* of green high-low velvet with silver brocade,
made in the form of a short cape f. 10

A *giornea* with the livery of Duke Francesco [Sforza],
called the "tunic of the dog" f. 20

A half *giornea* of white damask studded with gold used for tournaments f. 1

Another *giornea*, black with gold brocade, used for tournaments f. 6

A pale taffeta *giaco*, embroidered all over
A man's *farsetto* of damask with silver brocade
A boy's *farsetto* of damask with silver brocade
A *farsetto* of green satin embellished with silver
A *farsetto* of green satin shot with silver
A *farsetto* of pale satin shot with silver
A pair of sleeves for a *gabbanella*, faded, embellished in silver
 Altogether f. 15

[folio 59 recto]

A prize cloth of sky-blue silk velvet, lined in iridescent taffeta, and 14 br. of velvet	f. 10
A piece of crimson wool velvet of 5 br., valued at	f. 10
A piece of gray wool velvet of 1¼ br.	f. 2
An antique-style *vesta* with cape sleeves, all in crimson high-low velvet, purple velvet	f. 40
A long green velvet *vesta* in two fabrics	f. 12
Two black velvet *giornee* in two fabrics, one in the Lombard style, the other with red folds	f. 6
A *gonnellino* in the German style of sky-blue velvet A sky-blue velvet *gabbanellina* [short coat] lined in red taffeta Another *gabbanella* in the same velvet, plain A *gonnellino* in the German style of sky-blue satin	f. 10
Two *gonnellini* in the German style, of crimson velvet and with embroidered sleeves, made for boys	f. 4
Two *gabbanelline* of black damask, well used	f. 3
A *pitoco* of black damask, worn	f. 1
A *gabbanella* of tan satin, lined in gray damask	f. 3
A *robettino* of pale satin lined in iridescent taffeta A boy's *giornea* of green satin with wide pleats	f. 3
A green velvet *pitoco* A purple satin *pitoco* A man's *giubberello* [doublet] of black satin	f. 2
A child's *cotta* of green damask, worn	f. 3
A piece of dark green-brown camlet	f. 3
A piece of green camlet	f. 3
A piece of green-yellow camlet	f. 3
A length of purple camlet, 2 br. A length of black camlet, 3 br.	f. 1

A length of green taffeta for backing, 10 br.	f. 3
A narrow length of poor-quality iridescent taffeta, 13 br.	f. 1
Two lengths of Levant damask fabric	f. 4
Two more lengths of starched Levant fabric	f. 2

[folio 59 verso]

A tabby lining for an old cape
Two crimson velvet *berrette*
A purple and crimson velvet *cappelletto* [hat]
Five remnants of green velvet, old f. 1

A gray velvet *gabbanella*, unstitched, old and poor	f. 1.10
A remnant of pale taffeta from the Levant, worm-eaten, 12 br.	f. 1
An ornament of gold tinsel taken from the middle of a prize cloth	
Nine wool *giornee* in the livery of Piero di Cosimo, embroidered	f. 20

Three *gonnellini* in livery pattern, of purple and white
velvet and with branches and letters and imprints from the bust down f. 6

Two boys' *gonnellini* in the same style and embroidered	f. 8
A boy's *giornea* in purple and white velvet with branches	f. 1

Giuliano's clothes

A *gabbanella* of gray satin, lined in lynx	f. 3
A *gabbanella* of crimson damask, lined in squirrel, used	f. 5
A *gabbanella* of gray damask, lined in ermine	f. 8
A *gabbanella* of gray satin, lined in belly skins	f. 4
A *gabbanella* of crimson satin, lined in ermine	f. 8
A *gabbanella* of black cloth, lined in squirrel	f. 3
A *turca* of tan cloth, lined in squirrel tail	f. 6
A *gabbanella* of reddish cloth, lined in squirrel	f. 5
A *turca* of crimson satin, lined in sable and marten	f. 25
A *turca* of purple velvet, lined in ermine	f. 20

A *turca* of crimson damask, lined in squirrel f. 22

A *cappa* of rose cloth, lined in sky-blue velvet f. 10

A *gabbano* of purple cloth, lined in Lucchese silk cloth f. 8

A *cappa* of Flemish cloth with a black velvet hood f. 5

Two *mantelli* of pink cloth, of which one extends to the feet
and the other has pockets like a *catalano* f. 20

[folio 60 recto]

Three pairs of Lucchese silk hose, new f. 4

A *farsetto* of pale satin shot with silver
A *farsetto* of white satin shot with silver
A *pitoco* with sleeves of green satin shot with silver f. 10

A *farsetto* of gray damask, and a *giornea* of black cloth
with wide pleats in the Lombard fashion f. 2

IN THE LITTLE ROOM [BATHROOM] OF THE SAME ANTECHAMBER

A *cassone* of about 4 br., within which are:

Three thin towels in the Parisian fashion, poor and torn
A hand towel
Six small cloths in square pattern
Six old sheets f. 6

A large brass Flemish washtub, weighing 33 lib. f. 3

A copper bowl and two copper jugs and a pitcher, weighing 30 lib. f. 2

A round brass pail with a pitcher
A brass lamp with a base in the form of a candleholder f. 1

IN THE MEZZANINE ROOM ABOVE THE AFOREMENTIONED LITTLE ROOM

Two pairs of storage boxes and a poplar-wood chest with three
lids, of 6 br., all old, within which are about 80 lib. of flax of all sorts,
from white to yellow f. 12

A painted wood torch holder
Forty-three silver containers
Two baskets, within which are many utensils and tools f. —

IN THE PRIEST'S ROOM ON THE TERRACE

A painting in the French style with a gilt wood frame depicting
Our Lady with the Magi f. 2

Another very small painting with a gilt frame, also in the French style

A poplar-wood bedstead with a cornice and architrave of walnut
and intarsia, 5½ br., with cane lattice mat, straw mattress, and trestle f. 6

Two box benches nearby with four lids, half-decorated

A poplar-wood box-settle, with a walnut cornice and architrave,
5½ br., with a clothes rack and a *cassone* with two lids f. 6

[folio 60 verso]

An antique-style chest [*forziere*], completely gilt, 3½ br. f. 1

A beautiful little wickerwork table with two trestles, 6½ br. f. 2

A cypress chair, carved in Crete
An old poplar-wood armchair, 1 br.
Two upholstered women's chairs and a poplar-wood stool f. 1

A poplar-wood box of 3 br., holding a scale f. 1

A bed mattress full of wool
A down comforter and two pillows full of feathers, weighing — lib. f. 7

A cover used as a quilt, of green and blue canvas f. 1

A small sheepskin mattress for a settle, poor condition
A cover and a leather cushion f. —.10

A panel painting with the face of Madonna Lucretia
[Tornabuoni, Lorenzo's mother]
Another panel painting depicting six half figures, small
Two gilt cups, within which are two round balls,
depicting on them two spheres f. 60

A pair of andirons, tongs, shovel, and fork
A brass lamp with a base f. 1

Sixty-five lib. of coarse combed linen f. 3

IN THE ANTECHAMBER

A poplar-wood bedstead, 3½ br., with straw mattress, cane
lattice mat, trestle, and two box benches with four lids f. 2

A red mattress full of stuffing
A down comforter and a pillow full of feathers, weighing — lib.
An old-fashioned green and red spread, torn
A lined window curtain
A copper pail, old and broken f. 4

IN THE TERRACE ROOM TOWARD THE STREET

A poplar-wood bedstead with a walnut and intarsia cornice, 5 br.
A straw mattress, trestle, cane lattice mat, and bench
Two bench chests with four lids, half-decorated f. 6

A poplar-wood bed-settle with a clothes rack and *cassone,*
paneled in walnut and with the Medici arms f. 3

[folio 61 recto]

A cypress table with two trestles, 5 br. f. 2

Two walnut benches with high backs
Four upholstered women's chairs f. 1

Two mattresses covered in mattress ticking, full of wool f. 3

A down comforter and a pillow full of feathers weighing — lib. f. 7

A blue Venetian-style bedspread, embroidered f. 2

A pair of andirons, tongs, and shovel, and a fire chain
and a cypress-wood chair f. 1

Two thin mattresses for the bench bed, full of wool
An old green blanket, all torn, for the box-settle f. 1

A little painting, with writing and an Annunciation

IN THE ANTECHAMBER

Two earthenware figures of women, in the round

An astrology book

A panel of walnut, on which is a perspective

Several astrology panels

A large poplar-wood cabinet with two doors and a shelf in the middle, in which are many pieces of armor, as below:

Three large jousting cuirasses	f. 18
Two large jousting helmets	f. 24
A tournament helmet	f. 6
Six large jousting shields	f. 30
Two new jousting shields, reinforced	f. 8
Seven cross-braced jousting shields	f. 28
Four jousting scabbards	f. 4
A jousting cuirass cover	f. 1
Four jousting brassards	f. 4
Fourteen pauldrons, for the left and right side, for jousting	f. 7
Seven brassards with a shield, all for jousting	f. 10.10
Four short wrist cuffs, for jousting	f. 2
Two right-hand gauntlets, for jousting	f. 1

[folio 61 verso]

Continuing in the aforementioned cabinet with more armor

Two head armors for horses, for jousting	f. 4
Six small head armors for horses	f. 3
Three pairs of pauldrons for armed men	f. 3

A pair of large brassards with guards, equipped with buckles and things in silver	f. 2
A pair of greaves	f. 1
Three long back and hip protectors for jousting, of thick chain mail	f. 6
Four pairs of iron shoes	f. 2
A helmet with visor and beaver	f. 1.10
A beaver for a helmet	f. —.10
A jousting collar	f. 3
Thirty-two points for lances	f. 8
One hundred and seven tips for lances	f. 6
Twelve large points for lances	f. 6
Twenty-six points for lances, from large to small	f. 7
Two pins to fasten helmets	f. —.10
Two Moorish targets	f. 2
Twelve tournament banners	f. 1
Three shields, of which one is large and steel and the others small	f. 2
A pair of Moorish stirrups, large and beautiful	f. 4
Three open-field cuirasses	f. 10
Sixty burnished crossbow bolts of various kinds	f. 1
A pair of Turkish castanets	f. —
A gilt helmet crest with two branches	f. —
A casket within which are many arrow shafts without heads	f. —

IN THE ROOM OF THE LIBRARY ON THE SAME TERRACE

[lapsus]

[*folio 62 recto*]

IN THE LARGE ARMORY ABOVE, NEXT TO THE ROOF

Thirty-one plastrons covered in green silk
Sixty-nine pairs of pauldrons for the plastrons, covered in
the same material f. 62

Sixty-six pairs of chain-mail sleeves with canvas for use as tassets f. 33

Forty-four chain-mail tunics for foot soldiers f. 22

Forty-six chain-mail gorgets for foot soldiers f. 7

One hundred and three helmets and head gear, called *ribalde* f. 100

A long Turkish *vesta*, or rather *corazzine* [heavyweight tabard],
covered in green silk velvet f. 10

Two antique-style plastrons, covered in purple velvet f. 3

Four cuirasses for cavalry f. 8

Twelve helmets for cavalry f. 24

Ninety-three pairs of cuisse and greaves f. 279

Sixteen pairs of greaves f. 16

One hundred and eleven pairs of brassards f. 111

Eighty pairs of greaves f. 45

Two head armors for horses f. 1

Three cuirass chest pieces without plates f. 1

Fourteen pairs of pauldrons f. 14

Eleven pairs of iron shoes f. 6

Two pairs of tassets for cavalry f. 2

Two thick breastplates f. 3

A helmet covered in crimson velvet f. 3

Three sets of back and thigh armor for jousting f. 6

Two pairs of large stirrups for jousting f. 2

Forty points for lances
Eight hand guards for lances f. 14

A pair of white horse armors covered in velvet with gold decorations f. 10

A pair of steel horse armors with a linen cover embroidered in feathers f. 100

Three wooden frames to hold the horse armors f. 2

Seven billhook lances with shafts f. 3.10

Twenty-three sword lances with shafts f. 11.10

[folio 62 verso]

Two pikes with poles f. —.10

Twenty-seven rapiers f. 10

Thirteen jousting lances, from good to poor f. 1

Six iron torch holders to hold banners f. 2

Forty-four fixed-position crossbows, of which six are bench-mount f. 106

Thirty-seven field crossbows, of which one is small and of wood
and all the others are of steel f. 37

Sixteen crossbow winches, of which one is for the
bench-mount crossbows f. 24

A mounting bench for crossbows f. 2

Thirty-two stocks for crossbows
Thirty crossbow frames f. 16

Six boxes of crossbow bolts, assorted large and small f. 24

Ten wooden trestles to hold the weapons f. 10

Five steel harquebuses
A field tent with all its gear f. 30

A wooden loom of 5½ br. with a piece of linen attached f. 1

A deer head with the antlers
A catapult f. 1

Fourteen large and small pieces of alabaster, two of which are round f. —

Twelve marble heads of various kinds f. —

A majolica vase used as a storage cask f. —

ON THE STAIR LANDING NEXT TO THE ROOF

Eight catapults, six small and two large f. —

A cart and two trestles for the catapults f. 7

A field bed f. 4

A wagon to carry people f. 3

Many lead tiles, formerly used for the roof covering f. 20

Two models of houses, large and old f. 10

A net of iron wire, torn f. 1

Many pieces of wood used for the dais of the cardinal's reception, and
two torches on two poles, with a pewter pot used for a weathercock f. 5

[folio 63 recto]

CONTINUING INTO THE VINEGAR ROOM

Four casks containing about 34 *barili* of vinegar
A little barrel and two kegs f. 3.10

A cask holding about 6 *barili* for salting down meat f. —.10

A low bench, about — br. long f. —.5

Eleven wood panels, 1⅛ br. each, painted with a rose, to use as a stage f. 1

A wooden panel of 1¼ br., framed in walnut f. —.4

A piece of wood and two barrel holders for the above-mentioned casks f. —.2

A tub for carrying water
A tray to hold salt
A beech-wood plank door f. —.10

Several thick rush mats, 4 br. each f. 3

Several wide baskets and high baskets f. 1

A strainer to bottle the vinegar f. —.4

A large brass basin on a pedestal f. 2

A large copper bowl, weighing about 60 lib. f. 2

Six earthenware platters, or rather bowls, for gelatin f. 2

Six green glazed earthenware jugs f. 2

A large cauldron cover f. —

A linen comb and a wool-winder spindle f. —

A —, that is, many window panes, from broken to whole f. —

IN THE CHAMBER OF THE MUTE WOMAN

A cell in the room, of spruce-wood planks, to be used by the mute
as a bed enclosure, two faces of which are 12 br. long and 5 br.
high, and the other two faces set against the wall f. —.10

Fifteen pieces of spruce-wood planks for the surround, and
three pieces for beams f. —.6

A wooden bed of beams with cane lattice mat and bench, of 4½ br. f. 1

A spinning wheel to spin wool, for women f. —.4

Thirty beech-wood boards, 5 br. each, to make enclosures f. —.1

About twenty-five jousting lances f. 2

Twenty lib. or more of chicken lib. [*sic*] f. 1

bernia, bernie: A woman's coatdress or gown, open in front and/or at the side, narrower at the top and widening as it descends to the floor. Several are mentioned in the inventory, including one of velvet lined in taffeta in the room of Monsignore, one of gray Frisian wool in the *tascha* room, and a fancy one of green and gold watered satin lined in gray velvet in the wet nurses' room.

berretta, berrette: A cap. The inventory makes little distinction between types, except to specify double or single (plain) among seven caps in Piero's room and, among the total of forty-five of assorted colors in Lorenzo's wardrobe, one gashed in gold brocade and another all in velvet.

borgognone: An overcoat (Burgundian?). Mentioned only once in the inventory, in Lorenzo's wardrobe (fol. 16r).

calze, calzoni: Hosiery, either tights or stockings, traditionally two pieces tied at the top with laces called points. A single mention of *calzoni* (fol. 16r) possibly is meant to distinguish tights. Sometimes they are described with *solate e pedali,* meaning attached soles (fols. 16r, 40r). Some are mentioned as in two colors or in livery, meaning a different solid color for each leg (fols. 40v, 45v). Some were stored rolled up in a length of cloth (fol. 15v). As for the materials, the mention of a piece of black twill for hosiery suggests a heavier weave (fol. 39v), and in another place the fabric is Lucchese, which probably means silk (fol. 60r).

camicia, camicie: A linen chemise, shift, or shirt used as a man's or woman's undergarment worn next to the skin. Sometimes specified for men (fol. 33r) or for women (fol. 48v) or assorted for men or women (fol. 49v), suggesting that although the same word is used for both genders, the garments were clearly different. Three *camiciotti da bagno,* used for modesty in bathing, are inventoried in the wet nurses' room. The same term, *camiciotti,* is used for smocks worn while sifting flour in the bread room.

cappa: A cape or cloak with a hood of contrasting color. One belonging to Piero was of pink cloth lined in black velvet and had a gold and silver

ruffle, valued at 40 florins (fol. 44r). Two mentions of a *cappetta* probably
refer to a short cape (fols. 39v, 44r).

cappuccio, cappucci: A hood or cowl, often with a long tail, either separate
from or attached to a cape or overcoat. Sometimes these are inventoried
in groups of six, ten, or thirteen, as if they were common headwear apart
from the coat (fols. 15v, 39v, 45v).

catalano, catalani: A kind of long coat, probably from Spain, judging by the
name. One mention of a cape made with pockets, "like a *catalano*,"
suggests that *catalani* were distinguished by their pockets (fol. 59v).

cazzotto: A single mention of one among men's clothes suggests a codpiece or
short breeches not commonly worn (fol. 45r).

cioppa, cioppe: A woman's full-length gown worn over the undergown, of
extravagant materials and linings, sometimes with facings, buttons,
and/or collars.

collaretta, collarette: A band of material worn around a woman's neck.
Mentioned in two groups (fols. 34v, 35r).

converciere, convercieri: A man's or woman's linen undergarment.

corazzine: A long tabard worn over armor. Mentioned only once, in the
armory (fol. 62r).

cotta, cotte: A woman's gown or tunic, worn over the *camicia* and beneath the
overgown, most often with sleeves of contrasting color and fabric. The
gown itself, though seldom lined, was made of such extravagant fabrics
as satin, taffeta, velvet, high-low velvet, damask, camlet, and silk, and
often is described with added decorations such as velvet borders and
gold brocade appliqués.

cuffia, cuffie: A generic term for a man's or woman's lightweight fine linen cap,
like a nightcap or caul.

farsetto, farsetti: Most common term for the doublet, the man's close-fitting
upper-body jacket. *Farsetti* are extremely varied as to color and material;
the inventory records *farsetti* made of damask, satin, silk, and velvet.
Some are associated with livery bearing the Medici arms (fol. 57r)
and some with tournament gear (fol. 58v). The most unusual are two
armored doublets, one covered with Milanese armor plate (fol. 6v) and
another made of damask filled with chain mail (fol. 16r).

gabbano; gabbanella, gabbanelle: A common term (from the Arabic *gaba*) for
a loose overgown for men or women, usually with sleeves but sometimes
without, like a tunic, and often lined and/or hooded. Most were made of
common fabrics and were inexpensive, but one belonging to Giuliano
is of purple damask with gold brocade, valued at 32 florins (fol. 40r).
A *gabbanellina* (pl. *gabbanelline*) (fol. 59r) was a shorter *gabbanella*.

gammurra, gammurre; gammurrino, gammurrini: A term for a gown worn
under an overdress and over the chemise, twice described as without
sleeves (fols. 40r, 50v).

giachetta: A woman's coat or overdress. All mentions of these are in the wet
nurses' room, most of them made of extravagant materials and colors.
One is described as like a *cioppa* with a bodice (fol. 51v).

giaco: A man's jacket, overcoat, or tunic. Mentioned twice among tournament
gear (fols. 46v, 58v).

giornea, giornee: A tunic or long overdress applied to both men's and women's
garments, described as having deep pleats "in the Lombard fashion"
among Giuliano's clothes (fol. 60r). Also a ceremonial garment made
in livery colors (fols. 56v, 58v, 59v) or of extravagant materials, such as
satin embroidered with gold and silver thread, satin lined with iridescent
taffeta, high-low velvet with silver brocade, or damask studded with gold.

giubberello: A doublet similar to a *farsetto*. Mentioned only once (fol. 59r).

gonnellino, gonnellini: A ceremonial tunic worn over armor, similar to a
giornea but with a waist and a skirt. Two are described as in German
style and one as in French style, suggesting an origin in foreign
tournament wear.

guardacuore (Fr. garde-corps): A seldom-used term meaning a tunic, one of
which is described as made of silk with a bodice with sleeves, to wear at
night (fol. 45v).

lucco, lucchi: The classic Florentine male citizen's gown, a long, voluminous
robe with wide sleeves covering the body from shoulders to feet. Fabrics
and linings are contrasting and conspicuously luxurious, reflecting the
ostentation of the garment: English wool lined in fine squirrel skin, rose-
colored wool lined in ermine, turquoise wool lined in crimson leather,
shot satin of turquoise and crimson lined in white leather, turquoise twill
lined in crimson taffeta, crimson velvet lined in crimson taffeta, black
twill lined in black taffeta, and so on.

maniche (sing. *manica*): Sleeves. These were often attached separately to
garments to lend contrast in color or material; the inventory lists twelve
pairs of satin sleeves (fol. 49v). The fashion may have been introduced
into Italy from France.

mantellino, mantellini: A short, decorative *mantello*. The most lavish was one
in Piero's wardrobe, of French linen with a gold-thread plaid studded
with emeralds and valued at 25 florins (fol. 50r).

mantello, mantelli: A cape or cloak that, judging by its ubiquitous appearance
in the inventory (twenty-one are recorded), was a most common form
of outerwear. *Mantelli* are sometimes specified as hooded and are often

lined or half-lined. They can be of undistinguished material or of fine fabric such as silk twill, camlet, or gray damask lined with ermine. One of Lorenzo's is specified as rainwear, thus possibly treated with some waterproofing substance (fol. 16r).

mongile, mongili: Traditionally a shawl or *mantello*-like wrap. The five mentioned in Lorenzo's wardrobe are of satin, damask, and taffeta, and two are lined (fol. 15v). Five more of taffeta, damask, and tabby are listed among Piero's clothes (fol. 44v).

mongiluzzo, mongiluzzi: A short wrap.

pappafiche, pappafichi: A hood or cowl appearing in only one place in the inventory, as a group of four among Lorenzo's clothes (fol. 16r). The inventory distinguishes it from a *cappuccio,* another kind of hood.

pitoco, pitochi: A cloak or cape, often with a fancy lining, including fur (fol. 45r), gores, or buttons, and twice specified with sleeves (fols. 45r, 60r). When it appears in the context of armor, a *pitoco* is a tabard (fols. 6v, 47v).

roba, robe: A woman's gown similar to a *cioppa.*

robetta, robbette: A common term for a man's short robe or gown. No fewer than forty-two are recorded among Lorenzo's clothes (fol. 15v) and thirteen among Piero's (fol. 44v), most of fine fabrics such as crimson damask, black satin, imported wool, and satin shot with turquoise and crimson. Linings are of sable, ermine, wolf, squirrel, cat, and black lambskin, as well as silk and satin.

robettino: An even shorter robe.

saia, saie: A term used in this inventory for a man's gown but also referring to the silk fabric alone. Here the garments are lined and of fine fabric, sometimes tailored with gores of contrasting fabric (fols. 44v, 45r).

tabarro: An overcoat appearing only once and described as "in the Spanish style" (fol. 44r).

turca, turche: Apparently a kind of gown or robe, like a caftan, named after its resemblance to Turkish garb.

vesta, veste: A man's gown, like a *lucco,* of fine materials and linings, often imported, several of wool lined with squirrel, sable, velvet, or silk. Since the same term is used with the modifiers "Turkish" or "French" style (fol. 44v), and is also described as a *corazzine* (fol. 62r), it probably has a generic usage meaning any long gown.

vestito, vestiti: A woman's or girl's dress of simple materials, unlined, with sleeves (fols. 49v, 57r).

NOTES

Introduction

1. Landucci, *Florentine Diary,* 8 April 1492, 54.

2. For a review of the period, see Rubenstein, *Government of Florence,* 150–76.

3. For the dispersal of the family property, see Musacchio, "Medici Sale of 1495"; see also Fusco and Corti, *Lorenzo de' Medici,* 159–74. Though some goods were stolen, the reported sacking of the palace never took place. The sale was conducted by the Magistrato dei Pupilli, the government agency responsible for selling goods left to minors or owned by citizens who died intestate (Musacchio, "Medici Sale of 1495," 313–14 and n21). The quantity of goods was so great that the sale continued from July through December. The diarist Luca Landucci reported that on 19 July 1495, "Piero de' Medici's household effects and clothes [i.e., the contents of the Medici palace] were sold by auction; this work took several days," and on 11 August, "All these days they were selling by auction in Orsanmichele Piero de' Medici's household effects; there were velvet counterpanes embroidered in gold, and paintings and pictures, and all kinds of beautiful things." Landucci, *Florentine Diary,* 91, 93.

4. Landucci, *Florentine Diary,* 5 October 1512, 263.

5. On the purpose of the copy, see Andreas Grote's appendix in Dacos, Giuliano, and Pannuti, *Tesoro di Lorenzo il Magnifico,* 167. Lorenzo di Piero surpassed his uncles when he became the head of the Florentine government in 1513, the same year that Machiavelli dedicated *The Prince* to him. Though he died young, in 1519, his daughter Caterina (1519–1589), Lorenzo il Magnifico's great-granddaughter, fulfilled the family's highest ambitions. She married Henry, Duke of Orleans, in 1533 and became the queen consort of France when her husband was crowned King Henry II. Three of her sons became kings of France, one daughter was the queen consort of Spain, and a granddaughter became the Grand Duchess of Tuscany.

6. Inventory of the Goods of Lorenzo il Magnifico: The Medici Palace, Mediceo Avanti Principato, Archivio di Stato di Firenze, filza 165.

7. The Spallanzani–Gaeta Bertelà publication is of the entire manuscript, including the Medici villas and farm properties outside Florence. My translation in this volume is of the city palace alone. The transcription underscored the document's importance and made it clear to scholars that it is a mine of information about daily life among the wealthy in Renaissance Florence. Publications of parts of the inventory include Muntz, *Les collections des Médicis;* Shearman, "Collections of the Younger Branch of the Medici"; Spallanzani, *Ceramiche orientali a Firenze;* Scalini, "Weapons of Lorenzo de' Medici"; and Spallanzani, *Metalli Islamici.*

8. Guicciardini, *History of Florence,* 69.

9. For overviews of Florence and the Medici in the quattrocento, see Brucker, *Florence;* and Hale, *Florence and the Medici.*

10. Two excellent texts—Miles J. Unger's *Magnifico: The Brilliant Life and Violent Times of Lorenzo de' Medici,* and Francis William Kent's *Lorenzo de' Medici and the Art of Magnificence*—illustrate the challenges to objectivity when dealing with a historical icon. Both point out the numerous flaws in Lorenzo's actions over the course of his career but also praise him in the final analysis.

11. Lorenzo's famous carnival song "Quant'è bella giovinezza," which celebrates youth while lamenting the shortness of life, is an example of this shift toward melancholy. It was written for the May Day celebrations around 1490, when Lorenzo was in constant pain from gout, and it echoes a number of Latin memento mori poems, including, notably, Horace's ode 1.11, *Carpe diem*, and Ausonius's *De rosis nascentibus*.

12. For a fuller discussion of the political implications of Lorenzo's attendance at the wedding, see Unger, *Magnifico*, 82–87.

13. For the Rome trip, see ibid., 101–9.

14. Ibid., 1–19.

15. An exhaustive analysis of the plot is presented in Martines, *April Blood*. See also Acton, *Pazzi Conspiracy*. Poliziano, who had witnessed the events, even fleeing with Lorenzo into the sacristy, wrote a treatise for the record—curiously, in Latin, *Coniurationis commentarium*. A recent discovery of a coded letter seems to implicate Federico da Montefeltro, Duke of Urbino, in the plot. See Simonetta, *Montefeltro Conspiracy*.

16. For the medal commemorating the assassination, see Christiansen and Weppelmann, *Renaissance Portrait*, 178–79.

17. Landucci, *Florentine Diary*, 13 and 16 March 1480, 29.

18. The artists were Sandro Botticelli, Cosimo Rosselli, and Domenico Ghirlandaio. They were joined by Pietro Perugino, who was from Perugia in Umbria but had been trained in Florence. Exactly why Sixtus agreed to invite the Florentine painters is unknown. He had a number of skilled fresco painters at his disposal, including Perugino and Melozzo da Forlì, who had already worked for him, as well as others around Italy who would have jumped at the chance to paint the walls of the pope's chapel.

19. Unger, *Magnifico*, 200–209; Williamson, *Lorenzo the Magnificent*, 226.

20. His grandfather, who had taken the bank to its highest level of profitability, suffered no such qualms, maintaining tight control and firing those who made bad business decisions. The classic history of the Medici bank is de Roover, *Rise and Decline of the Medici Bank*. See also Unger, *Magnifico*, 212–14.

21. See Shearman, "Collections of the Younger Branch of the Medici."

22. He appointed two humanists, Naldo Naldi and Giorgio Antonio Vespucci, as their tutors. Further proof of Lorenzo's concern for the education of his nephews is provided by Botticelli's pedagogical painting *Primavera*, which Lorenzo gave to them for their palace. Lightbown, *Sandro Botticelli*, 2:51–53.

23. Recent research has indicated that he may also have embezzled from the state coffers as much as seventy-five thousand florins. See Unger, *Magnifico*, 339–41.

24. The inventory provides glimpses of the mind of a man of letters in its documentation of his collections of ancient cameos, gems, hardstone vases, and books. Note, for example, the books he kept in his private study, fols. 26v–27r.

25. Landino also wrote a well-known account of a discussion among several Florentine thinkers about the relative merits of the active and contemplative lives—*Disputationes Camaldulenses*—in which Lorenzo and Alberti argue the two sides of the question. Among Alberti's works were his volumes *On Painting* and *On Sculpture* and especially his treatise *On Architecture*, as well as a study, *On Family*, and two works on philosophy. Ficino was first patronized by Cosimo de' Medici, who commissioned him to translate all the works of Plato into Latin, but he became an important mentor to Lorenzo.

26. Pico brought upon himself the censure of the church in Rome when he published his *Conclusiones*, nine hundred principles based on his study of ancient Christian, Jewish, Arabic, and pagan writings. He dedicated his published defense of this work to Lorenzo. See Garin, *Giovanni Pico della Mirandola*.

27. The curricula were divided so that Pisa was responsible for law, medicine, and theology, while Florence concentrated on philosophy and philology. Unger, *Magnifico*, 225. See

also Kent, *Lorenzo de' Medici*, 105–6; and Hankins, "Lorenzo de' Medici as a Patron of Philosophy." The definitive treatment of the Studio is Verde's *Studio fiorentino*. The first scholars of Greek in England were Thomas Linacre and William Grocyn, both of whom studied in Florence in the 1470s and '80s before returning to Britain to establish the study of Greek at Oxford. Hibbert, *Rise and Fall of the House of Medici*, 170.

28. A selection of Lorenzo's poetry can be found in *Lorenzo de' Medici: Selected Poems and Prose*.

29. Translated in Unger, *Magnifico*, 135. See Medici, *Autobiography of Lorenzo the Magnificent*.

30. See Watts, *Original Poems and Translations*.

31. Two studies have exhaustively analyzed Lorenzo's collections and collecting tastes: Fusco and Corti, *Lorenzo de' Medici*; and Kent, *Lorenzo de' Medici*. Kent maintains that Lorenzo was also interested in collecting modern art while on his trips abroad, but on a much smaller scale. But as Kent himself demonstrates, Lorenzo was truly passionate only about antique objects (29–36).

32. Lorenzo, *Ricordi*, quoted and translated in Fusco and Corti, *Lorenzo de' Medici*, 6, 337.

33. Fusco and Corti, *Lorenzo de' Medici*, 13–21, 302.

34. Folio numbers refer to the original pagination in the inventory, my translation of which contains the folio numbers in brackets.

35. Quoted in Ajmar-Wollheim and Dennis, *At Home in Renaissance Italy*, 288.

36. See Ames-Lewis, *Library and Manuscripts of Piero de' Medici*; Hook, *Lorenzo de' Medici*, 127.

37. Kent, *Lorenzo de' Medici*, 7, 45–46. Ascanio Condivi, in his *Life of Michelangelo* (1553), mentions the project in passing: "Lorenzo the magnificent was having the marble, or rather the cut stonework, done there to ornament the very noble library which he and his forebears had collected from all over the world (the building, which has been neglected because of the death of Lorenzo and other misfortunes, was taken up again after many years by Pope Clement)" (11–12).

38. Quoted in Williamson, *Lorenzo the Magnificent*, 268–69; see also Unger, *Magnifico*, 436–37.

39. Machiavelli, *Florentine Histories*, 362.

40. Many sources quote letters from and about Lorenzo. An early but still useful compilation is found in Ross, *Lives of the Early Medici*. Shane Butler has collected Poliziano's letters.

41. For discussions of the palace, see Cherubini and Fanelli, *Palazzo Medici Riccardi*; Caplow, *Michelozzo*; Hyman, *Fifteenth-Century Florentine Studies*; Hyman, "Notes and Speculations on S. Lorenzo"; Morolli, Acidini Luchinat, and Marchetti, *Architettura di Lorenzo il Magnifico*, 51–62; and Hatfield, "Some Unknown Descriptions of the Medici Palace." For the calculation of the date of the family move, see Saalman and Mattox, "First Medici Palace," 329.

42. Preyer, "Florentine Casa."

43. Fusco and Corti, *Lorenzo de' Medici*, 110.

44. For the date and political implications of the statue and its inscription, see Sperling, "Donatello's Bronze *David*."

45. Two daughters, Lucrezia and Maddalena, had married and moved out. Another daughter, Luisa, had died in 1488 at age eleven. For Lorenzo's children, see Unger, *Magnifico*, 215–19.

46. Alfonsina became an important political figure in Florence after her husband's death. See Tomas, *Medici Women*, 164–94.

47. For a discussion of the room layout of Florentine palaces, see Thornton, *Italian Renaissance Interior*, 284–320; see also Rubin and Wright, *Renaissance Florence*, 314–15. For the Medici palace in particular, see Morolli, Acidini Luchinat, and Marchetti, *Architettura di Lorenzo il Magnifico*, 55–57.

48. The Piero bust was sculpted by Mino da Fiesole in 1453–54 and signed and dated as the rooms were beginning to be decorated. See Christiansen and Weppelmann, *Renaissance Portrait*, 166–68.

49. Lo Scheggia's *spalliera* paintings of Lorenzo's joust prove that it had been Lorenzo's room. For Giovanni's upbringing, see Unger, *Magnifico*, 415–17.

50. This is evidenced by the Botticelli paintings and tournament helmets and horse armor that adorned the walls, part of Giuliano's prizes for his tournament victories in 1474.

51. Apparently, this room was in the process of being renovated, and the books may have been in storage. See Kent, *Lorenzo de' Medici*, 7, 45–46.

52. For comparative inventories, see Kent, "Making of a Renaissance Patron," 72–75, 135. See also Gombrich, "Early Medici as Patrons of Art"; and Goldthwaite, *Wealth and the Demand for Art in Italy*, 224–55.

53. Note, however, that a great many items recorded in the inventory are not assigned a monetary value. Had they been, the total for the estate would have been higher.

54. See Goldthwaite, *Building of Renaissance Florence*, 342–50.

55. Ibid., 400–407. Lorenzo owned more vases and gems than are listed in the inventory: according to recent studies, he had at least fifty-one more gems and cameos than the seventy-five mentioned in the inventory, as well as thirty more hardstone vases than the thirty-three listed there. See Fusco and Corti, *Lorenzo de' Medici*, 92–96.

56. Lorenzo more than doubled the size of the library holdings. Hook, *Lorenzo de' Medici*, 127.

57. Janson, *Sculpture of Donatello*, 77–86, 198–205. See also Musacchio, "Medici Sale of 1495," 318–19.

58. For a summary of some of the other pieces not listed in the inventory, see Fusco and Corti, *Lorenzo de' Medici*, 29 and passim.

59. The clerk recorded only 284 antique silver coins, 200 various coins, and 1,844 bronze coins, far fewer than Poliziano's account (folio 28v). See also Fusco and Corti, *Lorenzo de' Medici*, 108, 121, 168–69, 195.

60. Dacos, Giuliano, and Pannuti, *Tesoro di Lorenzo il Magnifico*, vol. 1, *Le gemme*. See also Bober and Rubenstein, *Renaissance Artists and Antique Sculpture*, catalogue no. 68, 104–5.

61. The Apollo, Marsyas, and Olympus carnelian is now in the Museo Archeologico Nazionale in Naples. It was originally owned by Cosimo. See Bober and Rubenstein, *Renaissance Artists and Antique Sculpture*, catalogue no. 31, 74–75.

62. Fusco and Corti, *Lorenzo de' Medici*, 77–78.

63. For discussions of the *cassone*, see Pope-Hennessy and Christiansen, "Secular Painting in Fifteenth-Century Tuscany"; Witthoft, "Marriage Rituals and Marriage Chests"; and Callmann, *Apollonio di Giovanni*. The standard older work is Schubring, *Cassoni*.

64. Thornton, *Italian Renaissance Interior*, 111–28; Morolli, Acidini Luchinat, and Marchetti, *Architettura di Lorenzo il Magnifico*, 126–30; see also Ajmar-Wollheim and Dennis, *At Home in Renaissance Italy*, 119–23, 224–27.

65. Many studies have dealt with Renaissance clothing. See Currie, "Textiles and Clothing"; Jones and Stallybrass, *Renaissance Clothing*; Herald, *Renaissance Dress in Italy*; and Frick, *Dressing Renaissance Florence*.

66. This number does not include mosaics, ivories, enamels, or *cassone* paintings. Of the 139 works, only about seventeen are known today. The loss of so many works from a singular collection of fifteenth-century artists is a sobering reminder of how little we know of the full picture of quattrocento painting.

67. For a discussion of artworks in the Florentine palazzo in general, see Motture and Syson, "Art in the Casa"; and Wackernagel, *World of the Florentine Renaissance Artist*, 146–92. For a discussion of the art patronage of Cosimo and Piero, see Gombrich, "Early Medici as Patrons of Art."

68. Domenico Veneziano wrote to Piero in April 1438 requesting Piero's intervention with Cosimo on his behalf in securing a commission to paint an altarpiece for San Marco. Were he to receive the commission, he wrote, he would make himself "subject to every desired correction, and to undergo whatever trial might be required, honoring everyone concerned. . . . If you only knew the desire I have to execute some famous work, and especially for you, you would be favorable to me in this matter." Quoted in Wohl, *Paintings of Domenico Veneziano*, 14–15. On Piero's art patronage, see Ames-Lewis, "Art in the Service of the Family."

69. For the quotation, see Gilbert, *Italian Art, 1400–1500*, 8. Whether Gozzoli did in fact eliminate the angels is open to question.

70. For Lorenzo as collector, see Fusco and Corti, *Lorenzo de' Medici*, 131–47.

71. *Spalliera* paintings were works specially commissioned to be set into the paneling of nuptial chambers and became de rigueur among upper-class Florentine families beginning in about 1469; Lorenzo was on the cutting edge of interior decoration. Their use in Florentine interior decoration lasted until about 1520. Barriault, *Spalliera Paintings of the Italian Renaissance*, 1–8.

72. See Christiansen and Weppelmann, *Renaissance Portrait*, 169–71.

73. To this short list must be added the Uccello San Romano series, which seems to have been augmented by Lorenzo; see Caglioti, *Donatello e i Medici*, 1:265–81. Not mentioned in the inventory but known to have hung in the palace was the large painting *The Court of Pan* by Luca Signorelli of about 1484–92, destroyed in World War II in Berlin.

74. The *St. Jerome* is probably the painting attributed to Petrus Christus now in the Detroit Institute of Art. The unique fact that the small painting was still preserved in a case (*guaino*) suggests that it was part of the cardinal's traveling kit, and that when he was buried in the Certosa monastery at Galluzzo outside Florence, Cosimo may have bought the painting from his estate. See Stapleford, "Intellect and Intuition," 69.

75. Wohl, *Paintings of Domenico Veneziano*, 120–23.

76. Musacchio, "Medici-Tornabuoni *Desco da Parto*."

77. In a letter of 1494 Pollaiuolo wrote that he had executed the Hercules series for the palace thirty-four years earlier, that is, in 1460, when the decoration was being completed. They are all lost. Wright, *Pollaiuolo Brothers*, 75–83. Just as the San Romano battle scenes in the Sala Grande on the ground floor extol the virtue of Florence, the Pollaiuolo labors of Hercules series may relate to the self-image of the Medici family.

78. The painting, now in the National Gallery in Washington, is considered a collaboration with Filippo Lippi, who finished the work. See Ruda, *Fra Filippo Lippi*.

79. See Janson, *Sculpture of Donatello*, 77–86, 198–205.

80. The bronze relief of a battle scene above the fireplace in the *saletta* is certainly the one now in the Bargello by Bertoldo. Note, however, that Bertoldo had died in 1491 and did not live in the palace, as is often erroneously reported. The "chamber of Bertoldo, that is, the servants' room," is in the mezzanine area among the servants' quarters, a location that would have been beneath his station (fol. 11v). See Kent, *Lorenzo de' Medici*, 57–59; and Draper, *Bertoldo di Giovanni*.

81. The medallions set into the vaulted ceiling of the study were also by Luca della Robbia, though they are not cited in the inventory. See Syson, "Medici Study."

82. A statuette by Pollaiuolo of Hercules and Antaeus, now in the Bargello in Florence, is larger than that in the inventory, 18 inches versus 7.5 inches tall (46 cm vs. 19.4 cm). (Note that I have corrected the dimension given in Wright for the inventory's one-third braccia for the height from 17 cm to the accurate 19.4 cm.) Though it is often cited as the one referred to in the inventory, the inventory statuette is too small to be the Bargello work. Wright, *Pollaiuolo Brothers*, 334–40, 527–28; see also Rubin and Wright, *Renaissance Florence*, 40.

83. Lippi and Pesellino were associated professionally. Pesellino collaborated with Lippi on the altarpiece that the latter executed for Santa Croce, and when Pesellino died

prematurely in 1457, Filippo completed his unfinished altarpiece for the church of Santa Trinitá in Pistoia.

84. This painting of Saint Jerome may have been by Mantegna as it was on canvas and painted to imitate a marble relief, both characteristics of the Mantuan artist. See Lightbown, *Mantegna*, catalogue nos. 50–57.

85. Holmes, *Fra Filippo Lippi*, 172–82.

86. Dunkerton et al., *Giotto to Dürer*, 274.

87. Vasari states that Botticelli "carried out many works in the house of the Medici for Lorenzo the Magnificent, notably a life-size Pallas on a shield wreathed with fiery branches." Vasari, *Lives of the Artists*, 225. See Lightbown, *Sandro Botticelli*, 2:58–59; and Horne, *Botticelli, Painter of Florence*, 157. It should be mentioned that Botticelli's *Primavera* was probably commissioned by Lorenzo, though it belonged to his wards, Lorenzo and Giovanni di Pierfrancesco.

88. For the della Stufa purchase, see Musacchio, "Medici Sale of 1495," 323n79.

89. Vasari, *Lives of the Artists*, 136. See also White, *Birth and Rebirth of Pictorial Space*; and Edgerton, *Renaissance Rediscovery of Linear Perspective*, 143–52.

90. Compare the abbreviated annotated description in Wackernagel, *World of the Florentine Renaissance Artist*, 143–52.

91. For purposes of comparison, in 2011 the U.S. median household income for a family of four was $52,000. For monetary equivalents, see Goldthwaite, *Building of Renaissance Florence*, 342–50. For measurements and monetary equivalents, see Jacks and Caferro, *Spinelli of Florence*, xix–xx; Fusco and Corti, *Lorenzo de' Medici*, xxi; and Spallanzani and Gaeta Bertelà, *Libro d'inventario*, xiv–xvii.

92. A guide to the layout may be found in Bulst, "Uso e trasformazione del Palazzo Mediceo."

93. This is the first of two suites belonging to Lorenzo. The other was the Sala Grande suite on the *piano nobile*.

94. For a discussion of the circumstances surrounding the painting, see Christiansen and Weppelmann, *Renaissance Portrait*, 169–71.

95. Spallanzani, *Ceramiche orientali a Firenze*. Much of the porcelain collection seems to have been bought in the 1495 sale of Medici goods by Caterina Orsini, mother of Piero's wife, Alfonsina, probably fronting for the exiled Piero. Musacchio, "Medici Sale of 1495," 316.

96. Bertoldo's room has been thought to have belonged to the sculptor Bertoldo di Giovanni. It is clearly identified, however, as part of the servants' quarters called "the chamber of Bertoldo, that is, the servants' room," and thus not suitable quarters for the artist Bertoldo, who in any case had died in 1491.

97. Roettgen, *Italian Frescoes*, 326–57; Acidini Luchinat, *Chapel of the Magi*.

98. Ruda, *Fra Filippo Lippi*, 447–48. See also Strozzi, "Adoration of the Child." In 1495 the altarpiece by Filippo Lippi and the carved choir stalls were purchased for 845 florins and installed in the Palazzo della Signoria; see Musacchio, "Medici Sale of 1495," 318.

99. Fusco and Corti, *Lorenzo de' Medici*, 73–74.

100. Ibid., 143.

101. This may be the relief *The Ascension and the Giving of the Keys* now in the Victoria and Albert Museum in London. See Janson, *Sculpture of Donatello*, 92–95.

102. After the expulsion of the Medici, the birth salver was sold to Bartolomeo di Bambello for slightly more than three florins, in spite of its estimate of ten florins in the inventory. It is now in the Metropolitan Museum of Art in New York. See Musacchio, "Medici-Tornabuoni *Desco da Parto*."

103. Compare Wackernagel, *World of the Florentine Renaissance Artist*, 166–67.

104. For a discussion of fabrics, see Jacks and Caferro, *Spinelli of Florence*, 77–85.

105. Overall, the clerk managed to attach artist names to only forty-four of the total 139 artworks in the inventory.

106. The clerk made no mention of the twelve large glazed terracotta rondels by Luca della Robbia embedded in the vaulted ceiling of the study and now in the Victoria and Albert Museum in London. For the study, see Syson, "Medici Study," 288–92, 366.

107. Rubin and Wright, *Renaissance Florence*, 137.

108. See Dacos, Giuliano, and Pannuti, *Tesoro di Lorenzo il Magnifico*, vol. 1, *Le gemme*.

109. Fusco and Corti, *Lorenzo de' Medici*, 76–78.

110. For clocks as furnishings, see Thornton, *Italian Renaissance Interior*, 270–72.

111. It is a work of ca. 1470–90 and is now in the Bargello in Florence. See Ajmar-Wollheim and Dennis, *At Home in Renaissance Italy*, 302, 367; for the sale, see Musacchio, "Medici Sale of 1495," 317.

112. Paris, Bibliothèque nationale, MS Italien 548; Rubin and Wright, *Renaissance Florence*, 130–32.

113. Library of the Earl of Leicester, Holkham Hall, Holkham, Norfolk, UK, MS 41; Rubin and Wright, *Renaissance Florence*, 134–35.

114. The painting is now in the Detroit Institute of Art; see Panofsky, "Letter to Saint Jerome."

115. This might be a work by Andrea Mantegna, Francesco Squarcione's more famous pupil, who produced several paintings of Judith with the head of Holofernes. See Lightbown, *Mantegna*, catalogue nos. 52 and 56.

116. For the subsequent history of this tabernacle, see Musacchio, "Medici Sale of 1495," 316–17.

117. This is Giuliano's mounted and framed processional banner, mentioned above, which Vasari described when he saw it some fifty years later, still in place in the palace. See Horne, *Botticelli, Painter of Florence*, 157.

118. See Scalini, "Weapons of Lorenzo de' Medici."

119. See Tomas, *Medici Women;* and Pernis and Schneider, *Lucrezia Tornabuoni de' Medici*.

120. Vasari, *Lives of the Artists*, 163–64.

WORKS CONSULTED

Acidini Luchinat, Cristina, ed. *The Chapel of the Magi: Benozzo Gozzoli's Frescoes in the Palazzo Medici-Ricardi, Florence.* New York: Thames and Hudson, 1994.

——. *The Treasures of Florence: The Medici Collection, 1400–1700.* Munich: Prestel, 1997.

Acton, Harold. *The Pazzi Conspiracy: The Plot Against the Medici.* New York: W. W. Norton, 1979.

Ahl, Diane. *Benozzo Gozzoli.* New Haven: Yale University Press, 1996.

Ajmar-Wollheim, Marta, and Flora Dennis, eds. *At Home in Renaissance Italy.* Exh. cat. London: V&A Publications, 2006.

Ames-Lewis, Francis. "Art in the Service of the Family: The Taste and Patronage of Piero di Cosimo de' Medici." In *Piero de' Medici "Il Gottoso," 1416–1469,* ed. Andreas Beyer and Bruce Boucher, 207–20. Berlin: Akademie Verlag, 1993.

——. *The Library and Manuscripts of Piero de' Medici.* New York: Garland, 1984.

Barriault, Anne B. *Spalliera Paintings of the Italian Renaissance.* University Park: Pennsylvania State University Press, 1994.

Bober, Phyllis, and Ruth Rubenstein. *Renaissance Artists and Antique Sculpture.* New York: Oxford University Press, 1986.

Bode, Wilhelm von. *Italian Renaissance Furniture.* New York: William Helburn, 1921.

Brucker, Gene. *Florence: The Golden Age, 1138–1737.* Berkeley and Los Angeles: University of California Press, 1998.

——. *Renaissance Florence.* Berkeley and Los Angeles: University of California Press, 1969.

Bulst, Wolfger A. "Uso e trasformazione del Palazzo Medici fino ai Riccardi." In *Il Palazzo Medici Riccardi di Firenze,* ed. Giovanni Cherubini and Giovanni Fanelli, 98–124. Florence: Giunti Gruppo Editoriale, 1990.

Caglioti, Francesco. *Donatello e i Medici.* 2 vols. Florence: Olschki, 2000.

Callmann, Ellen. *Apollonio di Giovanni.* Oxford: Oxford University Press, 1974.

——. *Beyond Nobility: Art for the Private Citizen in the Early Renaissance.* Exh. cat. Allentown, Pa.: Allentown Art Museum, 1980.

Caplow, Harriet McNeal. *Michelozzo.* New York: Garland, 1977.

Cherubini, Giovanni, and Giovanni Fanelli, eds. *Il Palazzo Medici Riccardi di Firenze.* Exh. cat. Florence: Giunti Gruppo Editoriale, 1990.

Christiansen, Keith, and Stefan Weppelmann, eds. *The Renaissance Portrait from Donatello to Bellini.* Exh. cat. New York: Metropolitan Museum of Art, 2011.

Condivi, Ascanio. *Life of Michelangelo.* Translated by Alice Sedgewick Wohl. 2nd ed. University Park: Pennsylvania State University Press, 1999.

Currie, Elizabeth. "Textiles and Clothing." In *At Home in Renaissance Italy,* exh. cat., ed. Marta Ajmar-Wollheim and Flora Dennis, 342–51. London: V&A Publications, 2006.

Dacos, Nicole, Antonio Giuliano, and Ulrico Pannuti, with an appendix by Andreas Grote. *Il tesoro di Lorenzo il Magnifico.* Vol. 1, *Le gemme.* Florence: Sansoni, 1973.

de Roover, Raymond. *The Rise and Decline of the Medici Bank, 1397–1494.* Cambridge: Harvard University Press, 1963.

Derruisseau, L. G. "Dress Fashions of the Italian Renaissance." *CIBA Review* 17 (January 1939).

Draper, J. D. *Bertoldo di Giovanni.* Columbia: University of Missouri Press, 1992.

Dunkerton, Jill, Susan Foister, Dillian Gordon, and Nicholas Penny. *Giotto to Dürer: Early Renaissance Painting in the National Gallery*. New Haven: Yale University Press, 1991.

Eberlein, Harold Donaldson. *Interiors, Fireplaces, and Furniture of the Italian Renaissance*. New York: Architectural Book, 1916.

Edgerton, Samuel Y. *The Renaissance Rediscovery of Linear Perspective*. New York: Harper and Row, 1975.

Ettlinger, L. D. *Antonio and Piero Pollaiuolo*. Oxford: Oxford University Press, 1978.

Frick, Carole Collier. *Dressing Renaissance Florence*. Baltimore: Johns Hopkins University Press, 2005.

Fusco, Laurie, and Gino Corti. *Lorenzo de' Medici: Collector and Antiquarian*. New York: Cambridge University Press, 2006.

Garin, Eugenio. *Giovanni Pico della Mirandola*. Parma: Comitato per le Celebrazioni Centenarie in Onore di Giovanni Pico, 1963.

Gelli, Iacopo. *Guida del raccoglitori e dell'amatore di armi antiche*. Milan: Ulrico Hoepli, 1900.

Gilbert, Creighton, ed. *Italian Art, 1400–1500: Sources and Documents*. Englewood Cliffs, N.J.: Prentice Hall, 1980.

Goldthwaite, Richard. *The Building of Renaissance Florence*. Baltimore: Johns Hopkins University Press, 1982.

———. *The Economy of Renaissance Florence*. Baltimore: Johns Hopkins University Press, 2009.

———. *Wealth and the Demand for Art in Italy*. Baltimore: Johns Hopkins University Press, 1993.

Gombrich, Ernst H. "The Early Medici as Patrons of Art." In Gombrich, *Norm and Form: Studies in the Art of the Renaissance*, 35–57. London: Phaidon, 1966.

Guicciardini, Francesco. *The History of Florence*. Translated by Mario Domandi. New York: Harper Torchbooks, 1970.

Hale, John R. *Florence and the Medici: The Pattern of Control*. London: Thames and Hudson, 1977.

Hankins, James. "Lorenzo de' Medici as a Patron of Philosophy." *Rinascimento* 34 (1994): 15–53.

Hatfield, Rab. "Some Unknown Descriptions of the Medici Palace in 1459." *Art Bulletin* 52, no. 3 (1970): 232–49.

Heikamp, Detlef, ed. *Il tesoro di Lorenzo il Magnifico*. Vol. 2, *I vasi*. Florence: Sansoni, 1974.

Herald, Jacqueline. *Renaissance Dress in Italy, 1400–1500*. Atlantic Highlands, N.J.: Humanities Press, 1981.

Herlihy, David, and Christiane Klapisch-Zuber. *Tuscans and Their Families*. New Haven: Yale University Press, 1985.

Hibbert, Christopher. *The Rise and Fall of the House of Medici*. Harmondsworth: Penguin Books, 1974.

Holmes, Megan. *Fra Filippo Lippi: The Carmelite Painter*. New Haven: Yale University Press, 1999.

Hook, Judith. *Lorenzo de' Medici: An Historical Biography*. London: H. Hamilton, 1984.

Horne, Herbert P. *Botticelli, Painter of Florence*. London: George Bell and Sons, 1908. Reprint, Princeton: Princeton University Press, 1979.

Hyman, Isabelle. *Fifteenth-Century Florentine Studies: The Palazzo Medici and a Ledger for the Church of San Lorenzo*. New York: Garland, 1977.

———. "Notes and Speculations on S. Lorenzo, Palazzo Medici, and an Urban Project by Brunelleschi." *Journal of the Society of Architectural Historians* 34 (1975): 98–120.

Jacks, Philip, and William Caferro. *The Spinelli of Florence: Fortunes of a Renaissance Merchant Family*. University Park: Pennsylvania State University Press, 2001.

Janson, H. W. *The Sculpture of Donatello*. Princeton: Princeton University Press, 1963.

Jones, Ann Rosalind, and Peter Stallybrass. *Renaissance Clothing and the Materials of Memory*. New York: Cambridge University Press, 2001.

Kent, Francis William. *Lorenzo de' Medici and the Art of Magnificence*. Baltimore: Johns Hopkins University Press, 2004.

———. "Palaces, Politics, and Society in Fifteenth-Century Florence." *I Tatti Studies* 2 (1987): 41–70.

Kent, Francis William, and Alessandro Perosa. *Giovanni Rucellai ed il suo zibaldone*. Vol. 2. London: Warburg Institute, 1981.

Klapisch-Zuber, Christiane. *Women, Family, and Ritual in Renaissance Italy*. Chicago: University of Chicago Press, 1985.

Landucci, Luca. *A Florentine Diary from 1450 to 1516, Continued by an Anonymous Writer Till 1542 with Notes by Iodoco del Badia*. Translated by Alice de Roven Jervis. London: J. M. Dent and Sons, 1927.

Liebenwein, Wolfgang. *Studiolo: Die Entstehung eines Raumtyps und seine Entwicklung bis um 1600*. Frankfurt: Frankfurter Forschungen zur Kunst, 1977.

Lightbown, Ronald. *Mantegna, with a Complete Catalogue*. Berkeley and Los Angeles: University of California Press, 1986.

———. *Sandro Botticelli*. Vol. 2, *The Complete Catalogue*. Berkeley and Los Angeles: University of California Press, 1978.

Machiavelli, Niccolò. *Florentine Histories*. Translated by Laura F. Banfield and Harvey C. Mansfield Jr. Princeton: Princeton University Press, 1988.

Martinelli, Giuseppe, ed. *The World of Renaissance Florence*. New York: G. P. Putnam's Sons, 1968.

Martines, Lauro. *April Blood: Florence and the Plot Against the Medici*. Oxford: Oxford University Press, 2003.

Medici, Lorenzo de'. *The Autobiography of Lorenzo the Magnificent: A Commentary on My Sonnets*. Translated by James Wyatt Cook. Binghamton: Medieval and Renaissance Texts and Studies, 1995.

———. *Lorenzo de' Medici: Selected Poems and Prose*. Edited and translated by Jon Thiem. University Park: Pennsylvania State University Press, 1991.

Morolli, Gabriele, Cristina Acidini Luchinat, and Luciano Marchetti, eds. *L'architettura di Lorenzo il Magnifico*. Exh. cat. Florence: Silvana Editoriale, 1992.

Motture, Peta, and Luke Syson. "Art in the Casa." In *At Home in Renaissance Italy*, exh. cat., ed. Marta Ajmar-Wollheim and Flora Dennis, 269–83. London: V&A Publications, 2006.

Muntz, Eugène. *Les collections des Médicis au XVe siècle: Le musée, la bibliothèque, le mobilier*. Paris: Librairie de l'Art, 1888.

Musacchio, Jacqueline Marie. "The Medici Sale of 1495 and the Second-Hand Market for Domestic Goods in Late Fifteenth-Century Florence." In *The Art Market in Italy, Fifteenth–Seventeenth Centuries*, ed. Marcello Fantoni, Louisa Matthew, and Sara F. Matthews-Grieco, 313–23. Modena: F. C. Panini, 2003.

———. "The Medici-Tornabuoni *Desco da Parto* in Context." *Metropolitan Museum Journal* 33 (1998): 137–51.

Panofsky, Erwin. "A Letter to Saint Jerome: A Note on the Relationship Between Petrus Christus and Jan van Eyck." In *Studies in Art and Literature for Bella da Costa Greene*, ed. Dorothy Miner, 102–8. Princeton: Princeton University Press, 1954.

Pernis, Maria Grazia, and Laurie Schneider. *Lucrezia Tornabuoni de' Medici and the Medici Family in the Fifteenth Century*. New York: Peter Lang, 2006.

Poliziano, Angelo. *Coniurationis commentarium*. Edited by Alessandro Perosa. Padua: Antenore, 1958.

———. *Letters*. Vol. 1, books 1–4. Edited and translated by Shane Butler. Cambridge: Harvard University Press, 2006.

Pope-Hennessy, John, and Keith Christiansen. "Secular Painting in Fifteenth-Century Tuscany: Birth Trays, Cassone, Panels, and Portraits." *Metropolitan Museum of Art Bulletin* 38, no. 1 (1980): 2–64.

Preyer, Brenda. "The Florentine Casa." In *At Home in Renaissance Italy*, exh. cat., ed. Marta Ajmar-Wollheim and Flora Dennis, 34–48. London: V&A Publications, 2006.

Roettgen, Steffi. *Italian Frescoes: The Early Renaissance, 1400–1470*. New York: Abbeville Press, 1996.

Rosenthal, Margaret, and Ann Rosalind Jones. *The Clothing of the Renaissance World*. New York: Thames and Hudson, 2008.

Ross, Janet. *Lives of the Early Medici as Told in Their Correspondence*. London: Kessinger, 2006.

Rubenstein, Nicolai. *The Government of Florence Under the Medici (1434–1494)*. Oxford: Clarendon Press, 1999.

Rubin, Patricia Lee, and Alison Wright. *Renaissance Florence: The Art of the 1470s*. London: National Gallery, 1999.

Ruda, Jeffrey. *Fra Filippo Lippi: Life and Work, with a Complete Catalogue*. London: Phaidon Press, 1993.

Russell, Douglas. *Costume History and Style*. Englewood Cliffs, N.J.: Prentice Hall, 1983.

Saalman, Howard, and Philip Matox. "The First Medici Palace." *Journal of the Society of Architectural Historians* 44 (1985): 329–45.

Scalini, Mario. "The Weapons of Lorenzo de' Medici: An Examination of the Inventory of the Medici Palace in Florence." In *Art, Arms, and Armour: An International Anthology*, ed. Robert Held, 12–29. Chiasso: Aquafresca Editrice, 1979.

Schottmüller, Frida. *Furniture and Interior Decoration of the Italian Renaissance*. Stuttgart: Julius Hoffmann, 1928.

Schubring, Paul. *Cassoni: Truhen und Truhenbilder der italienischen Früh-Renaissance; Ein Beitrag zur profanmalerei im Quattrocento*. 3 vols. Leipzig: Verlag Karl W. Hiersemann, 1915, 1923.

Shearman, John. "The Collections of the Younger Branch of the Medici." *Burlington Magazine* 117 (January 1975): 12–27.

Simonetta, Marcello. *The Montefeltro Conspiracy: A Renaissance Mystery Decoded*. New York: Doubleday, 2008.

Spallanzani, Marco. *Ceramiche orientali a Firenze nel Rinascimento*. Florence: Cassa di Risparmio, 1978.

———. *Metalli Islamici a Firenze nel Rinascimento*. Florence: SPES, 2010.

Spallanzani, Marco, and Giovanna Gaeta Bertelà. *Libro d'inventario dei beni di Lorenzo il Magnifico*. Florence: Amici del Bargello, 1992.

Sperling, Christine M. "Donatello's Bronze *David* and the Demands of Medici Politics." *Burlington Magazine* 134 (April 1992): 218–24.

Stapleford, Richard. "Intellect and Intuition in Botticelli's *Saint Augustine*." *Art Bulletin* 76 (March 1994): 69–80.

Strozzi, Beatrice Paolozzi. "*The Adoration of the Child* by the Workshop of Filippo Lippi." In *The Chapel of the Magi: Benozzo Gozzoli's Frescoes in the Palazzo Medici-Ricardi, Florence*, ed. Cristina Acidini Luchinat, 29–32. New York: Thames and Hudson, 1994.

Syson, Luke. "The Medici Study." In *At Home in Renaissance Italy*, exh. cat., ed. Marta Ajmar-Wollheim and Flora Dennis, 288–93, 366. London: V&A Publications, 2006.

Thornton, Peter. *The Italian Renaissance Interior, 1400–1600*. New York: Harry N. Abrams, 1992.

Tomas, Natalie. *The Medici Women: Gender and Power in Renaissance Florence*. Aldershot: Ashgate, 2003.

Unger, Miles J. *Magnifico: The Brilliant Life and Violent Times of Lorenzo de' Medici.* New York: Simon and Schuster, 2008.

Vasari, Giorgio. *Lives of the Artists: A Selection.* Translated by George Bull. London: Penguin Books, 1965.

Verde, A. F. *Lo studio fiorentino, 1473–1503.* 5 vols. Florence: Istituto Nazionale di Studi sul Rinascimento, 1973–94.

Wackernagel, Martin. *The World of the Florentine Renaissance Artist.* Translated by Alison Fuchs. Princeton: Princeton University Press, 1981.

Watts, Susannah. *Original Poems and Translations, Particularly Ambra from Lorenzo de' Medici, Chiefly by S. W.* London: British Library, Historical Print Editions, 2011.

Welch, Evelyn. *Art and Society in Italy, 1350–1500.* New York: Oxford University Press, 1997.

White, John. *The Birth and Rebirth of Pictorial Space.* Cambridge: Belknap Press of Harvard University Press, 1987.

Williamson, Hugh Ross. *Lorenzo the Magnificent.* New York: G. P. Putnam's Sons, 1974.

Witthoft, Brucia. "Marriage Rituals and Marriage Chests in Quattrocento Florence." *Artibus et Historiae* 3 (1982): 43–59.

Wohl, Hellmut. *The Paintings of Domenico Veneziano, ca. 1410–1461.* New York: New York University Press, 1980.

Wolfthal, Diane. *The Beginnings of Netherlandish Canvas Painting.* Cambridge: Cambridge University Press, 1990.

Wright, Alison. *The Pollaiuolo Brothers.* New Haven: Yale University Press, 2005.

Yarwood, Doreen. *The Encyclopedia of World Costume.* New York: Scribner's, 1978.

INDEX

Page numbers in *italics* refer to illustrations.

CPSIA information can be obtained
at www.ICGtesting.com
Printed in the USA
LVHW041928120120
643360LV00004B/375/P